CU00797626

Guy Van Den Langenbergh

Introduction by Marco Pastonesi

FABIAN CANCELLARA

Annotated and authorised
by Fabian Cancellara

B L O O M S B U R Y

LONDON · OXFORD · NEW YORK · NEW DELHI · SYDNEY

CONTENTS

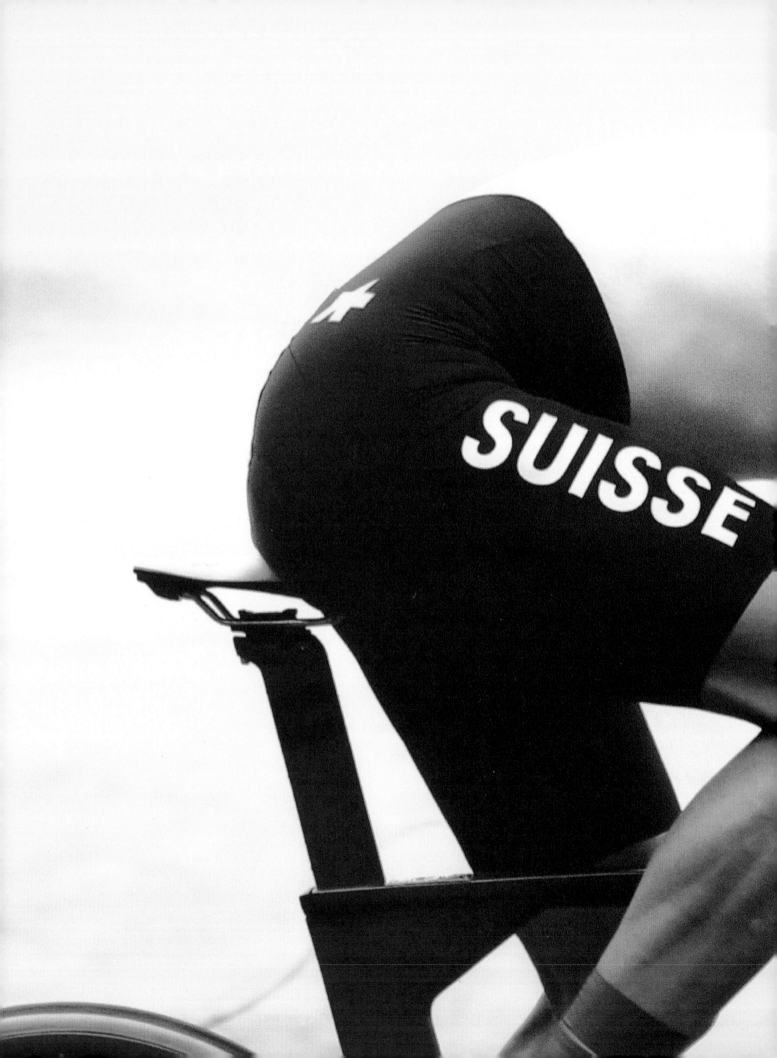

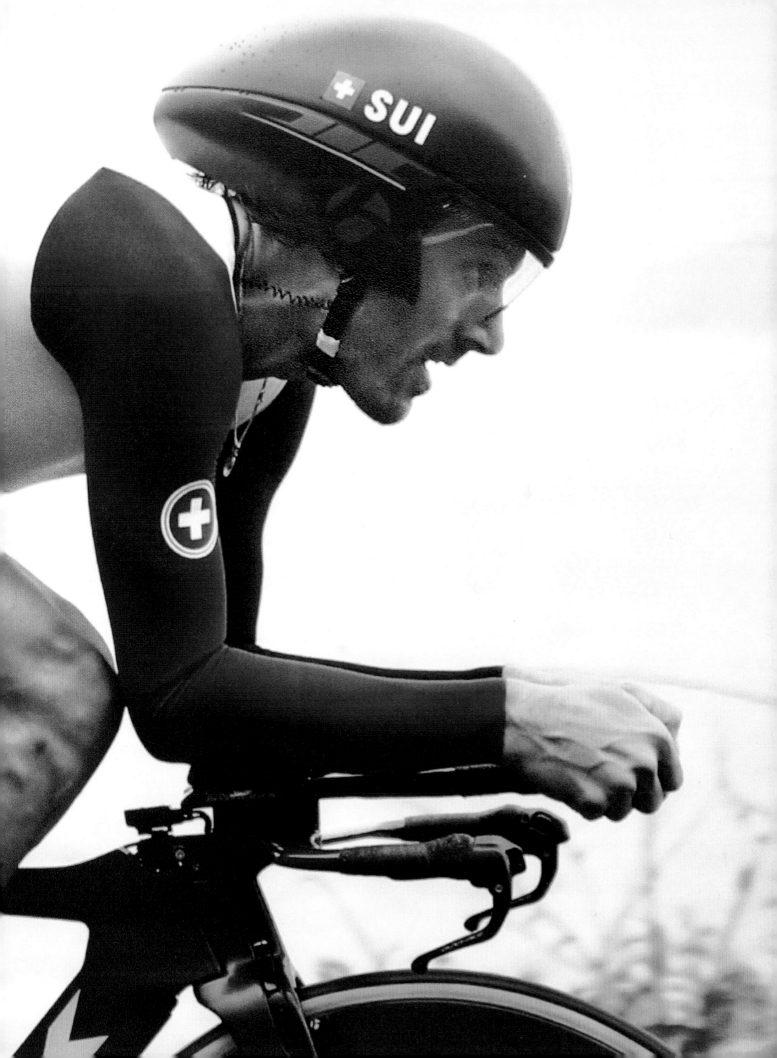

INTRODUCTION

Marco Pastonesi

Four hours and 37 minutes. 122 kilometres of tarmac and some 53 kilometres of gravel roads. Winding its way like a labyrinth between heaven and earth, the cycle race takes on the aura of a game of chess; it is all about strategy and tactics. But it is also about hurtling along at 40 kilometres per hour; and about lactic acid. Four riders lead the field. Two members of the same team – the Czech rider Zdenek Stybar and the Italian Gianluca Brambilla – ride alongside the Slovakian Peter Sagan and the Swiss Fabian Cancellara. Stybar, the retiring champion in this competition, has thrown his title into the ring as if it were the world middle-weight boxing championship: the most prestigious title imaginable if the bicycle were somehow transformed into a pair of boxing gloves and the cycle race into a boxing match. Sagan wears the colourfully striped rainbow jersey; he is world champion and thus Captain of Planet Earth. For a whole year he has borne the responsibility of being the patron saint of everyone who climbs into the saddle – not just the professional riders, but also the amateurs, the fans, the partners and children, the Sunday cyclists and the people who use their bikes day in, day out to go to and from school, work or the local market. Cancellara has the greatest number of northern classic races to his name, including this, the most southerly of the northern classics – not taking place in the Flemish triangle, not under cloudy Baltic skies, but in the Italian province of Siena, beneath the Tuscan sun. Of our four riders, Brambilla has won the fewest prizes, has the least number of titles to his name, is the least favourite. But he is in the lead.

The finishing line beckons; just one kilometre to go. The course now turns brick-red as it flies over the Via Esterna di Fontebranda before sweeping on to the uphill Via Santa Catarina. Brambilla stands on his pedals, grimly challenging his self-doubt and fatigue. So much self-doubt and fatigue compared with his almost exhausted reserves of strength, making his machine dance like a *tanguero* leading an inexperienced or unwilling partner. He draws strength from the encouragement and applause of the spectators; is nourished and refreshed by it; converts it into courage and hope, because his energy has long since been exhausted. Just 500 metres from the finish, Brambilla is still a lonely figure at the head of the race; who knows, perhaps he can banish the confusion of thoughts about who is pursuing whom, whose heels are being snapped at, who is in danger of being swallowed up. Behind him, the three men in pursuit check each other out with narrowed, staring eyes. They challenge each other. Their battle is one of resisting gravity, of biting down on the pain, of banishing temptation and emotion. At the end of the climb they are faced with a ninety-degree right-hand bend. Brambilla, still alone at the front, throws himself into the bend and sends up a pious supplication to the gods of cycle racing to show a scrap of compassion. Sagan loses several wheel-lengths, while Cancellara and Stybar throw their whole weight into the pursuit. They know every angle. They also know that whoever takes the lead now will win the race. They measure themselves. They are now neck and neck, almost touching. Cancellara on the inside, Stybar on the outside. It is a minimal territorial advantage which Cancellara grasps eagerly to take full mastery of the road. In less than a fraction of a moment, Cancellara and Stybar – in that order – catch Brambilla. They leave him and his courageous exhaustion behind and throw themselves into the descent over the mediaeval paving stones into the final bend, another right-hander. Cycling has now taken on a different dimension; it has become a procession and a horse race through city streets each of which grudgingly relinquish the riders as they pass on to the next street. Cancellara doesn't give an inch, maintains his willpower and surges forward in the bid for glory. He sweeps onto the Piazza del Campo and flashes across the finish line beneath the triumphal arch. He has won Strade Bianche. For the third time.

This is the story of the Strade Bianche 2016, one of the hundreds of victories achieved by Fabian Cancellara. It may not be the best-known or most highly rated race, nor the biggest or most glorious victory, but there is so much in this victory of Cancellara himself, always of himself. The courses ridden by the cyclists eventually begin to resemble the riders, even taking on their names. Costante Girardengo: that was Milan-San Remo. He knew every straight and every bend on that course; he had mastered its language and its peculiarities right down to the last iota. Fausto Coppi gained eternal fame in the ride from Cuneo to Pinerolo, in the 1949 Giro, joining immortals such as Maddalena, Vars, Izoard, Monginevro and Sestriere. Gino Bartali was a god of the mountains, always on the attack – first purely for the sake of attacking, then attacking his opponents and finally attacking his own shadow and himself. Jacques Anquetil was a chronometer; he rode like a metronome, with the rhythmic cadence of a well-oiled time machine; a textbook example of dividing time to the last millisecond; so stable and controlled that he could carry a glass of champagne in his backpack without spilling a drop. Eddy Merckx was the man of the final kilometre; whether uphill or downhill, in a breakaway group or a sprint – it made no difference to him where the course was, whether it was a one-day race or a tour, a race full of world-class riders or a pootle around the church tower.

The roads that make up the Strade Bianche are bathed in a blinding mix of dust and light, glittering with gravel and shining puddles. The route is pregnant with vines and olive trees, as it winds its way through history and geography. This is the habitat of farmers and shepherds; a paradise for cycle tourists and cycling fanatics. Fifty shades of brown when the weather is wet; 50 shades of yellow when it is dry; 50 shades of green on all sides; 50 shades of blue in the endless, boundless sky. Heroism is in the air; romance is rooted in the surrounding nature; the pioneering spirit bubbles out of the landscape. And yet they are white, these Strade Bianche. It's all a little mad, to be honest. But then, cycle racers would not be cycle racers if they weren't a little mad. It is often said – and always thought – that cycle racers must be mad. One only has to think of the blistering speed of a Milan-San Remo race; of the stubborn cobblestones of a Paris-Roubaix; of the bone-jarring cold of a Paris-Nice; of the teeming rain of a Tour of Lombardy; of the searing heat of a Tour de France; of the height differences in a Giro or a Vuelta; of the climbs that look like walls; of the descents that teeter on the edge of the abyss. Anyone who steps onto the Strade Bianche, who leaps onto their bicycle, mad or otherwise, and turns the pedals, with or without a number on their back, is by definition a little mad, some more than others. Pedalling away from the start and with eyes fixed on the arrival; away from timetables and other concerns; away from giving and taking orders; away from dependencies, obligations and routines. Riding towards a new balance on two wheels. Nowhere else is life more like a wheel than here: in the past, the four wheels of cart and carriage; today, the two wheels of a bicycle. Cycling: compared with the steel constructions from times gone by, the modern machines are like jewels, exotic creations, prototypes, installations, artistic frames or technological *tours de force* whose only similarity to their predecessors is that they share the same number of wheels: two. Perhaps the greatest human invention since the wheel: two wheels. Moving like-mindedness.

The Strade Bianche – an event that gives us a more complete picture of the Cancellara of Paris-Roubaix, of the Tour of Flanders, of the yellow jersey or the rainbow jersey – is full of paradox. It is a recent race that smacks of history; an original course that is like all courses used to be; a more real course, not because the others are not real, but because that realness here is rooted in the earth, in the land, in the soil, in the area, in the clods of earth; and because 'real' here is a symbol for rough, for raw. The Strade Bianche is a classic race which is ageless;

a classic of the north, yet held in an area that is not even in the north of its own region of Tuscany, but which lies at the heart of a country that is resolutely in the south of Europe. A northern classic that is held in the south, then, where the walls are made of baked clay, where the landscape is shaped and defined by climbs and descents, where the roads have been fragmented, crushed, pulverised by the centuries-old cadence of carts and carriages, of innumerable generations of farmers and now of whole hordes of tourists, on bicycles to boot. It is probably also the course that is the most loved by the riders themselves. They love it for its introvert and extrovert character; for the thin ribbon that courses through time more than through space; for the interface between adventure and mystery; for its elusive and musical nature. It is a course that resonates and echoes, that nods towards tongue-twisting rap, hip-hopping rhythm and, in the best case, jazzy improvisations.

Cancellara is (I simply cannot bring myself to use the past tense and write 'was' because, let's face it, a cyclist cycles for ever, even if only on the cobblestones of memory and in the hills and valleys of fantasy) – Cancellara is such an archetypal racing cyclist that he looks new and avant-garde, as solid and as strong as his forebears of the same calibre, so real because he is made from that earth, that land, that soil, yes even that roughness and rawness. Cancellara could have competed with the Red Devil Giovanni Gerbi, with the eternal runner-up Tano Belloni, with the fighter-on-a-bike Jean Robic, with the Flemish emperors Rik I (Van Steenbergen) and Rik II (Van Looy), with the little chimney-sweep Maurice Garin and with the mud-king and stonemason Luigi Ganna, with the flea that was Torrelavega Vicente Trueba or with the eagle of Adliswil Ferdi Kübler. He could even have raced side-by-side with Alfonsina Strada, the only woman in the history of cycle racing (we are talking about 1924) to be admitted to one of the major competitions (the Giro d'Italia) for men (she finished out of time, but was brought back into the rankings because the organisers were forced to respond to her popularity). Cancellara began as a trial racer during the era that a certain Marco Pantani was gracing the circuit. After all that has happened since – from the triumphant highs to the fall of Armstrong, via the heyday of British cycling with names such as Cavendish, Wiggins and Froome, the globalisation of the cycle racing calendar, of the competitions and of the riders – that now seems to be an eternity ago, as if it belonged in a different century.

The stage on which Cancellara does battle is paved with flat routes, pistes, cobblestones and walls, bends and loops, hope and pain, Arenberg forests, crypts and churches (think of the Kapelmuur and the Wall of Geraardsbergen), arenas and colosseums; and then it is easy to make the connection with Spartacus, because Cancellara shares with that hero the smell of sweat, the indefatigable determination, the intricate design of his strip which makes him recognisable even in a black-and-white photograph. Cancellara-Spartacus is the gladiator of cycle racing, who fascinates and enchants because he embodies how much suffering a human being can bear, how heavily fate can weigh upon his shoulders and how that fate can be transformed in the mind into the power to thunder across kilometres of road for hours on end in a test of strength against speed. Over the 16 years in which passion and profession have been melded together, in which the craft has been fuelled by art even more than by talent, Cancellara-Spartacus has excelled in power and resilience, in potential and arrogance, solo or in a group, in a breakaway group or in a peloton, against the clock or against the emotions. Sometimes he has won even when he came in second, or third, or 40th place. Because who would dare to claim that only the rider who finishes in first place is the winner? Each of those victories, each of those top places in a general classification, was treated as a celebration of cycle racing and of the bicycle, as a pinnacle of ethical and epic proportions, of sport and sportsmanship. Give everything, only

allow the legs to buckle after you have crossed the finishing line, acknowledge the merits and hide the tears behind the smile: everything that glitters here is gold.

Like all cyclists, but so much more so in Cancellara's case, he is both an ambassador for life and a missionary of adventure, a total embodiment of the eternal values of cycle racing: willpower, stubbornness, solidarity, respect, danger. He too – no one is perfect and entirely immune to vulnerabilities, not even Spartacus – will have known moments of self-doubt and uncertainty, will have been troubled by moments of vulnerability and weakness, moments of crisis and powerlessness, or at least disillusion and despondency; but he has always tried to empty his – and our – troubled mind, to give his and our thoughts a pedal-push in our everyday lives.

Cancellara could have been born as a tractor or a locomotive, a zebra or a waterfall, a double-bassist or an oak, as granite or iron; but nature made him into a whirlwind, son of the wind, father of the wind, and raised him in a genetic miracle to a sort of godliness that stretches to the poles and the Antipodes. If he had been born in Wales, his life would have been filled with rugby. If he had been born in New Zealand, his torso would have been swathed in a black jersey: not the colour of he who comes last, but of the champion's jersey. If he had first seen the light of day in the United States, we would have seen him entering the boxing ring in Madison Square Garden or stepping onto the diamond of the Yankee Stadium. If his father had remained in the Italian *Basilicata*, we might have seen him pulling on the oars of a two-man boat (a tandem without wheels), or as a roving centre-forward (easier and pays more). But instead he followed his heart and his favourite instrument: the bicycle. And a good thing too.

He is 35 years old, a fact indisputably recorded in black and white in the population register. But Cancellara is ageless. He announced his retirement from cycling before the decline materialised on the horizon, whilst his name is still high in the classification rankings, whilst he is still full of dreams and projects. Anyone trying to change his mind is given short shrift. It isn't about money or contracts; this is what he wanted to do. 'I know that winning isn't everything,' he stated unequivocally. 'Cycling is part of my life; I enjoy what I do; I want to experience my freedom.' Turning the pedals of a bicycle requires not just physical effort, but also the drive of the emotions. Choosing the right moment to stop is a subtle and very rare skill that is given to only a few. The fact that we shall miss such a generous racer as Cancellara (one San Remo, twice winner of the Tour of Flanders and three times winner of Paris-Roubaix, with two double victories, four World Time Trial Championships, plus two junior titles, two gold and one silver Olympic medal and so much more) is beyond doubt, even though we can enjoy endless replays on the Internet and YouTube. But he will stay with us. I see him before me, on the chalk-white roads of the Strade Bianche. Not for a trial ride, where he has already been immortalised in gravel sector number 6 – the Monte Sante Marie, the toughest. I see him joining in the amateur race out of which the Stade Bianche grew, the Eroica which first took place in Gaiole in Chianti, and which dates back to 1987. A race that harks back to the days of handlebar moustaches, toe-clips, external cables, woollen jerseys and shorts, tubes around the shoulders and at least two water bottles. The retro-experience that is the Eroica has since been exported to California, Japan, Spain and Great Britain, exists in a version for hikers (but still with the trappings of a race) and a year-round cycle track. It has become a consumer product that rides the waves of fashion and trends. I see him before me now, Cancellara the hero, wearing a woollen jersey, tubes around his neck, and who knows with a handlebar moustache, turning the pedals out of pure enjoyment, out of sincere gratitude. It is so beautiful: cycle racing, his cycle racing, will never die.

FABIAN CANCELLARA

20 CAREER KEY MOMENTS

HOW IT ALL BEGAN

Fabian Cancellara was barely seventeen years old and a first-year junior when he won his first World Time Trial Championship in Valkenburg in the Netherlands. One year later he pulled off the same feat in Treviso in Italy. Although they were no guarantee of a successful professional career, these two world titles were an indication of the Swiss cyclist's potential. In the meantime, Cancellara tried to lead as normal a teenage life as possible. However, it gradually became clear that the young Swiss rider was unusually talented.

An old road bike belonging to his father Donato, an Italian-made Chesini with pedal straps, was enough to make the young Fabian Cancellara fall in love with cycling. At first happy to race against friends in his hometown of Wohlen, he took part in his first competitions at the age of twelve. 'Cycling should first and foremost be enjoyable,' says Cancellara. 'Cycling certainly wasn't a priority for me at that age. I played football as well, at SC Wohlensee. Left wing, right wing, occasionally in midfield. I also joined a local cycling club: CI Ostermundigen.'

Cancellara was twelve years old when he first lined up at the start of a cycle race. 'It was just for fun. I only took part in local races. And I couldn't ride in very many as I was still playing football.'

The young cyclist/footballer didn't want to choose, until circumstances forced him to. 'One day there was a bike race and a football match scheduled simultaneously. I decided to prioritise the bike, but I didn't realise that both events were taking place in the same village. It so happened that the changing rooms for the race and the match were in the same sports hall. There I was, with my bike, standing in front of my teammates in their football strips. Afterwards our football coach took me to one side. "Fabian," he said, "if you want to do well at something, you have to make a choice."'

And Cancellara made the choice. He stopped playing football and from that moment on devoted all his energies to cycling. But even then it was still primarily a hobby. 'You can't compare it with the way young people are trained nowadays,' he says. 'There was no such thing as individual training programmes. Quite often we all trained together, young and old. In winter, we'd get our mountain bikes out or go jogging together. I even took part in some cyclo-cross races. I remember in particular that I often went training with older riders. As a result, I would go on long rides as a young teenager, up to 120 kilometres. Way too much for that age, but apparently my body could handle it. Presumably that's why I've achieved what I have.'

The bike started to take an increasingly central role in the Cancellara family. 'My parents always supported me, even though we weren't wealthy. My sister Tamara, who's two years older than me, also chose to go into cycling a few years after my debut. She was talented too, and even made the World Championships team in 1998. However in those days, results weren't a priority for me. I just wanted to have fun on my bike. If we went on holiday to southern Italy, where my father grew up, then I always took my road bike or my mountain bike.'

Cancellara's talent soon rose to the surface. At the age of thirteen he won his first victory. 'That must have been in Rietbach, not far from where we lived. The three junior categories rode together. I was the best in my age group, but that didn't necessarily mean that I was the fastest, because each race was followed by a compulsory obstacle track race. The results of the two races were added together to determine the winner. At my first national competitions we were even presented with a written test: what's allowed on a bicycle, what isn't... a long list of questions. If I remember rightly, I refused to complete it, and incurred penalty points as a result.'

The first successes were at regional level. But after arriving as a newcomer, it soon turned out that Cancellara was the best in the whole of Switzerland. 'As a second-year novice I won just about every race I took part in. I was noticed by the Federation, which led to my first races abroad. I took part in the European Youth Olympics in Lisbon, where I finished second, behind a certain Bernhard Eisel as it happens. I also began watching the great classic races on television during that period. On Sunday mornings I would go racing and in the afternoons I would watch classics like Milan-San Remo, the Tour of Flanders and Paris-Roubaix. The Tour didn't appeal to me as much back then.'

Fabian Cancellara is crowned junior World Time Trial champion for
the second year in a row in Treviso, Italy.

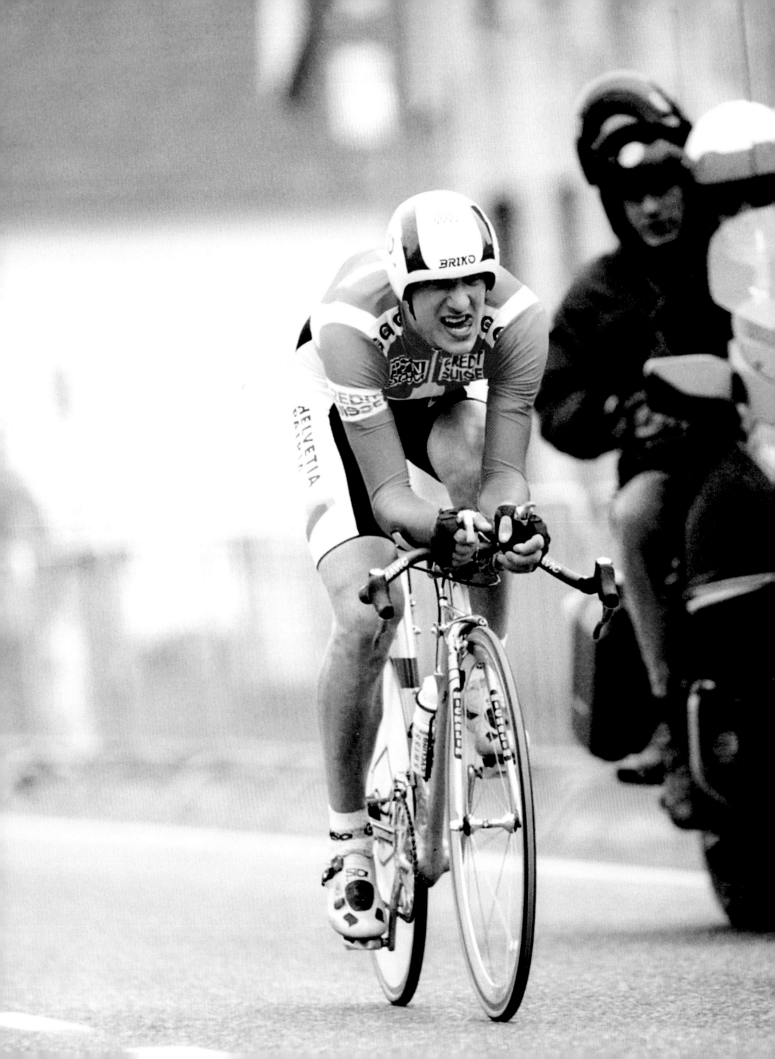

APPRENTICESHIP

Fabian Cancellara's family played an important role in the development of the young cyclist. His father Donato, an affable Italian who left his homeland at the age of eighteen to seek a better future in Switzerland, drove his son to all his races. His mother Rosa did her best to encourage Fabian with his studies. She was determined he should get some qualifications. 'Unfortunately, it never clicked between me and the classroom,' laughs Cancellara. 'I liked learning things but rarely got very far with textbooks. Studying wasn't for me. So I started an apprenticeship as an electrician. That was more up my street. Even now I still do most of the small electrical jobs at home. But the bike began to take up more and more of my time. Luckily I had an understanding boss who gave me enough time off to train. Again, I eventually had to make a choice, because if you want to do well at something, you have to really go for it.'

Cancellara realised at an early age that the bike could be a source of income. 'A win meant you could easily take home an envelope containing 100 Swiss francs. That was and still is a lot of money for a boy of fifteen. What's more, my club operated a premium system. Like a proper accountant, I kept a record of all my results. Those premiums quickly reached 2000 Swiss francs and more. All those pennies went to the bank. Once I gave in to temptation and bought what was then an elegant pair of shoes. I paid more than 200 francs for those shoes, and I wore them with pride for years. I also used to spend money on bike stuff, but I soon had a contract with a local bike shop in exchange for advertising on my jersey. I didn't want the flashiest gear, I wanted the best gear. As a result, I used to change bikes quite often. Later on I used to slip my dad some money now and then to cover the petrol costs. I never got pocket money, I earned enough myself for that.'

Cancellara's burgeoning talent didn't go unnoticed by the Swiss Cycling Federation. He became the spearhead of the national squad. 'As a junior, I did most of my races with the national team,' he recalls. 'That also meant that I went abroad more often. Suddenly life was an adventure. I raced in Italy, Austria, the Czech Republic... I was always on the road in a Federation coach, with the trainer, a mechanic and a *soigneur*

at the front and the riders at the back. I bought my first mobile phone, which then didn't work in the Czech Republic. I was so annoyed! And I faced Tom Boonen for the first time, in an Austrian stage race. I was impressed by Boonen and Steegmans, the Belgian giants. *[With a glint in his eye]* But I did win two stages and the overall classification.'

TIME TRIALS

It was becoming increasingly clear how fast Cancellara could ride. 'I was with the national team at a training camp near Gruyere, and the emphasis was primarily on time trialling. I didn't have a time trial bike, but that didn't stop me from being the best at that too. I liked it because it was something different. The speed, the battle against yourself: suddenly I had a whole new challenge. I became the Swiss champion and was selected for the World Championships in Valkenburg. The Federation provided me with a second-hand time trial bike. As a first-year junior I wasn't the favourite, but because I'd achieved a good result in the Grand Prix des Nations, I was able to start quite late. And I won! And the next year, in Treviso, I won again. And I won the World Cup.'

These successes represented a turning point in the life of the growing teenager. 'Cycling was gradually becoming a performance-based sport,' he remembers. 'Results began to be important. But it didn't change me. When I went to the local youth centre in the village, they knew that I was the cycling world champion, but that was it. I kept seeing the same friends, I went to parties. But if they went to a nightclub afterwards, I would go home. Alcohol and drugs were never an issue in my youth, I never experimented, I never did things in order to be "cool". Although I do remember once having a very heavy night at a party one Easter Saturday. On Monday there was a race, and my dad was beside himself. That wasn't how an athlete behaved, he said. And he was right. On Sunday, I was good for nothing, on Monday I broke away after a handful of kilometres and then kept the lead for the next 70 kilometres to win by a large margin. I had learned my lesson. I never got tired of the bike, not even in my so-called adolescence. Little by little I came to realise that cycling could be my profession.'

02 EXPLOSIVE ENTRY ONTO THE PROFESSIONAL STAGE

Fabian Cancellara made his debut in the pro peloton in the autumn of 2000, with a contract from Patrick Lefevere's Italian-Belgian team Mapei-Quick Step. It wasn't long before his first professional victory. On 21 February, 2001, the Swiss cyclist was the fastest in the prologue of the Tour of Rhodes, ahead of the then relatively unknown Briton Bradley Wiggins. No one could have known then that these two men standing on the podium would go on to become two of the greatest racers of their generation.

Shortly after becoming the World Junior Time Trial champion for the second time, Fabian Cancellara received a phone call from the famous Mapei training centre. The Italians were engaged in developing a core group of promising youngsters and Cancellara was an obvious choice. 'In the summer of 1999, I drove down to Italy with my parents to meet Patrick Lefevere, Alvaro Crespi and Aldo Sassi. They saw something in me. But there was still the matter of my apprenticeship, which my mother expected me to complete. Unfortunately I had to repeat a year, simply because I didn't like studying. And even if I resigned from my apprenticeship, I knew I had military service training hanging over my head.'

Turning professional overnight wasn't an option. Cancellara moved to the U23 category in 2000. 'I was put through my paces in the Mapei centre near Milan. And I passed the test. But because I didn't want to give up my electrician's apprenticeship, I was placed in MG Boys in Verona, a feeder team for the U23s. Our captain was Francesco Chicchi. We often rode crits in Italy, and predominantly flat races as well.'

It wasn't exactly the easiest period, as the Swiss cyclist now realises. 'I was the only rider in the team who still had a job besides cycling. I was still riding for the Swiss national team at the same time. I certainly wasn't bad and I won races, but my appren-ticeship was an obstacle until one day my employer finally realised that my heart lay in cycling. Just like my football coach years earlier, he too advised me to make a choice. After consulting with my parents, I decided in May 2000 to drop my studies and focus entirely on cycling. This wasn't an easy decision, but with hindsight it was the right decision. My mum found it more difficult than my dad, but eventually she agreed too.'

During the Mapei period, Cancellara discovered a scientific approach to cycling, which was totally different to anything he'd experienced before. 'For me, Mapei was a real revelation. Suddenly I was working with a heart rate monitor, I had a training programme, I was being tested and observed. I felt like I was at Real Madrid! I still consider Mapei as the perfect example of how a team should be structured. Now, fifteen years later, I still see very few teams with that sort of training centre with hardly any budgetary limits. I'm glad that in my last year as a professional I was able to collaborate with Mapei Sports again and reconnect with the big boss Giorgio Squinzi. It felt like I'd come full circle. *Vincere Insieme,* Win Together, was the motto of the Mapei team, and one I've always carried with me. When I look back on those years, they weren't the best of my career, but were perhaps the most important because of what I learned and discovered.'

RACING INSTINCTIVELY

Cancellara made his professional debut in September 2000 as a *stagiaire* (an amateur rider). He was sent to Belgium, where he took part, among others, in the GP Jef Scherens, Brussels-Izegem, and the Circuit Franco-Belge multi-day stage race alongside Johan Museeuw. Later that year, he also took part in the U23 time trial at the World Championships in Plouay. Only the Russian Evgeni Petrov was faster than the nineteen-year-old Swiss cyclist. 'Cycling was still fun, but because I realised that I could make my hobby my profession, it slowly but surely became serious too. Before, I had rarely ridden as part of a team, and almost never with a predetermined task. I raced on instinct and never according to a plan. They were all things that I had to learn.'

In 2001, the Swiss cyclist finally became a fully-fledged professional, but there was one obstacle: he still had to complete his military service. 'I did eight weeks of training. Luckily my lieutenant-colonel was very keen on sport. He told me that if I took my training seriously – made my bed properly, polished my boots, cleaned my rifle regularly – then I would get time to train. After those eight weeks, I was allowed to attend a kind of sports camp for five weeks. I could train hard, but only when I was allowed to, not when I wanted to. It meant

"The youth team was sent to smaller races, where we won what we wanted to win. We also got to see a bit of the world. I raced in South Africa, others went to Cuba."

that my first season wasn't exactly what I'd expected.'

Nevertheless, Cancellara soon achieved his first professional victory in a Mapei-Quick Step jersey. At the beginning of February 2001, he was sent to the Tour of Rhodes. 'With a super-strong team full of young riders: Sinkewitz, Petrov, Rogers... it was great, there was no jealousy. Sometimes I was the captain, sometimes someone else. But wherever we went, we rode to win. And we won often: *Vincere Insieme,* again!'

Rhodes was no different. In the prologue, Cancellara beat none other than Bradley Wiggins, and the Swiss cyclist wore the leader's jersey from start to finish. 'I didn't know Bradley. The fact that he'd won an Olympic medal on the track the previous year had completely passed me by. In retrospect, it was cool that I scored my first professional win against him. My victory meant that we had a leader's jersey to defend and that I had to go over the mountains wearing it. We pulled this off too. That first professional victory meant a lot to me and my family. We had made the right choice.'

AROUND THE WORLD

In 2002, Cancellara's second season at Mapei, new UCI legislation meant that the youth team was separated on paper from the 'big' Mapei. 'In the first year, we'd been

allowed one older rider with us at each race. That wasn't possible any more. But it wasn't a problem: the youth team was sent to smaller races, where we won what we wanted to win. We also got to see a bit of the world. I raced in South Africa, others went to Cuba. The team also had a base in Italy for the foreign riders: Alan Davis, Evgeni Petrov... I went there occasionally to train. It was a wonderful time. I'm still in touch with Pippo *[Filippo Pozzato].* Initially we didn't hit it off, but when the team management decided to put us in the same room, we realised we had a lot in common. I used to go round to his house a lot in those days, and still see and hear from him regularly today.'

The younger riders stayed in contact with the Mapei A-team, where stars like Paolo Bettini were enjoying success. On joint training rides, the young Fabian was still keen to make his mark. 'I remember one training camp in Tuscany, where we went out on the road with the seniors. During one of the climbs I sat in behind Stefano Garzelli, who had won the Giro the previous year. Following him was no problem. As arrogant as I was, I even began to whistle a tune just below the summit. The others couldn't believe their ears. I was immediately put straight. That day I realised I still had a lot to learn.'

At Mapei, Cancellara met the young sports scientist Luca Guercilena, later the

manager of Trek-Segafredo. 'We were both on a learning curve. He wanted to become a good trainer, I wanted to become a good rider. Luca drew up my first training schedules and occasionally came to races. He was mainly focused on young cyclists, which therefore included me. It's no coincidence that we worked together again later on.'

At the end of 2002, Mapei boss Squinzi decided to turn off the money tap. 'That was a big disappointment,' Cancellara confesses. 'We had all become involved in a project that we didn't get the chance to finish. The goal was to develop into the A Team but we didn't get the opportunity. Squinzi realises that now too. Maybe that's also the reason why Trek and Mapei Sports reunited again this year.'

At the end of 2002, Cancellara was forced to look for a new employer. It was to be Fassa Bortolo, managed by Giancarlo Ferretti, the Iron Sergeant.

03 TIME TRIALIST TURNS CLASSICS RIDER

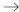

Cancellara riding for Fassa Bortolo, the team led by 'Iron Sergeant' Giancarlo Ferretti.

→

At the age of 22, Fabian Cancellara moved from the progressive Mapei-Quick Step to the old-fashioned Fassa Bortolo, which was ruled by the fearsome 'Iron Sergeant' Giancarlo Ferretti. The Italian, one of cycling's most successful directors, knew exactly what he wanted to do with Cancellara. He sent him to the cobbled classics, resulting in a fourth place in Paris-Roubaix in 2004. Little by little, Cancellara discovered a love for the northern European classics.

The decision by Mapei boss Giorgio Squinzi to turn off the money tap forced Cancellara to seek out a new home. The Italian team Fassa Bortolo came knocking. 'My manager Armin Meier knew the team. My compatriot Sven Montgomery was riding for them at the time too, and I preferred to stay in an Italian environment. So Fassa Bortolo seemed to me like a logical choice, and my good friend Pozzato chose them too. Unfortunately, it never clicked between Pippo and Ferretti.'

Cancellara was introduced to team kingpin Giancarlo Ferretti's style right from the negotiation stage. 'He made a proposal, and when we made our counter-proposal, you could see him sneaking a look at a piece of paper and making calculations. And sighing! Then he'd make another proposal. And so it continued for a while. But, admittedly, the contract that he offered me was more than decent.'

Ferretti symbolised the old approach. 'His will was law. Everyone involved in the team listened to him. The contrast with Mapei was huge. Mapei represented the soft approach, with room for discussion and consultation. Ferretti embodied the opposite. Also, the scientific approach which I had experienced at Mapei wasn't immediately present at Fassa Bortolo. And time trials weren't a priority for Ferretti. The time trial bikes were certainly not the best on the market. But the biggest adjustment was that I was suddenly the youngest rider on the team, excepting Pozzato. I found myself among a group of adults: most riders were married and had children. The contrast with the previous year at Mapei, where I was hanging around with peers, was significant. I had to fight hard to win my place in the group.'

RIGOROUS DRILL

'If you were late for training, Sergeant Ferretti would make you pay. If you turned up to a race in an expensive car, he would tear strips off you. According to his philosophy, riders should drive old, decrepit Fiat Pandas. He didn't think we should invest our money in expensive cars or designer clothes. He was old-fashioned in his thinking. He was very passionate, always focused on the race, but he could also be incredibly hard. Apparently he once went up to Chicchi when he was having a massage and asked him in front of several other people whether he was sure cycling was the right sport for him.'

The lack of scientific support within the team led a lot of riders to look for it elsewhere. It so happened that Fabian Cancellara came into contact with the Italian trainer Luigi Cecchini. 'At our first meeting I was overwhelmed, as overwhelmed as I was when I first set foot in the Mapei centre. His office was full of posters of riders he worked with. And here was I, little old Fabian Cancellara, paying him a visit.'

Cecchini would over time come to be mentioned in the same breath as Michele Ferrari – the evil genius behind Lance Armstrong – and Francesco Conconi, two scientists who brought the role of cycling coach into a twilight zone. Cecchini also got into choppy water in 2006 when his name was linked to Eufemiano Fuentes, the doctor at the centre of Operación Puerto, one of the biggest doping cases in cycling history. 'He came straight to the point with me,' says Cancellara. '"If you've come here to find drugs to make you go faster, there's the door." He was quite clear. He never mentioned doping to me. Doping was never an issue for me. I was young and naive, I didn't know what was for sale in the world. The reason for my visit was simple: I wanted to train intelligently. I'd paid for an SRM PowerMeter out of my own pocket, I wanted training schedules. He tested my endurance and explosive power. He kept looking at his computer screen and making calculations during the tests. I'd never experienced such an approach. Until I found out later on that he'd been checking the stock market.'

Cancellara impressed the Italian trainer. 'Apparently I pulverised Rolf Sörensen's record in the short test. That saw to it that

"At our first meeting I was overwhelmed. His office was full of posters of riders he worked with. And here was I, little old Fabian Cancellara, paying him a visit."

Some things never change: throughout his career, the Swiss racing cyclist never gave less than 100%. Here Cancellara makes his Paris-Roubaix debut, riding for Fassa Bortolo.

→

I was accepted not only by Luigi but by the whole family. I was always welcome, and often stayed for dinner. He drew up training schedules for me, and I felt I benefited from them. Our relationship was optimal. He made time for me when I needed him. He treated me with great respect.'

Cancellara worked with Cecchini for several years, but when the latter's name was linked too prominently to doping in 2006, he said goodbye to his Italian mentor. 'The pressure was too great and the risk of reputational damage too. Still, I'm not afraid to admit that, without all those stories, I'd still be working with Luigi today. Of course I asked myself questions afterwards. Why dope one rider and not another? Was it because he saw that I didn't need anything extra? I really don't know. I still haven't found a suitable answer.'

STRAIGHT TO FLANDERS

Meanwhile there were races of course. To Ferretti's great credit, he sent Cancellara to Flanders straight away. 'Funnily enough I can't remember that anymore,' he says. 'Was I eleventh in Gent-Wevelgem in 2003? Did I race in the Tour of Flanders too? I honestly don't know. All I remember of my first year are the prologue wins in Romandie and Switzerland.'

Starting in the Flemish classics was compulsory not optional, Cancellara confirms. 'Ferretti relied on his Italian riders for the Italian classics. There was no room for me. So I was sent to the north. I certainly wasn't the captain and it didn't feel like a childhood dream come true. It was just part of the learning process; I had to work for captains like Frank Vandenbroucke. On the other hand, I did learn the routes.'

Cancellara first demonstrated his mettle on the cobblestones in 2004. He was barely 23 years old when he found himself sprinting for victory on the track at Roubaix. 'I didn't understand it either. Suddenly I was at the front, when the previous year, the first time I'd taken part, I'd been rattling through the Arenberg Forest on my own, and wisely pulled out at one of the feed zones. I wasn't beaten by my opponents but by the route. I hated the cobblestones.'

One year later, it turned out that the Swiss cyclist was a fast learner. 'It was the great Johan Museeuw's last season and his last official race was in three days' time. That other dominant Belgian, Peter Van Petegem, was also top favourite. But Museeuw got a puncture on the last cobble and Van Petegem had to come back from too far behind after a previous setback. And suddenly I was there, with Backstedt, Hammond and Hoffman. Don't ask me how I got there, it

just happened. The four of us were on the track of the velodrome and I was convinced I'd do well. The piste experience I'd acquired as a youngster would come in handy.'

Cancellara resolutely took the lead and seemed to use the track for speed. However, at the last turn he was overtaken by his three fellow sprinters to finally finish in fourth position, just missing the podium. 'I was really disappointed. I lacked experience and made mistakes, and I actually could have won that day. Because I wasn't slow. But the great Franco Ballerini took me aside that same night and said it was better that way. He was convinced that I would win Paris-Roubaix not just once but several times, and that a victory too early on wouldn't have done me any good. In hindsight I have to agree with him. If I'd won that Sunday, my palmares would have looked completely different and certainly no better. The pressure would have been too great. That defeat gave me another couple of years to mature.'

What's more, Cancellara had another weapon: the time trials. The defeat in Roubaix became a distant memory in Liège on 3 July, 2004 with a prologue win in the Tour de France – ahead of the then untouchable Lance Armstrong – and his first yellow jersey. Suddenly the whole world knew who Fabian Cancellara was.

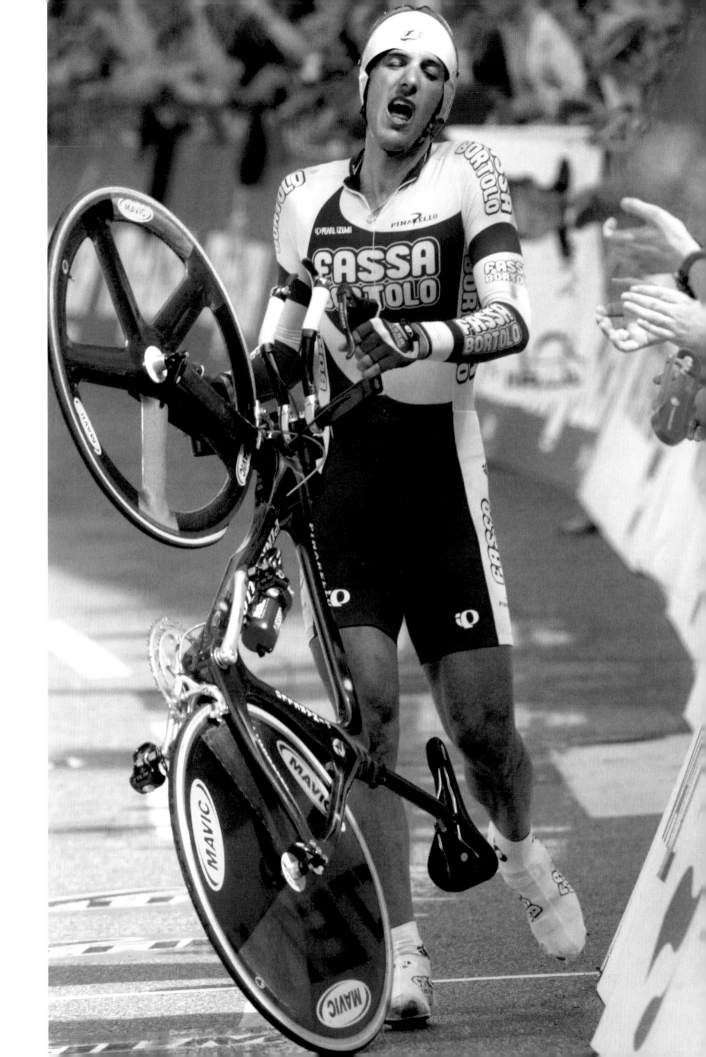

04 LOVE-HATE RELATIONSHIP WITH THE TOUR DE FRANCE

————

A fresh-faced Fabian Cancellara chats to Tom Boonen. Boonen wears the best young rider's white jersey, Cancellara gets his first taste of yellow.
→

Fabian Cancellara was barely 23 years old when he won the prologue of the Tour de France. And so the biggest race in the world was introduced to Cancellara, and vice versa. It was to be a strange relationship. No one wore the yellow jersey more often – 29 times in total – without winning the Tour than the Swiss, and yet the love was never unconditional. The Tour gave him a lot of satisfaction too. Not just when he wore yellow, but also when, in 2008, he was able to cycle through Paris alongside teammate Carlos Sastre, the overall winner.

Not many riders win the first stage and get to wear the yellow jersey on their Tour de France debut, but that's exactly what happened to Fabian Cancellara on the streets of Liège on 3 July, 2004. Lance Armstrong wanted to win the Tour de France for the sixth time and planned to start with a strong prologue. He achieved his overall goal, but in the prologue the American had to acknowledge the superiority of a 23-year-old from Switzerland. 'I had already won a number of prologues in my short professional career and was confident as I stood on the start line,' says Cancellara. 'A win meant the yellow jersey and the yellow jersey meant taking responsibility, leadership. I've always enjoyed wearing the leader's jersey, in any race.'

The ambitious youngster dreamt of winning and secretly imagined himself in yellow already. 'It was all the same to Ferretti. The team revolved around sprinter Alessandro Petacchi, not me. I had no pressure at the start, no one seemed to be paying me any attention. The Tour was Armstrong vs. Ullrich, I was just one of many riders. Only the experts considered me in with a chance of winning the prologue.'

And they were right. Cancellara rode the 6.1 kilometres two seconds faster than the American super champion. 'Lance started last; I sat in the so-called hot seat waiting for him to arrive. When it appeared that he was two seconds slower, I cried tears of joy for the first time in my life. Ferretti went crazy, so did I a little. Suddenly the whole world wanted to know who I was, where I came from. I'd beaten Armstrong, I'd beaten Ullrich.'

Cancellara was to wear the yellow jersey for two days in 2004. By the end of his career, he had worn it a total of 29 times, the most of any rider who has not won the Tour. He raced in the Tour de France eleven times, winning a total of seven stages, only one of which was a regular stage. Ironically this was in Compiegne, the starting point of Paris-Roubaix, where Cancellara, wearing the yellow jersey, pulled away from the pack in the final kilometre. Cancellara was also belatedly awarded another stage win in the 2008 Tour when the initial winner, the German Stefan Schumacher, failed a doping test. 'The fact that the Tour almost always began with a prologue inspired me,' said Cancellara. 'I nearly always won when there was a prologue on the schedule. The only one I lost was the opening time trial in 2008, but you couldn't really call 19 kilometres a prologue. On the other hand, I didn't win my first long time trial in the Tour until 2010.'

'YOU CAN GET USED TO WEARING THE YELLOW JERSEY'

Initially there was a lot of love between the Tour and the Swiss cyclist. 'It was a special race for me, for the sponsors, and it fitted perfectly into my schedule. After the classics I would take a break and start preparing for the Tour. It quickly became a habit for me. I was therefore very disap-

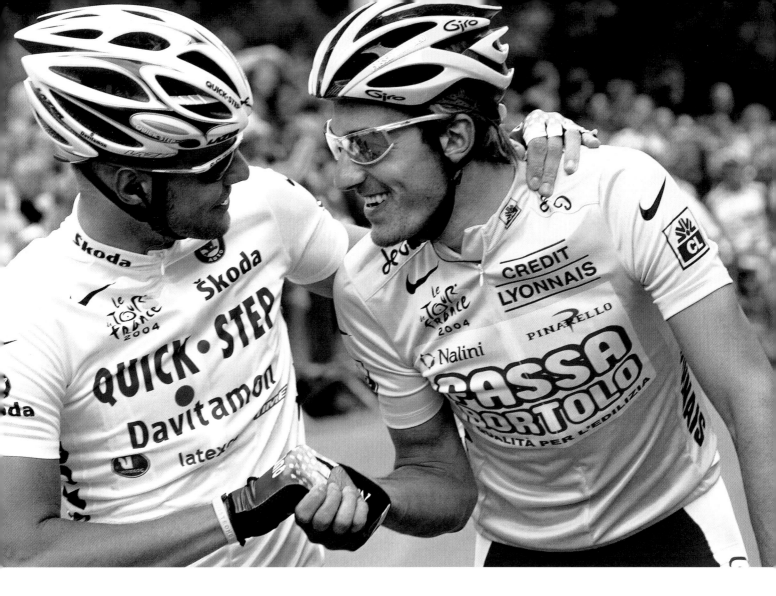

pointed when in 2006, during my first year at CSC, team manager Bjarne Riis told me I hadn't been selected. He needed an extra climber to assist Ivan Basso in the high mountains. I found that difficult to accept. As the winner of Paris-Roubaix, I thought my place in the Tour team was secure. But then when Operación Puerto erupted one week before the start in Strasbourg, with all the doping stories and riders who were sent home, I was glad I wasn't part of the circus.'

That prologue win in Liège was just the start. Curiously Cancellara won all his prologue victories on non-French soil. 'London was by far the best. That was the best prologue I've ever ridden. Everything went according to plan, and in an unlikely setting. I don't think I've ever seen so many people standing at the side of the road. Monaco was the least expected, because everyone thought the course would be too difficult. Rotterdam was good too, and the fact that my last Tour prologue and stage win was in Liège, eight years after my first yellow

jersey there, was in hindsight very symbolic.'

You can get used to wearing the yellow jersey, Cancellara confesses. 'Over the years it became almost par for the course. Win the prologue, wear the yellow jersey for a few days, my teammates at the front of the peloton, everything in yellow. A yellow bike already in the truck because the team was so confident in me. Losing the jersey always led to a bit of a mental dip. The Tour wasn't always pleasant for me. I've been ill during it, I've battled against the time limit. I even had to pull out while wearing the yellow jersey in 2015, after that terrible crash on the way to Huy.'

PERFECT TEAM

Although Cancellara can be proud of his many personal successes in the Tour over the years, 2008 was special for a different reason. He didn't win any stages himself – although he was subsequently assigned a time trial victory after the doping suspen-

sion of the German Stefan Schumacher – but he was able to help teammate Sastre celebrate his overall victory in Paris after three long weeks. Cancellara delivered some particularly flawless performances in the high mountains. 'It was never a problem for me to work for a classification rider,' he says. 'I was willing to do that. In fact, those were the best years. We lined up at the start as a group and we would have gone through fire for each other as comrades. Jens Voigt, Kurt Asle Arvesen, Nicki Sørensen, Stuart O'Grady: we were the midfielders who had to set up the strikers. Team manager Bjarne Riis excelled at putting together the perfect team. Riding the Tour with CSC and Saxo Bank was just the best experience. Things were never quite the same after I left Bjarne, at least as far as the Tour was concerned.'

The efforts of Cancellara and his team-mates during the 2008 Tour were finally rewarded when Sastre secured victory. 'Cycling through Paris at the side of the overall winner gave me an incredible feeling.

"If it hadn't been for that stage arriving in Bern, I'm not sure I would have gone to the Tour in my last year. The love was gone."

Satisfaction at the presentation of his first yellow jersey.

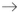

We won the team classification that year too. No surprise really, with top-class riders like Sastre and the Schleck brothers in the squad. For me, that Tour was the ideal preparation for the Beijing Games. I felt myself getting stronger day by day, so much so that I even took charge of the penultimate climb on the way to l'Alpe d'Huez. Everyone looked surprised, but a classics rider in top form is capable of a lot in the third week. If everything came together, even a few Alpine cols weren't a problem, thanks to Bjarne Riis, the greatest motivator I've ever worked with.'

However, despite the successes, the Tour was evolving from a goal to an obligation for the Swiss cyclist. 'In the early years it was fun to wear the yellow jersey. And riders would listen to the classification leader. After the massive crash in the stage on the way to Spa in 2010, I personally asked the peloton to slow down. Not because my teammates Fränk and Andy Schleck were behind, but because the roads were too dangerous. I didn't care that I lost the yellow jersey to Chavanel. I got it back the next day anyway. But in 2015, when I rode in yellow for the last time, all respect for the yellow jersey was completely gone. Nowadays the Tour means nervousness and stress, there are a lot more falls than before, and respect for each other and the team of the race leader has gone.'

Looking back on the Tour today, Cancellara has mixed feelings. 'The race gave me a lot but it also took a lot away from me,' he says. 'When I was younger I loved going to the Tour, but the race has changed over the years and so have I. The Tour has got bigger and is increasingly stressful and inconvenient for the riders. The older I became, the less I looked forward to it. If it hadn't been for that stage arriving in Bern, I'm not sure I would have gone to the Tour in my last year. The love was gone.'

He is also critical of ASO, the organiser of the Tour. 'I recognise the importance of ASO for cycling and see how many races they organise in the course of the season. But ASO is too controlling. As a top rider, you get to hear a lot about the political scheming behind the scenes between the UCI and ASO or an interest group like Velon. As far as I'm concerned, it's clear: you can't negotiate or discuss with the Tour. The Tour is the biggest and wants to stay the biggest, without thinking of the general interests of the sport. The Tour has become a commercial machine that lacks warmth. They want to create a monopoly for themselves and I can't support that.'

Cancellara also feels he has not been recognised by the Tour. 'In all these years, I've never been officially invited to the presentation of the Tour route. Despite the fact that, with my 29 yellow jerseys, I have meant something to the history of the Tour. General classification riders, top sprinters… they're the ones who matter to ASO, and so they're invited. But me, the time trialist who won five prologues, never. Yes, that did disappoint me. It would have shown respect if they'd invited me to the presentation just once.'

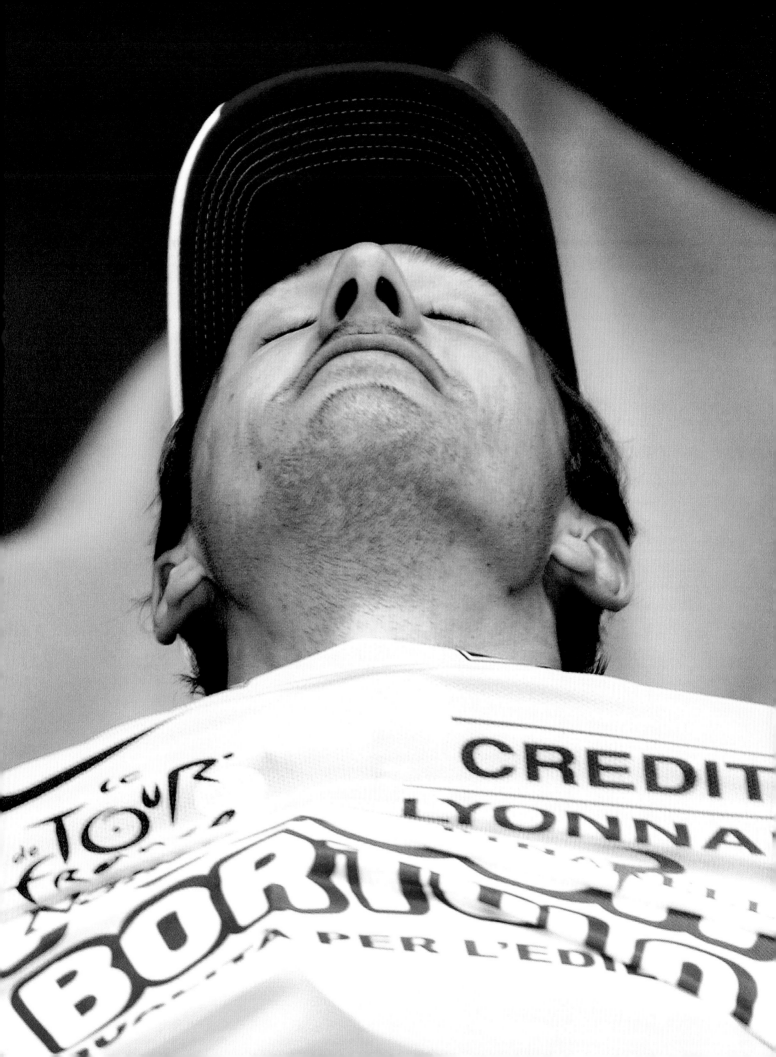

A RISING STAR AT CSC

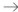

Three years after Fabian Cancellara joined Fassa Bortolo, this team also folded. It was the beginning of a U-turn in the Swiss cyclist's career. Having ridden for Italian teams for five seasons, he opted for the Scandinavian approach of Bjarne Riis and CSC. Cancellara was amazed at the difference, but chalked up a victory almost immediately, winning Paris-Roubaix in 2006, his first major classic. Later that year he also bagged his first world time trial victory as a professional. Cancellara was soon a star of the international peloton.

In late 2005, Cancellara signed a contract with the Danish team CSC, led by Bjarne Riis, himself a former Tour winner and at that time beyond reproach. For Cancellara it was a whole new world. Fassa Bortolo had followed a traditional approach, but with Bjarne Riis there was no room for improvisation. 'At Fassa Bortolo you had riders and you had team leaders. One team leader was responsible for this, another for that. Riis had a whole team behind him. They were responsible for practical matters. If you needed a plane ticket, you contacted the office. Everything was arranged! I'd never seen sponsors at a race before. With Bjarne, the riders were often invited to events with the sponsors. Everything was new.'

Was that why Cancellara chose the Danish team? 'I think I was curious more than anything, although I can't remember who took the initiative,' he says. 'Did Bjarne contact me or was it the other way around? I only know that we met each other for the first time in Zurich. He explained in great detail what he saw in me, and what goals he wanted to achieve.'

Cancellara was persuaded and was immediately introduced to the distinctive Scandinavian approach. His first meeting with the team took place in the north of Denmark: a survival training camp led by B.S. Christiansen, a former elite soldier with the Danish Army. His often tough approach was intended to show the riders that the group was stronger than the individual. With Christiansen, it was all about philosophy and values. 'I was impressed. Riis had told me beforehand that the things I would learn would be useful in the whole of life and not just in cycling. He was right. My children are still suffering the consequences of what I learned back then *[laughs]*.'

'Those survival training camps weren't exactly a walk in the park,' says Cancellara. 'They were tough! The weather conditions weren't easy: it was generally cold and wet. Night exercises, sailing trips, primitive conditions. It allowed me to get to know everyone in the team. At times like that, you need everyone in order to survive, from the mechanic to the person who books the plane tickets. "Try to make the best of every situation," that's what it came down to. If it's raining and you haven't got a raincoat, crying won't help.'

BJARNE RIIS THE GURU

The Swiss cyclist came through and went into the spring having learnt an important lesson: believe in yourself and aim for the top, without worrying about anyone else. 'In 2006 I wasn't the favourite for the Tour of Flanders or Paris-Roubaix. That role was reserved for Tom Boonen. Yet I believed in myself and eventually it all came together perfectly. I can't stress enough the importance of Bjarne's support in this. In fact he didn't know the cobbled classics that

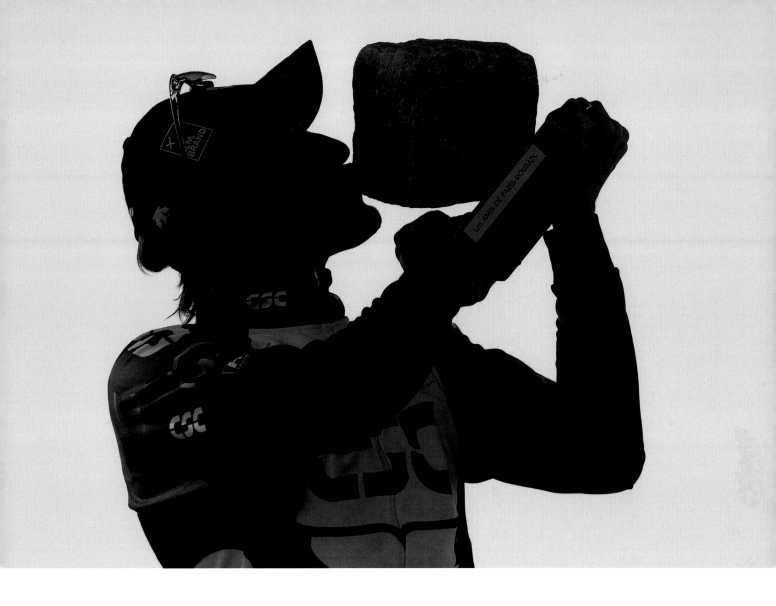

well. Bjarne wasn't at the wheel of the following car, that was Scott Sunderland, but he taught me to take a broader view. His unique approach, which he shared with me that winter, gave me the mental foundation I needed to go into the classics. I've never come across any other team offering what Bjarne offered to me in 2006 and the years after. And I think that's a shame. He saw things differently to other people. He even organised a team-building event for the riders' wives, because he wanted to know how they would react to certain situations, and to show them how hard their husbands worked.'

Riis turned out to be a guru who stressed time and again that the interests of the group transcended the riders' individual interests. 'With Bjarne, everyone was important, and values were paramount,' says Cancellara. 'I miss that in the peloton of 2015, I miss that in society too. There's a general lack of values and respect, because of a failing in education. Riders win one race and think they're heroes. That wouldn't wash with Bjarne. I won Paris-Roubaix in 2006 and was sure I would go to the Tour de France. Until, one week before the start, Bjarne told me I'd be staying at home and he had his reasons. My victory in Paris-Roubaix had stirred up a lot of interest in Switzerland, preventing me from preparing properly for the Tour. Bjarne saw that, I didn't. He also knew that I was getting married later in the year. Now, many years later, I have to admit that he was right.'

Cancellara and Riis went their separate ways in 2010, mainly for budgetary reasons. Riis was disillusioned, but got his own back in 2011 after guiding Cancellara's replacement Nick Nuyens to victory in the Tour of Flanders. Yet Cancellara won't betray his former team manager. 'I'm happy that I was able to work with Bjarne Riis at the peak of his abilities as a manager and sports director,' he says. 'Every era has a dominant team. In 2006-2008 that role was reserved for Bjarne Riis' team, which I was part of. I'm still sorry about what happened to him afterwards, that he succumbed to all the doping stories from the past that he couldn't shake off.'

As Cancellara mentioned above, his main accomplishment in 2006 took place in the spring. Still only 25 years old, the Swiss rider secured his first monument win at Paris-Roubaix on April 9. Unexpected? 'The favourite that day was Tom Boonen. He'd achieved the Flanders-Roubaix double the year before, and had won Flanders the previous week as world champion. I considered myself an underdog, nothing more. Although I was good in Flanders too. I was fifth but I saw how Boonen was able to ride away from us. That was the lesson I learnt: the first attack could be the good one.'

Battered but happy: the first
major classic victory.
→

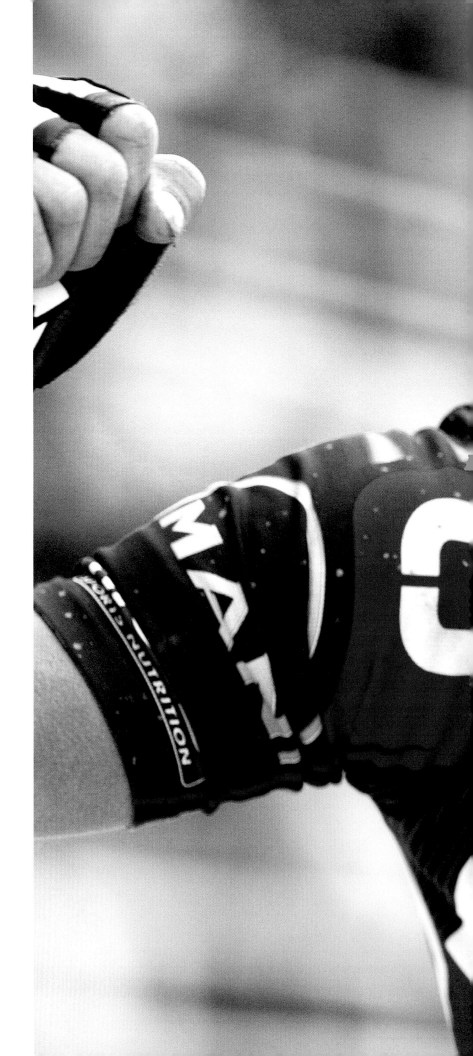

FIRST CLASSIC WIN

The Swiss cyclist learnt quickly, because a week later, on the cobblestones of Paris-Roubaix, he attacked first. 'It was on Carrefour de l'Arbre, a cobbled section that's often make or break. I was at the front of a group that included Boonen. To be honest, I don't know if there was a plan behind the attack or not. I just started to ride and didn't look back.'

He didn't need to. Cancellara rode away from the competition before their very eyes and headed straight towards his first classic victory. 'I knew it was a good performance, it's just a shame it was overshadowed by the train incident that was taking place behind me.'

Quite right! Cancellara just managed to ride under the level crossing barriers, but his three pursuers – Hoste, Van Petegem and Gusev – were too late. The trio refused to stop and were disqualified afterwards. 'I would certainly have won even without that incident,' says Cancellara. 'I was just the strongest on the day. That win didn't just mean a lot to me, it meant a lot to Switzerland. I sensed that I was going to win that day. When I left the team hotel in the morning, I told the owner that we'd come back in the evening for a party. Otherwise we would all have taken our cases with us, so we could fly home as quickly as possible in the evening. We didn't do that. We all rode back to the hotel to celebrate the victory.'

It wasn't to be his last party. Cancellara went on to win Paris-Roubaix a total of three times in his career, and to make his mark on the world's most feared cycling classic.

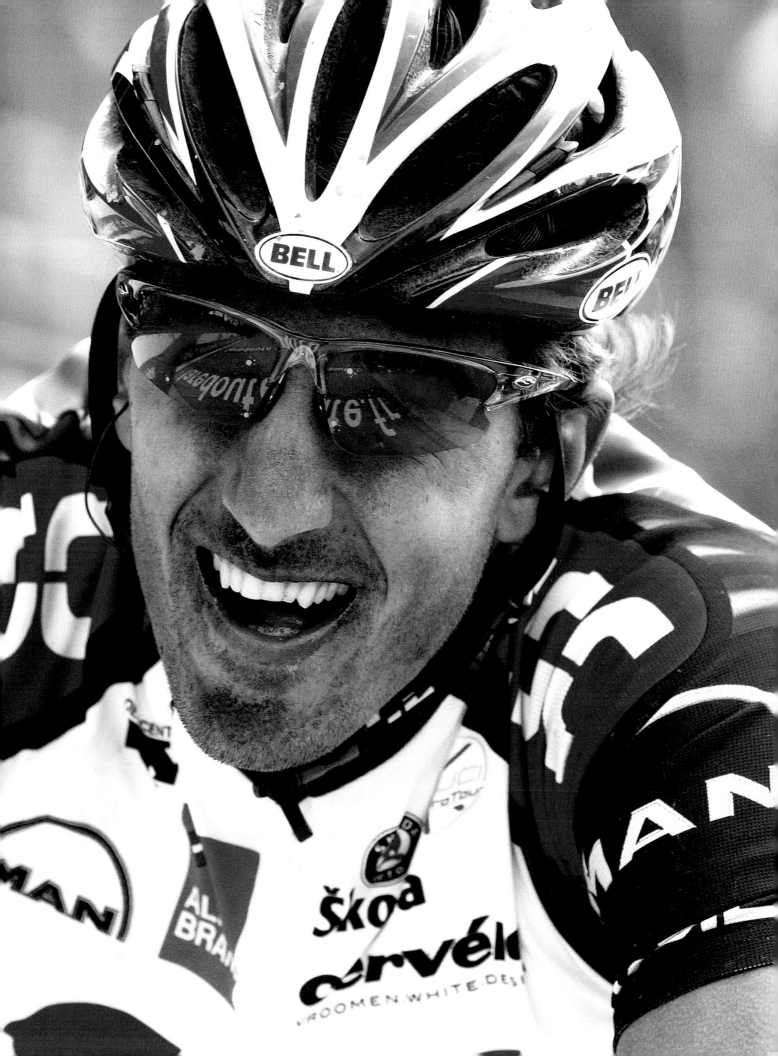

06 FOUR WORLD TITLES AND TWO OLYMPIC GOLD MEDALS FOR THE BEST TIME TRIALIST EVER

There was no stopping Fabian Cancellara as a time trialist. He went on to write a total of four world titles and two Olympic titles on his palmares.

→

With four world titles, Fabian Cancellara is still the most successful professional time trialist ever. The Swiss cyclist won his first rainbow jersey in 2006 and went on to dominate in individual time trial races in subsequent years. He was unbeatable at the World Championships until 2011. The only reason he didn't win in 2008 was because he wasn't there. Earlier that year, he was crowned Olympic champion in the discipline. After 2010, he began to feel Tony Martin in particular breathing down his neck, and he shifted his focus to the classics.

With four world time trial titles to his name, Fabian Cancellara has secured his place in the history books. Between 2006 and 2010, he dominated the discipline. For someone as talented as Cancellara, who already had two world titles on his palmares as a junior, it seems almost logical. But talent alone is not enough, according to the Swiss. At Fassa Bortolo for example, time trials were never a priority. 'The boss, Ferretti, wasn't really interested in time trials. The Pinarello bikes were good, but they weren't the best.'

But Cancellara won his time trials, especially prologues. In smaller stage races, but also in the Tour. His first major success in a longer time trial was in Salzburg in 2006, when he became world champion. It was no coincidence that he was riding for Bjarne Riis' CSC team at the time, Cancellara now realises. In the spring of 2006, the Swiss won Paris-Roubaix, and was deliberately kept out of the Tour so he could produce a blistering performance later in the year at the World

Championships in Salzburg. As a former Tour winner, Riis saw the importance and beauty of the individual time trial. 'He sent me to the Vuelta as preparation. I didn't even have to finish. It was all about Salzburg and nothing was left to chance. Riis called an Italian, a guy called Giovanni Cecchini. No one could prepare a bike better than him.'

NAKED BIKE

Prepare a bike… It sounds strange, even a little absurd. Yet the Italian made a real difference, Cancellara admits. 'For example, he used special bearings and a particular kind of oil to make the chain run faster, trimmed the spokes to improve aerodynamics, and applied a special coating to the whole frame to optimise drag reduction. He always began by 'degreasing' the bike so he could start with a naked bike, as it were, stripped of all ballast. You couldn't find the products he used in an ordinary shop, often they weren't even for sale.'

In a sport like time trialling where details matter, each individual element can be decisive. Nothing is left to chance. 'He even worked on my helmet', he says. 'That was polished with a special product and then placed immediately into a fridge to speed up the hardening process. Cecchini was an aerodynamics guru. Not just in cycling for that matter. He was interested in anything to do with speed and mechanics, a real fanatic. He used to use a stethoscope to listen to his ball bearings going round. He managed to get a wheel that was "driven" for one minute to run independently for three minutes. A prepared wheel spins for much longer than a normal wheel and that means that you as a rider have to make less effort.'

And that's what time trials are about. When added together, all the small elements make a big difference. 'I don't know whether this was how I achieved my first world title in Salzburg,' says Cancellara. 'In the end I was almost one and a half minutes ahead of the American Zabriskie. It certainly

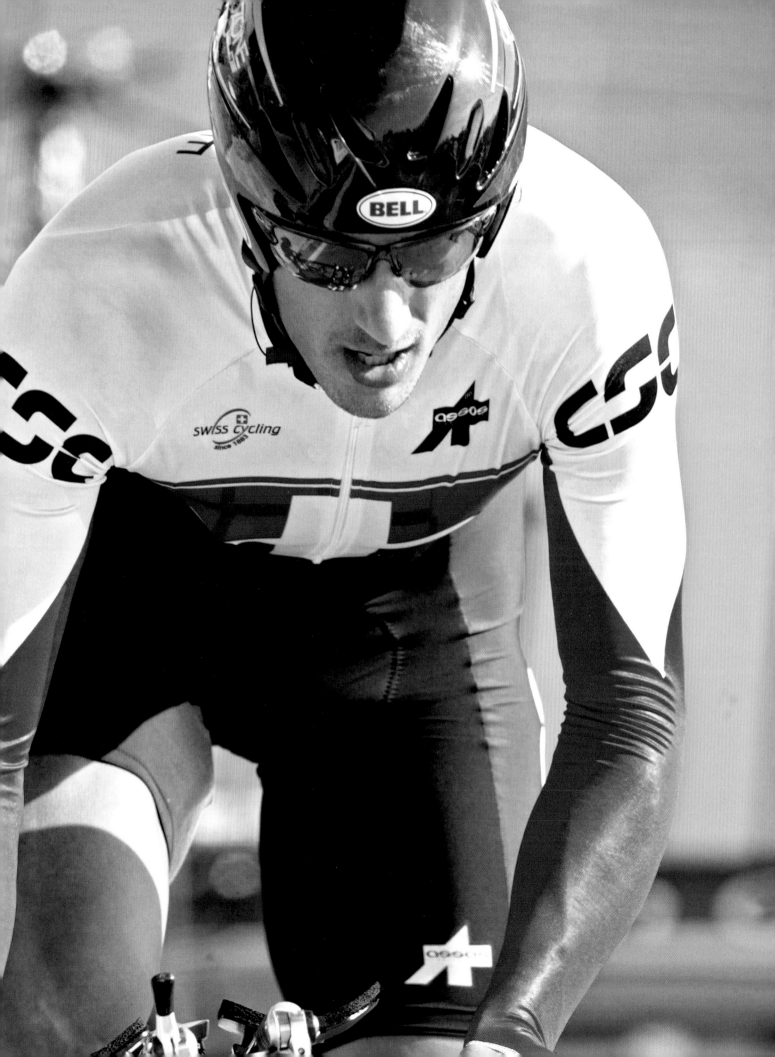

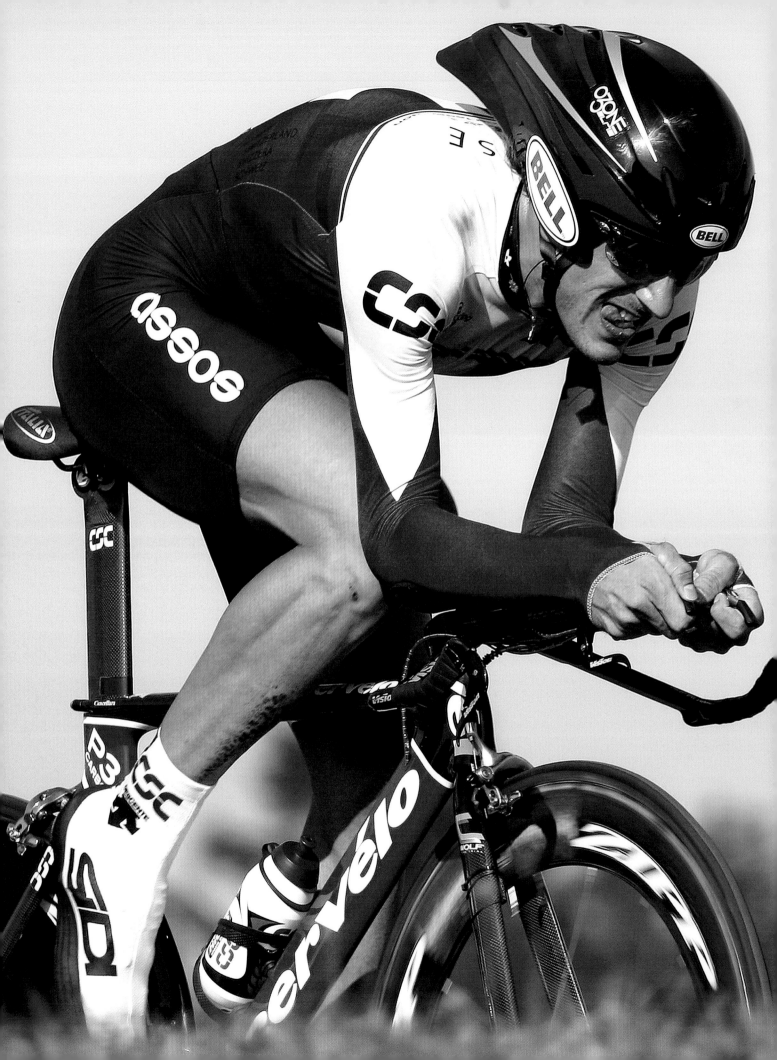

The time trialist in Cancellara meant he always pushed to the max.

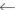

had an impact. But it wasn't just my bike that was in top form, I was too. Everything came together, as was so often the case with Bjarne. He didn't leave anything to chance, for example he always made sure he was able to choose the bike components himself. He went in search of the best wheels, the best tubes, the best everything. Now you sign a contract with a bike manufacturer and everything's included.'

STARTING IS WINNING

The approach bore fruit. 'Autumn 2006 was a major highlight in my life, both professionally and privately. Stefanie and I got married and I became a father to our first daughter, Giuliana. And in between I also became world time trial champion for the first time. I'd already won Paris-Roubaix in the spring. That left its mark. The spring of 2007 definitely wasn't my best because there'd been too much going on the previous winter. I wasn't ready for the classics in 2007, either mentally or physically. I hadn't yet got my new life under control. But fortunately I didn't make the same mistake again the following winter. It was all part of the learning process.'

Cancellara went on to dominate the time trial discipline for five years. Although he didn't race in the World Championships in 2008, he pocketed Olympic gold instead. 'Until 2009, starting was synonymous with winning for me. But in 2010 I began to feel the other riders nipping at my heels. That was the last year I was world champion. There were many different reasons. The competition was suddenly fiercer with the arrival of Tony Martin. At the same time, I felt less and less able to pep myself up for the time trial. I distinctly remember the Vuelta prologue in 2009, in Assen in the Netherlands. I only warmed up for about fifteen minutes, which is nowhere near long enough. And yet I won, by quite a margin. I felt unbeatable in those days, and that had an impact on my motivation. Why should I bother focusing on the time trial if I'd already won everything? If you've achieved

everything, you don't feel the urge to give everything anymore. The time trial stopped being a challenge, and you could see that in my results. I won again at the World Championships in Geelong in 2010, but I didn't feel unbeatable anymore. A year later, in Copenhagen, I had to settle for third place. That made sense, because I was focusing less on the time trial and wasn't obsessed with the materials the way I had been.'

However, the Swiss still has the most world titles to his name. 'I don't know if that's important. Of course I like the fact that I'm still at the top and of course I'm happy with my place in the history books, but I'm also aware that someone will outperform me sooner or later.'

OLYMPIC GOLD IN RIO

Cancellara rode his last major time trial at his fourth Olympics in Rio in 2016. 'It was my way of closing a cycle. I grew up as a trialist and so I found it appropriate to end my career in this discipline with the biggest time trial on earth. I cherish my Olympic memories. In Athens I was barely 23 years old and I went to learn. Four years later in Beijing, I won Olympic gold. I wanted to defend my title in London in 2012, but a fall in the road race meant I wasn't firing on all cylinders. And then there was Rio! I hesitated but said yes in the end. Not just to ride, but to perform. I realised that the competition would be tough but decided to challenge myself one last time. Even if it didn't work out, at least I'd know I'd given everything. By riding in the Tour, for example. The warrior in me wanted one last fight and for that I needed to make sure I was 100% ready.'

The extent of Cancellara's preparation was clear. Despite the difficulty of the course, Cancellara did what few thought possible: the Swiss outrode the competition and beat the Dutchman Dumoulin and Tour winner Chris Froome. The boy who at seventeen became internationally famous with a world junior title ended his time trial career at thirty-five years old with Olympic gold in Rio.

07 IN SEARCH OF A WORK-LIFE BALANCE

At the age of eighteen, Fabian Cancellara met Stefanie, a local girl six years his senior. It wasn't love at first sight, but their relationship grew over the years, leading to marriage and the birth of their first daughter, Giuliana, in 2006. Six years later another daughter, Elina, followed. With Fabian's growing status as a pro rider, the family decided to keep his sporting career and his private life strictly separate. Stefanie rarely appeared in the foreground, but was always there for her husband. For Fabian, his home was where he could relax.

Was it a coincidence or destiny? Fabian Cancellara was barely eighteen years old when he met his future wife Stefanie. She was twenty-three and knew nothing about cycling. The fact that the young man in front of her was a time trialling world champion meant nothing to her. 'It wasn't love at first sight,' says Cancellara. 'I didn't immediately want Stefanie to be my girlfriend. She was nearly six years older and I didn't have much experience with women. A week after our first meeting at a local party, I went to get my hair cut and there she was again. To my great surprise, she worked at the salon as a hairdresser. We started talking and one thing led to another. I was cautious and a bit awkward, the way teenagers are. I used to ring her occasionally to see if she wanted to go to the cinema, but more often than not she didn't have time. I wasn't exactly her knight in shining armour either. Our relationship was a slow burner. Later that year I raced in the World Championships in Verona, as a second-year junior. I sent her a card with a picture of Romeo and Juliet for a laugh. She knew by then that I was a cyclist, but she didn't fall in love with the cyclist or the glamour of life alongside someone famous. I wasn't famous at the time. If I hadn't met a woman until later, I might never have known if she'd fallen in love with me or the money and the fame. With Stefanie, I never had to ask myself that question.'

The two became a couple, and Fabian and Stefanie moved in together and made plans for the future. 'Bit by bit she learned about my sport,' he says. 'But she also insisted on being able to have her own life. She has her own hair salon and I still think that's important. Stefanie knows what she wants. She was of course aware from the beginning of the impact that my sports career could have on our relationship. Her parents had warned her. We talked openly and she quickly realised that our lives would very often revolve around me. No cyclist's wife likes that. But Stefanie accepted it.'

'Our age difference has never been an issue,' stresses Fabian. 'It might come up in discussion from time to time, but that's it. Throughout my whole life I'd always been around people who were older than me, so it wasn't a problem for me that my girlfriend was older. I understood early on that I could benefit from the experience of people who were older than me. When we've had issues, they've never really been a problem in the end. Stefanie wanted to have children before I did, for example. But we soon worked things out together. When Giuliana was born, I was still only 25. That might seem young but it wasn't a problem at all for me.'

CYCLIST VERSUS HUSBAND AND FATHER

It's striking how little the Cancellara family has appeared in the media over the years. 'At the beginning of my career, we quite enjoyed accepting requests from the media,' says Fabian. 'Everything was new. Magazines came along, took pictures, journalists came to our home... until suddenly we came to the conclusion that this wasn't what we wanted. A report in a Swiss magazine was the last straw: they came to our home and took pictures of the whole family, but the published story only mentioned my daughter and me. There was hardly a word about Stefanie. Then we realised that we could do more to protect our privacy. Fabian Cancellara the cyclist would remain a public figure but Fabian Cancellara the husband and father would not.'

The children's welfare has always been a priority for the Cancellaras. 'Stefanie and I didn't want our child – Elina wasn't born yet – to be unable to lead a normal life because her father was a successful cyclist,' he clarifies. 'We still want our children to be able to go to school like normal children and not be badgered because of their dad. I also didn't want them to think they were superior to others because their dad was famous. We just want to live as normal a life as possible. It's particularly out of respect for my family that I decided to ban the media from my private life. My wife has popped up in the media sporadically if she's been present at a race somewhere. She too has learned how the media work, both positively and negatively. Looking back on my career, I can say that although my family sometimes cost me energy – for example when I couldn't sleep as much as I wanted – on the whole it gave me energy.'

Cancellara can't emphasise enough the impact his private life has had on his sporting

"We still want our children to be able to go to school like normal children and not be badgered because of their dad. I also didn't want them to think they were superior to others. We just want to live as normal a life as possible."

career. His family gave him the mental balance he needed to perform well. 'Fatherhood gave me an enormous sense of responsibility,' he says. 'When I heard colleagues without children talking about how they lived, I knew that wasn't possible for me. There was the family, and there was my bike. If I was at home, I did my share of the work, just as I would in a team. After a workout, I would often take Giuliana to jazz ballet, and I would always be up and about with the children in the morning. There have no doubt been occasions when I didn't get enough rest because I was taxiing the kids around. But their smiles or their pride because their dad was there gave me a different kind of energy. I've always tried to strike a balance between my family and my bike. Top athletes are often very selfish and don't take their families into account. I've never been like that and I never will be. If I had, Stefanie would have left me a long time ago and my kids wouldn't be so proud of their dad. Those things mean more to me than my career does.'

Cancellara realises that he owes a lot to his wife. 'I'm very happy that with Stefanie I have a strong woman behind me. It's been necessary too. As a dad, I've been away a lot. Often decisions had to be taken while I wasn't there. As the children got older, I saw that it was harder for my wife to make those decisions alone. What's more, I was almost always away during the school holidays. I became aware that Stefanie was increasingly in need of my support, the support of a father, a husband. That certainly had an impact on

my decision to quit at the age of 35. And I noticed that I began to race differently. I took fewer risks, avoided falling more than ever, was no longer so keen to win at all costs...'

Sometimes Cancellara has missed races to be with his family. 'I've gone late to training camps because of school fêtes and things. And in 2013 I missed the Tour because I felt it made too many demands on my time. The Tour means a whole month away from home at a time when the children are off school. I just didn't fancy it that year and I chose the Tour of Austria. My family had expectations of me and I wanted to meet those expectations. The bike was just a part of my life, it wasn't my whole life.'

MENTALLY BURNT OUT

That became apparent in 2012 too. After his fall at the Olympic Games in London, Cancellara didn't compete again that year, although he could have taken part in races in the autumn. He was advised to race by the team but he chose not to. The reason for this lay in the fact that he had a lot going on at home. 'My wife's pregnancy, the birth of our second daughter, the fact that she had to be readmitted to hospital after just a few days ... That was a hard time. Seeing your newborn daughter hooked up to a drip without knowing what's wrong with her, that really upset me. Fortunately that didn't last long, but as a father and a husband, I couldn't allow myself to leave home again after the Games. I'd had a gruelling year on the bike

anyway. A stupid fall in the Tour of Flanders, an equally stupid fall in the Games in London ... Those falls cost me a huge amount of mental energy.'

The Swiss cyclist decided to store the bike away in the garage. For the second time in his life, he found himself struggling with feelings of depression. Cancellara: 'The sporting setbacks, the worries at home ... it was as if someone was trying to tell me to put the bike to one side for a while. Cycling wasn't a priority at the end of 2012. I was mentally burnt out and for the first time ever I sought help from a sports psychologist. And it helped. It gave me the energy to prepare for 2013 in a positive state of mind. If anyone wondered why I was so emotional after my victory in the 2013 Tour of Flanders, now they know.'

08 THE ITALIAN IN THE SWISS

——

March 2008: Cancellara surprises the competition with a late attack on the streets of San Remo and wins Milan-San Remo.

→

As the son of an Italian immigrant, Cancellara has always enjoyed racing in Italy. In 2008 he experienced a wonderful Italian spring. He finished his primavera with wins in the Strade Bianche, Tirreno-Adriatico and Milan-San Remo, the so-called Tripletta. He went on to be extremely successful in the last race in particular. Between 2011 and 2014, he achieved no fewer than four podium finishes, unfortunately without being able to win a second time. Cancellara recognises the important role Italy has played in cycling over the years but is also critical of his father's homeland.

Does Fabian Cancellara feel half Italian? That would make sense, given that his father arrived in Switzerland from the Italian boot in the seventies. But Donato didn't choose Ticino, the Italian-speaking part of the Alpine state. He settled in Bern, where Swiss German is the official language. And he met Rosa, a local girl. They married and had two children, Tamara in 1979 and Fabian in 1981. They grew up speaking German. 'I could only speak a few words of Italian as a teenager,' Fabian recalls. 'But because I raced a lot in Italy as a junior, I gradually increased my grasp of the language. Initially I was riding for Italian teams too. First Mapei, then Fassa Bortolo. Unfortunately they wouldn't consider me for the Italian races, especially not those in the spring.'

GOLDEN SPRING

That wasn't the case under Bjarne Riis at CSC. In 2006, Cancellara completed his first spring campaign on Italian soil and discovered that the races suited him. In 2008 he enjoyed a golden spring in Italy. 'La Tripletta was unique,' emphasises Cancellara. 'No one had ever achieved it before for the simple reason that Strade Bianche was a relatively new race. I must admit that the race was a lot easier in 2008 than in 2016, when I won for the last time.'

The successes in 2008 came as a surprise. 'I didn't do any special preparation for those races. I went almost straight from Gran Canaria, where I'd just had a good training camp, to Strade Bianche. And I won. It was the same in the Tirreno-Adriatico, I hadn't set my heart on the general classification there either. It just happened. Gasparotto was my toughest competitor though, I remember that.'

Perhaps it was fortunate that the route bypassed the really high mountains. Also, an individual time trial of almost thirty kilometres played to Cancellara's strengths. 'But I still had to fight hard for it,' says Cancellara. 'Then, having won in Tirreno and Strade, I was suddenly named by the Italians as the big favourite for Milan-San Remo.'

The peloton knew they couldn't allow this Cancellara to get as much as five metres ahead. 'And yet they allowed me to get five metres ahead. There are times when everything just comes together: your form, your age, the race conditions... everything was right. In retrospect, that was a day I could only ever experience once in my career. I might have been the favourite in 2008, but back then not everyone believed I could really win, because San Remo was a different type of race. But I won, simply because they lost sight of me briefly after the Poggio and I managed to open up a small gap. I never managed to win San Remo again after that victory in 2008 because I was being watched by everyone, because everyone knew I could win. As soon as I'd crossed the Poggio I

was a marked man. I stood on the podium four more times but unfortunately I never managed another win.'

THE STRONGEST DOESN'T ALWAYS WIN

Cancellara continued to give the race everything he had. The 2012 edition, in which he took both Vincenzo Nibali and the fast Australian Simon Gerrans with him after the Poggio, is a particularly good example of how you can *not* win San Remo. 'I wasn't enough of a bastard,' he explains. 'I've never been the sly type. At the same time, I knew my sprint speed could be surprisingly high after a race of almost three hundred kilometres. Seated sprints are my trademark. Perhaps I was a bit too sure of my abilities and that's why I kept on leading without looking back. I was just too sure of myself. I wasn't cunning enough to win that day. I wasn't just disappointed because I'd lost but mainly because of the way others had won. San Remo taught me that it's not always the strongest who wins. If I feel I'm the strongest, I want to ride everyone else into the ground. Unfortunately this doesn't always lead to victory, as I went on to experience frequently in my career.'

Nonetheless Cancellara continued to enjoy taking part in San Remo. 'Because you could never predict the circumstances. With Le Manie, without Le Manie, with a head-

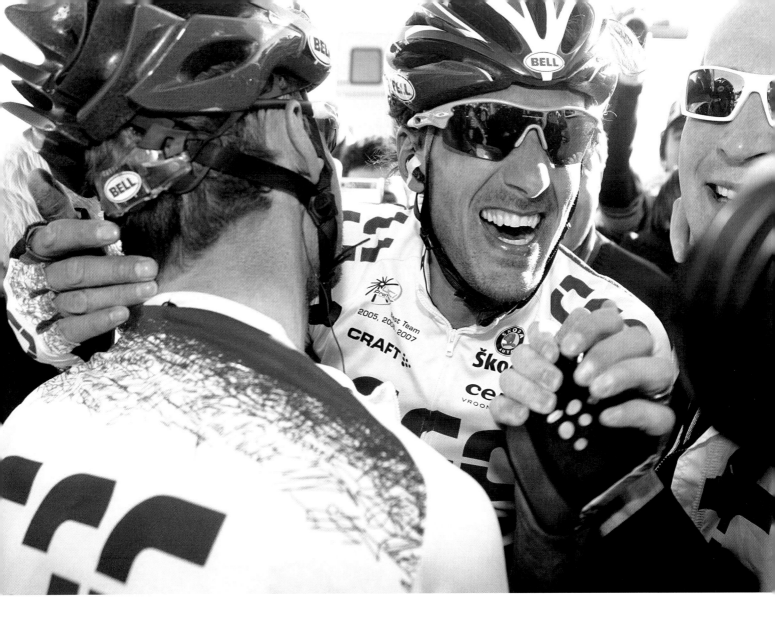

wind, with a tailwind, with snow or under a glorious sky... San Remo was different every year and it was that that made the race so special. What's more, it's a monument, the first major event of the season.'

Cancellara also became increasingly aware of his Italian side. 'As the son of an Italian father, I was very proud that I could win San Remo,' he says. 'And the Italians regarded me as one of them. The *Tripletta* that I achieved in 2008 was for them as important as my Harelbeke, Flanders and Roubaix hat trick was for Flanders in 2010. My father didn't really mind where I won, although he was of course proud when his son stood on the top step of the podium in San Remo. He has a Swiss passport nowadays but in his heart he's still Italian.'

Cancellara's palmares looked impressive, even on Italian soil. However, he hadn't yet realised all his dreams. In May 2016, he lined up at the start of the Giro d'Italia with one clear goal: to win the prologue in Apeldoorn

in the Netherlands and to claim the pink jersey. 'I only started the Giro three times,' he says. 'I always concentrated on the classics and then took a break, so the Giro didn't ever fit into my schedule. In my last season I was determined to go for it one last time. I'd worn the leader's jersey in the Tour and the Vuelta, it was just the pink jersey of the Giro that was missing. Unfortunately I fell ill a few days before the start, so I couldn't fully defend my chances in the prologue. I do regret that I've never worn the pink jersey. Afterwards I asked myself whether I should have entered the Giro more often. Unfortunately I can't turn back the clock.'

REAL SWISS

Cancellara is more often described as Italian than Swiss in the media. He'd like to set the record straight: 'Even though my father is Italian, I've always considered myself 100% Swiss. At home we only spoke

German. The only time anyone spoke Italian was when my father's family came to visit. My sister and I heard Italian at home regularly but we never really learnt it. I didn't really grasp Italian until later in life. Then, because I'd heard it so often, I was able to learn it pretty quickly.'

His relationship with his father's country is ambiguous. On the one hand Cancellara recognises the beauty of Italy, on the other hand he sometimes finds it irritating. "Italy is a beautiful country to live in: the food, the wine, la dolce vita ... The country is teeming with beautiful places like Capri and the southern tip. But lots of things about Italy annoy me. The politics for example, the way the country is run. As a child, during our holidays in Italy, I could see with my own eyes how very few things worked the way they should. Later on, when I came to Italy for races and training camps, that impression was confirmed. In Switzerland, you pay for something and you know it works. End

"My father didn't really mind where I won, although he was of course proud when his son stood on the top step of the podium in San Remo. He has a Swiss passport nowadays but in his heart he's still Italian."

of. At first sight, Italy is a country with few prospects. That's exactly why my father came to Switzerland. My father is from the south. Where he lived, there was no work, and there was work in Switzerland. It was as simple as that.'

However much Cancellara sings the praises of Switzerland, he describes his temperament as more Italian. 'I have the open character of an Italian,' he confirms. 'An Italian will tell it like it is and that's how I am. The Swiss don't let people into their lives very easily, they're not very open. I'm not like that. Unfortunately, I can't say I've inherited the Italian sense of fashion. But that's enough about that [laughs].'

Italy is no longer a great cycling nation either. 'Teams are disappearing, races are disappearing and there are fewer and fewer good riders. Italian cycling is weighed down by the crisis affecting the country. When I was young, Italy was the mecca for anyone who wanted to become a cyclist. I couldn't have asked for a better education than the one I had with Mapei and Fassa Bortolo. Unfortunately those days are long gone. This is particularly sad for Italy itself.'

Victory is sweet: Cancellara is beside himself with joy, while in the background the sprint is on for second place.

→

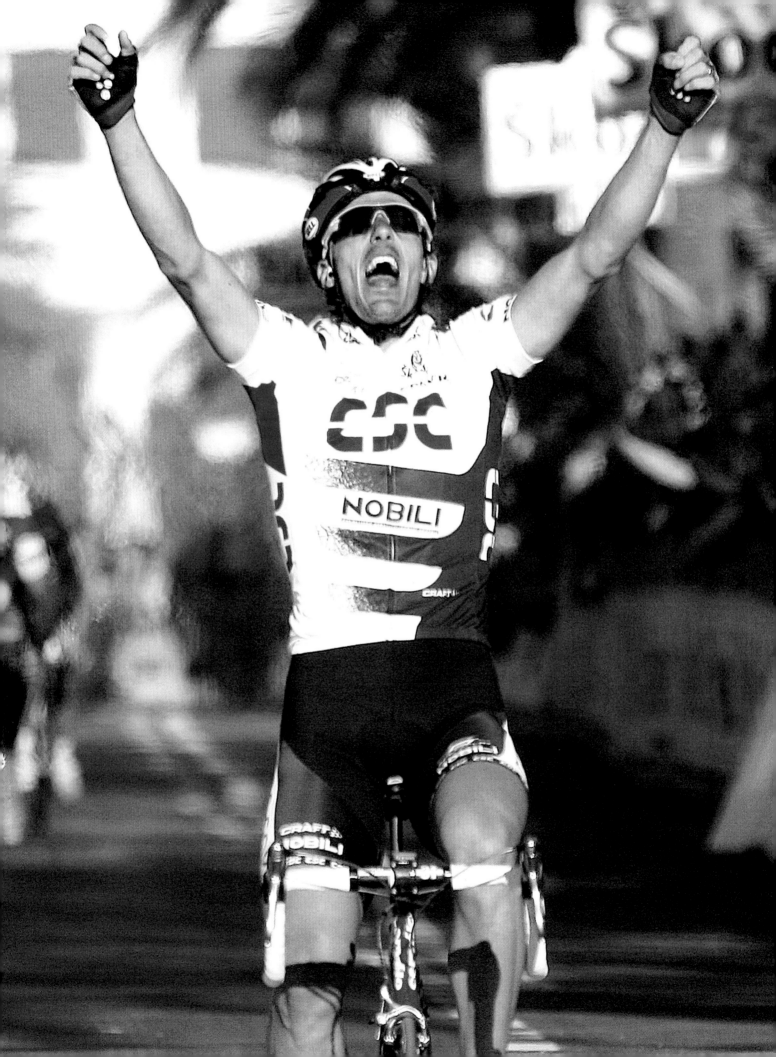

THREE-TIME MEDAL WINNER AT THE OLYMPIC GAMES

The Olympic Games in Beijing (2008) are just one big success story for Fabian Cancellara: he wins gold in the time trial and silver in the road race.

→

In 2008, Fabian Cancellara set off for the Chinese capital Beijing to take part in his second Olympic Games. Armed with the experience he'd gained at Athens four years earlier, he had one goal: to return to Switzerland with an Olympic gold medal. He succeeded in his mission. Not only did he win the time trial, he also picked up a bronze medal in the road race, which he later exchanged for a silver after the Italian Davide Rebellin tested positive for a banned substance. Four years later, in London, Cancellara literally crashed out of the battle for a medal. His last race was in Rio, where he unexpectedly provided a dazzling climax to his 2016 season.

In 2004, Fabian Cancellara celebrated his Olympic debut in Athens, the birthplace of the Olympic movement. The 23-year-old Swiss had just taken part in his first Tour de France, where he won the prologue, and headed off to Athens full of ambition. But the Tour had taken too much out of him and Cancellara limped home in what he admitted was a disappointing ninth place. He returned to Switzerland more determined than ever to win an Olympic medal.

'I live in a country where cycling isn't the most important sport,' he explains. 'We haven't had many cyclists, but the ones we've had have been good. We've always been less popular than winter sports, for example. The Olympic Games were the best way to attract the attention of the general Swiss public.'

In August 2008, he continued his quest for an Olympic medal, this time in the Chinese capital Beijing. But first there was the Tour de France, in which Cancellara worked himself into the ground in the service of the subsequent winner Carlos Sastre. 'The Tour is never preparation for a different race, but all the same I rode through France for three weeks with Beijing in the back of my mind,' says Cancellara. 'The last long time trial, to Saint-Amand-Montrond, was a kind of dress rehearsal for me. I came second behind Stefan Schumacher. He later tested positive for doping and had to give back all his titles, so I actually won the time trial, but of course I didn't know that on the day.'

ARRIVAL IN BEIJING

No sooner had he reached Paris than Beijing was in sight. 'The day after the Tour I returned home and immediately flew to China. I spent the first few days in the athletes' village, but then the Swiss and the Norwegian cycling squads travelled to a training camp in a small sports centre far outside Beijing. It looked like it was straight out of the GDR. Spartan, back to basics. There was me, Albasini, a mechanic, a masseur and a cook, that was it. We were in a real no-man's-land. It was a confronting experience. We saw people washing their clothes in washtubs on the edge of the street because they didn't have washing machines. We weren't far from the Great Wall. Not the part that western tourists get to see, but the part that the Chinese come to see.'

The preparation was ideal, as it turned out afterwards. Cancellara was able to recharge in peace for both the road race and the time trial. 'No one came to disturb us, no one knew us. Despite – or perhaps because of – the lack of western comfort we found it the ideal place to train in anticipation of the two races I was going to take part in. The staff from the Swiss Olympic Committee also made a difference. The oppressively hot climate made high demands on the body:

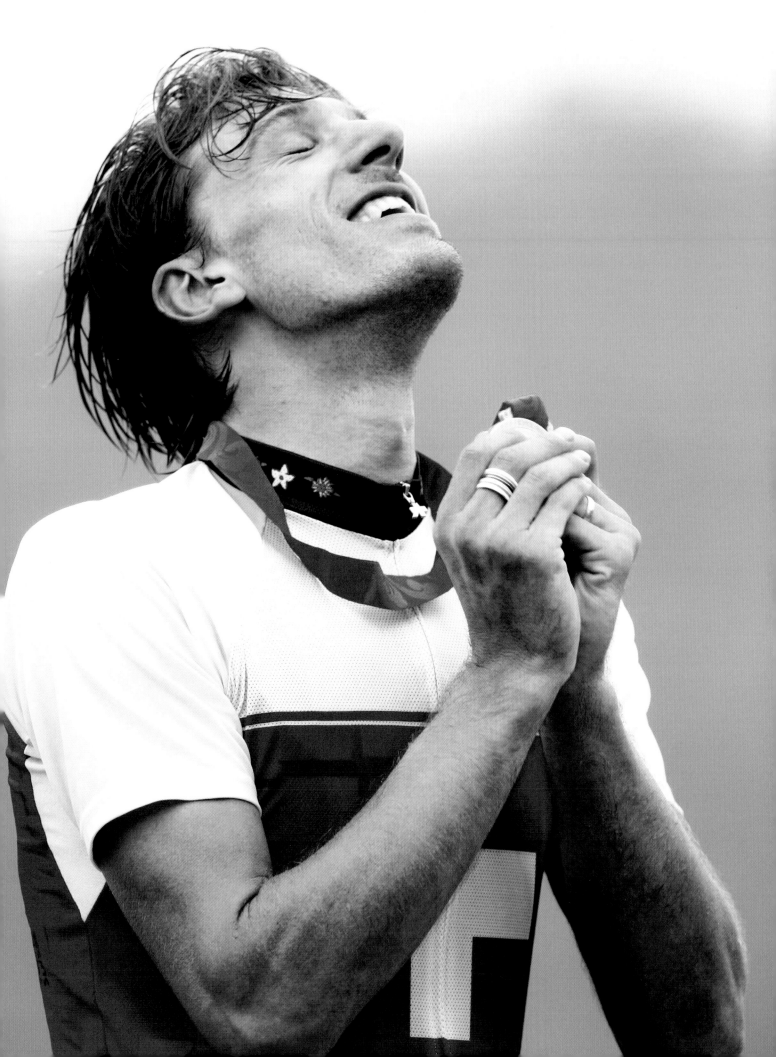

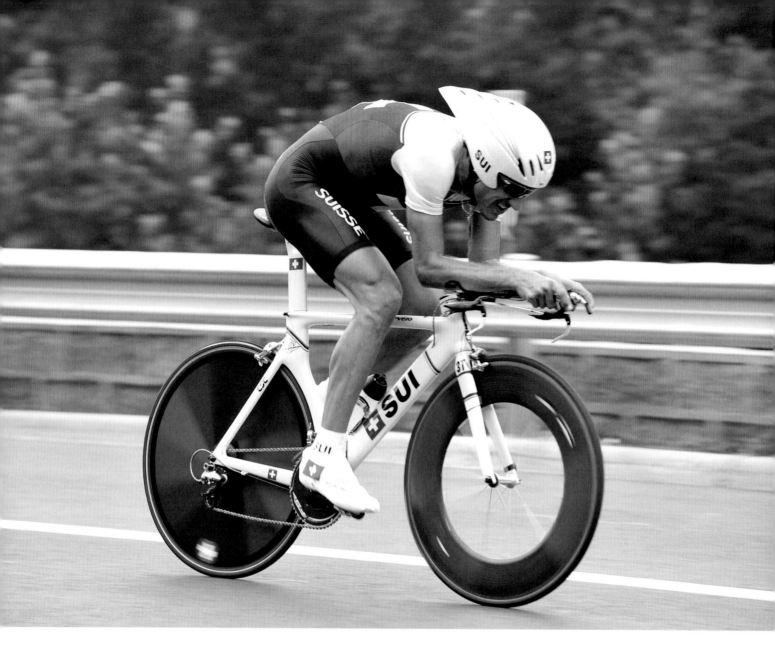

cooling and moisture absorption were hugely important. Everything seemed to go right for us. Even when we were back in the athletes' village, we were treated very well. We had our own cook, which meant we could eat in our own building. The restaurant was quite a way away and I don't like walking when I'm at the height of my training. In short, Beijing was close to perfection in terms of preparation and attitude.'

OLYMPIC DREAM FULFILLED

The road race was first on the schedule. Cancellara wasn't among the favourites. The Italian Paolo Bettini hoped to defend his title, while Alejandro Valverde was at the top of his game. Spain and Italy were clearly the leading countries. Moreover, the route was such that everyone thought only pure climbers would be in the running for a

medal. At the last climb, Cancellara wasn't in contention and a medal seemed unlikely. 'And then I rode what was perhaps the best descent of my life. There was a breakaway in front, a medal seemed a long way off. I let myself drop like a stone in the hope of scraping into the top ten, because that seemed the best possible result. Suddenly I saw Kolobnev and Rogers in front of me and I knew that the leading group wasn't far away. I gave everything and to my astonishment I scraped a bronze medal – a bronze that later became silver after Rebellin's disqualification. It wasn't gold, but it did take a weight off my shoulders. I went into the time trial with an easy mind.'

The trial didn't go exactly to plan. At the final time check, the surprising Swede Gustav Larsson was still a little ahead of Cancellara, but the Swiss rode another fantastic descent to ultimately win half a

minute ahead of his CSC teammate. Bronze went to the American Leipheimer. 'Gustav rode a fantastic time trial, that's the least you can say. But at the end of the day I didn't care how much I beat him by. Winning was the main thing for me. I had fulfilled my Olympic dream.'

Cancellara didn't realise the extent of the reaction in Switzerland until he got home. His Olympic medals lifted him out of his cycling cocoon. 'With my two medals at the Games, I was the Swiss hero. I was celebrated everywhere, suddenly it wasn't just cycling fans who wanted to know who I was. More people turned up in Ittigen, where I lived, than when I won San Remo or Roubaix. It was clear that those two medals were much more important to my country than a win at any other race. My Olympic medals were also more commercially profitable than the rest of my achievements.'

There was no stopping Fabian Cancellara in the Olympic time trial. His first Olympic gold medal was in the bag.

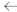

The sprint for gold: Samuel Sanchez (far left) beats Davide Rebellin and Fabian Cancellara (far right). Rebellin later fails a doping test and has to return his silver medal.

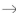

"With my two medals at the Games, I was the Swiss hero. I was celebrated everywhere, suddenly it wasn't just cycling fans who wanted to know who I was."

BEERS WITH ROGER FEDERER

Despite being almost permanently on the move, Cancellara enjoyed the unique atmosphere of the Olympic village. The Games have always been a special experience for him. 'It's always strange living with athletes who have finished their events and others who haven't had their turn yet. I remember one evening in Athens, we were having a few beers with Roger Federer and Marcel Fischer, and it got to four o'clock in the morning. Someone came to tell us that there were athletes who wanted to sleep. We went down into the basement and stayed there until seven o'clock, when the delegation leader came to look for us. That was part of the Olympic Games too. The Olympic village was like a different world to me and I've always found it fascinating.

All the same, I can't say that I met many other athletes or saw many other sports. I saw a few basketball games and I got to know Roger Federer. But the athletes' village is so big you don't really know where anyone is. I also had other athletes wanting to take selfies with me. I could live with it but I completely understood Roger Federer, who preferred to stay out of the village for as long as possible because too many people asked him for photos. I do like the Olympic atmosphere, I must admit, but at the same time I've seen athletes who've been completely overwhelmed by the grandeur of the event. No, you can't compare the Olympics with the Tour de France. At the Olympics you're in the hands of the IOC and they guarantee a very strict organisation. You have to comply with their decisions. In terms of organisation, there's nothing that beats the Games.'

Four years after Beijing, in London, he was at it again. After a failed spring – he broke his collarbone in the Tour of Flanders – Cancellara wanted another medal. But something went wrong during the road race. 'I just fell on a bend that I knew like the back of my hand. I felt very strong that day and I certainly would have been in the running for a medal. It was entirely my fault, I could have kicked myself. When it came to the time trial, I hadn't fully recovered from my injuries, so I finished in a disappointing seventh place. The London Games were a Games to forget, in fact 2012 was a year to forget.'

The Swiss finished his Olympic adventure in the Brazilian capital Rio. 'For me, my fourth Olympic Games weren't just a farewell, but a last chance to win another medal. That's why I made every effort to be in top form again. I left the Tour because I wanted to travel to Brazil in top shape. But I also realised that both the road and the time trial courses weren't in my favour. Whether I could win a medal or not this time also depended on the opposition. If everyone arrived in Rio in peak fitness, I knew it would be difficult. But a medal was the goal. Gold, silver or bronze, I didn't mind which.'

Cancellara kept his word and returned to Switzerland with a gold medal. With two golds and one silver, he joins a select group of athletes who dominated their discipline over a long period of time.

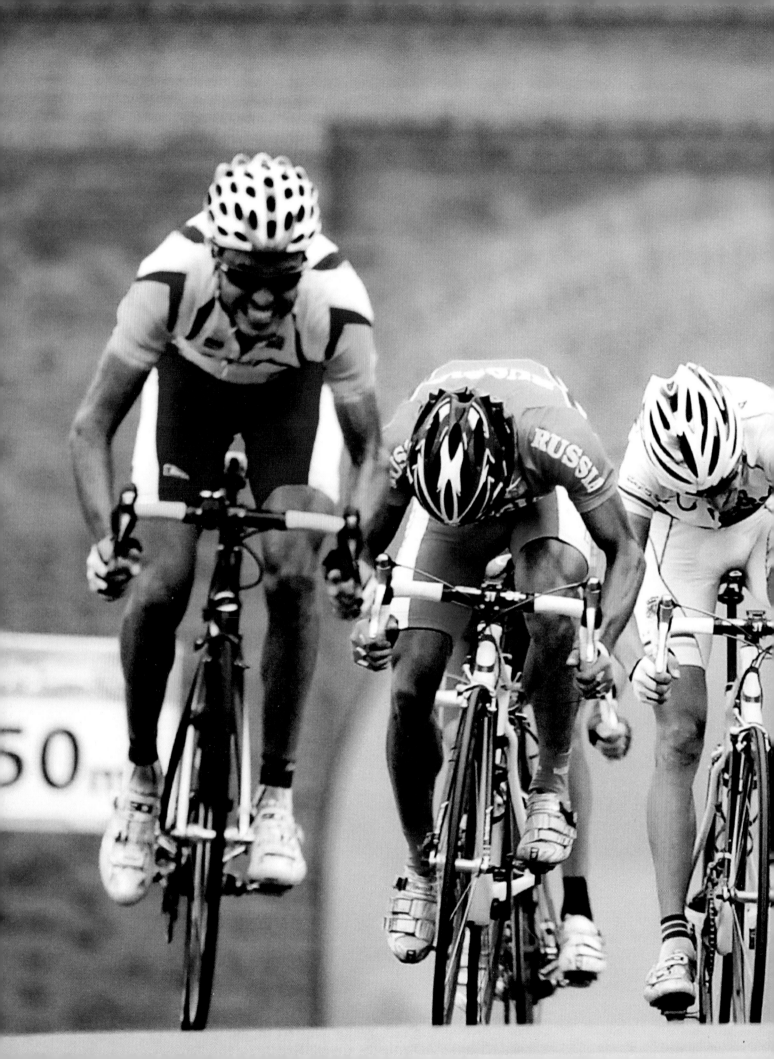

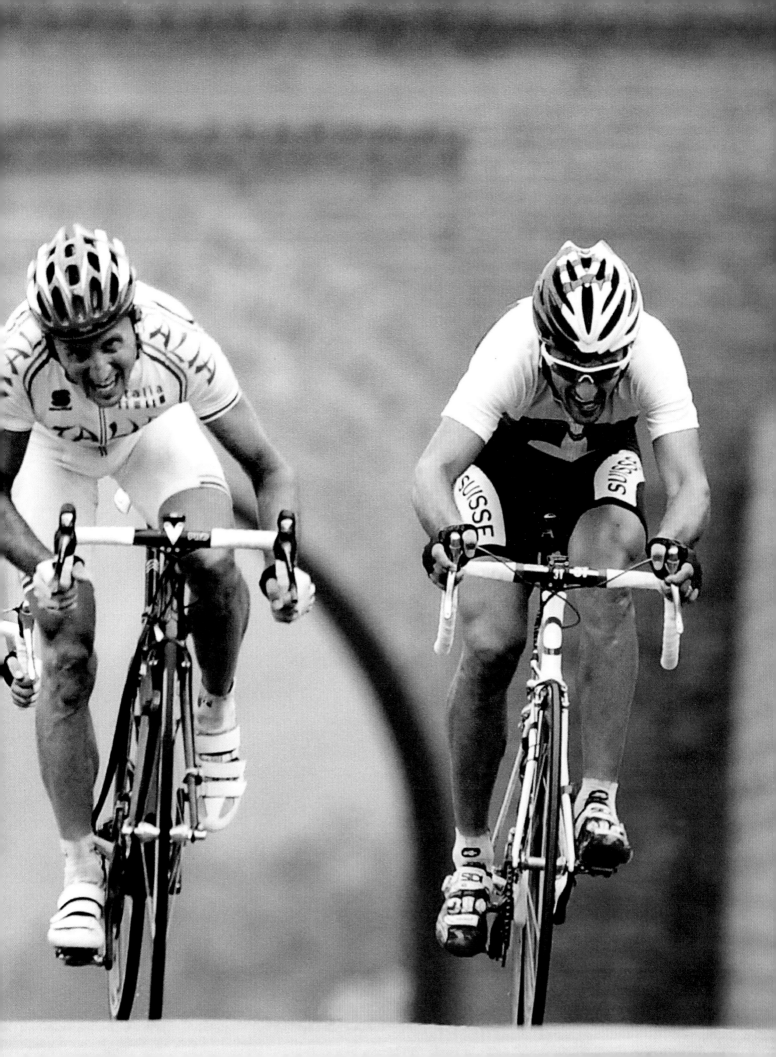

10 CONFRONTED BY THE SPECTRE OF DOPING

Even Fabian Cancellara couldn't escape the inevitable. At a time when almost every successful cyclist was being linked to doping, questions were asked of him too. Barely a few months after his success at the Beijing Olympics, the Swiss was accused of taking CERA, a new variant of the then better-known doping substance EPO. It turned out there was no case to answer, but the damage was done and the cyclist struggled to bounce back.

A fantastic 2008, with wins in Tirreno-Adriatico and Milan-San Remo, a Tour win for CSC teammate Carlos Sastre and two Olympic medals, ended in horror for Fabian Cancellara. On 29 September, the newspapers published a list of riders who were suspected of using CERA, at the time a more modern variant of EPO. Fabian Cancellara was on that list, and for the first time found himself confronted with the spectre of doping. 'Later on that list turned out to be a big lie.' The Swiss still can't hide his disappointment about the whole thing. 'But at the time you end up in a kind of bubble which you can't escape. After the euphoria of Beijing I was suddenly portrayed as a drug user. The way people saw me changed completely. My contact with the media had always been very positive, but suddenly I got to know the other side of it.'

For the first time in his career, Cancellara hit a low. He withdrew from public life and let his winter training slide. 'I wasn't used to dealing with negative publicity and didn't know what to do. I didn't feel I needed to respond because the story didn't hold any water. Anything I said would only give rise to new stories in the media. I tried to keep my composure and took my family and friends on holiday, far away from all the fuss. To forget the negative stories, I completely disregarded what a rider should and shouldn't do during the winter. The result was that I came out of the winter seriously overweight, having put on nearly ten kilos. I was sentenced without having had a trial, and without having done anything wrong. That situation was extremely distressing.'

DARK DAYS

Cancellara isn't the only rider to have ever been indicted. But while others, who were found guilty, carried on cycling as if nothing had happened, it was the beginning of a dark period for the Swiss. 'I've always been a very emotional person, who cared what was said about him. Consequently, I was sick of the whole cycling world. I told the team that was me finished for the season.

I also dropped out of the World Championships in Varese.'

Didn't the Swiss see the insinuations coming? After all, he grew up as a cyclist in an era in which every successful cyclist, almost by definition, was suspected of doping. Whoever won was on the stuff, according to the public. One more scandal wouldn't surprise anyone. 'I was indeed around at a time when doping was unfortunately a very topical issue, but you have to make a distinction between those who specialised in the Grand Tours and those riders who focused on the classics, like me. For classics riders, doping wasn't something that could make them better. And there's a second element: in the generation before me, doping was still organised at team level. I didn't experience that. Anyone of my generation who let themselves be talked into doping did so on an individual basis. You should also remember that there were very strict controls at that time, even within the team. At CSC, Bjarne set up an internal testing programme led by Rasmus Damsgaard, a well-known Danish anti-

doping expert. But I was often tested outside the team too. In 2007, I was tested a total of 52 times by UCI, WADA, the Swiss anti-doping agencies and at races. That's equal to one test per week. I didn't even mind. What I did mind was that there were still riders trying to cheat despite all the checks. Riders were still being caught in 2008, for example Rebellin and Schumacher... Luckily they were the exceptions. Cycling has come a long way in the fight against doping; unfortunately other sports are going to have to follow suit. The system in place in cycling is a good example of how to wage the war against doping.'

FESTINA TOUR

In 1998 Cancellara won his first world junior time trial. A few months earlier, the cycling world had been rocked by the so-called Festina Tour. The Festina *soigneur* was caught with doses of EPO and the police decided to turn the entire Tour caravan inside out. This led to one of the most hallucinatory editions ever, with riders and staff being taken into custody, night raids, and so on. 'As a seventeen-year-old, I didn't give it a moment's thought, I wasn't interested,' says Cancellara. 'My future manager, Armin Meier, was part of the Festina team that was kicked out of the Tour in 1998. Later he told me about that particular year. He told me they didn't know any better, because at that time nearly everyone was doing the same thing. The Festina Tour was the result of the prevailing morals in the peloton. But as a seventeen-year-old, doping was never an issue for me, although the fight against it was. When I raced with the Swiss national team, our bags were regularly checked by people from the Federation before we set off. For me that was a good thing, but I don't know if other countries were equally rigorous. I saw how some contemporaries posted solid results in the U23s, but quickly faded into the background after they'd signed a professional contract.'

Without realising it, Cancellara came close to disaster. His collaboration with the Italian trainer Luigi Cecchini from 2003 is still considered by many to be suspicious. 'But as I said earlier, Cecchini made it clear in our first conversation that he had no time for doping. If that was what I was looking for, then there was the door. I think he made a distinction between riders who didn't need doping and riders who would never reach the top without doping. He saw the results of the tests we did and knew what was possible with my numbers. And yes, I've sometimes wondered whether there was any

wrongdoing among the group of riders who trained with him. But no one ever mentioned doping to me, not Cecchini or anyone else. I can honestly say, hand on heart, that no one has ever suggested I use doping. It wouldn't have been an option for me either. Not just because I have a responsibility to the sport of cycling, but mainly because I want to be able to look my wife and children in the eye. I'm glad I went my own way and earned a lot of respect for doing so. If anyone wants proof: I didn't reach my peak until I was almost thirty years old, and I rode at a very high level until my senior year. That isn't possible for someone who has reached the top with doping.'

Cancellara narrowly beat Lance Armstrong, the figurehead of corruption in cycling, to win his first Tour prologue. And he cycled for five years under the guidance of Bjarne Riis, the Dane who after the end of his cycling career confessed to having won the 1996 Tour with EPO. However, he isn't angry at those who haven't raced clean. 'Angry isn't the right word. Disillusioned maybe. But I understand that they were cyclists in an era which viewed doping differently. I don't want to say that everyone used doping. Everyone knows that one add one makes two. I leave it to people to draw their own conclusions.'

The prominent users of yesteryear gradually fell one by one. 'At the end of the day it's clear that doping can cause an awful lot of damage. Look at my former team manager, Bjarne Riis. Back in 2007 he was one of the first who had the courage to confess everything. That confession cracked him. They crucified Bjarne in Denmark. I'll always stand by Bjarne. He was the perfect mentor, he got the very best from his riders and staff. He created the ideal conditions for me to perform. Not with drugs, but with advice. Perfect adjustment of the seat, my position on the bike... these were the things that Bjarne occupied himself with in detail and which had an effective influence on my performance. His doping history interests me less. I'll always look back on the years with Bjarne as a wonderful time.'

Cancellara is pleased that today's young people renounce doping. 'For youngsters turning professional nowadays it's no longer difficult to speak out openly against doping. There was a time when such a thing was difficult. If anyone raised the problem of doping they would end up being questioned about it themselves. Personally, I've always talked quite openly about doping, but I've noticed over the years that those who dared to raise the problem were approached about it themselves afterwards.'

PRIVACY

The Swiss has also experienced how the fight against doping has intensified in recent years, with the introduction of the biological passport, whereabouts rules, and out-of-competition testing. Professional athletes have given up a lot of their privacy. 'Initially, I had a hard time with it, but I gradually came to realise that this was part of my job too. My wife on the other hand always finds it difficult when there are doping controllers at the front door. It's not great if an inspector turns up for urine and blood while the kids are at home. You always have to be at home during your time slot too. Knowing that you could be tested on any given day is suffocating. It's very stressful, even if you've never even thought about doping. Have I filed my whereabouts information, have I forgotten anything, is the location correct? For people like me who lead a busy life, reporting my whereabouts was often too much. I thought the biological passport was a good idea. The passport monitored our health status and we found out more quickly if there was a problem with any blood values, such as an iron deficiency for example.'

Cancellara has now said goodbye to the doping hunters. 'After my career, I sent a letter to all the organisations concerned with the message that I never wanted to see them at my front door again.'

There's no such thing as a completely clean peloton, thinks Cancellara. 'There will always be guys who choose the wrong path. But cycling in the year 2016 has come a long way, even for those who want to win a grand tour: more specific training, better nutrition, optimal support. Even a simple measure like cycling on rollers at the end of a stage promotes recovery. If the classification riders had known that before, they might have been less quick to reach for the drugs.'

11 A SAINT IN HIS OWN COUNTRY WITH ELEVEN STAGE WINS IN THE TOUR DE SUISSE

——

2009 wasn't exactly a peak year for Fabian Cancellara. After a difficult winter due to doping rumours, he failed to get the engine going in time for the classics. But Cancellara kept at it, and went on to achieve his biggest success to date in a stage race in June, when, rather unexpectedly, he won the Tour de Suisse. But he didn't succumb to wishful thinking. The Tour, the Giro, the Vuelta – that would be aiming too high for a rider with his body. But winning the Tour de Suisse in front of his own countrymen and women tasted sweet.

Fabian Cancellara had his own fair share of fallow periods. 2009 was just such a period to begin with, coming after the winter in which he was first confronted with doping rumours. His two Olympic medals in Beijing brought him international fame, but then it turned out that even Cancellara was subject to the laws of the sport. If you don't take optimum care of yourself during preparation, you'll pay for it later. This is what happened to the Swiss in the spring of 2009. 'Although I did win my first race,' he says. 'Bjarne had found a new main sponsor to replace CSC, Saxo Bank. I went out with the team to California, for a training camp and then the Tour of California in February. All the sponsors were there; the riders knew how important this race was. Unfortunately I was ill, but out of respect for the sponsors I decided to start in the prologue anyway. It's still a mystery to me how I won the prologue. The next day I was forced to give up.'

VIA DOLOROSA

It was the beginning of a miserable period. Cancellara fell during training in Switzerland and suffered a shoulder injury. In the Tirreno-Adriatico, the Swiss was invariably among the first to fall behind, and he pulled out during the sixth stage. He skipped Milan-San Remo, the race which he won the previous year. 'Partly because I wasn't in top form, but mainly because an aunt had just died. The Thursday before San Remo, I scouted out the World Championship course in Mendrisio together with Tom Boonen. But my aunt was buried on the day of the San Remo and I had to be there. Family has always been a priority with me.'

There seemed to be no end to his bad luck. In the Tour of Flanders he stood on the Koppenberg with his chain in his hand, an image that showed exactly how he felt during those weeks. He finished Paris-Roubaix in 49th position, just under seven minutes behind winner Tom Boonen. Nothing seemed to work for the rider who had won two Olympic medals and Milan-San Remo the previous year. 'Because the spring had been such a failure, I then decided to ride the Giro. One way or another I managed to ride myself into shape during the Giro.'

After he pulled out of the Giro, he had three weeks before the start of the Tour de Suisse. 'Not taking part was never an option,' says Cancellara. As the figurehead of Swiss cycling, he couldn't afford to be absent. Moreover, the management company which represented his interests was involved in the organisation of the competition. It's striking that in the fourteen times he entered the Tour de Suisse, he never got further than 56th place in the final standings. Except in 2009. 'I didn't think for a minute I would win the Tour de Suisse,' he says. 'I just saw the tour of my country as good preparation for the Tour. But my team management saw it differently. Bjarne Riis invited me and my family out to Ticino, where we did some training behind the motorbike. I even remember that Bjarne's wife made me a probiotic drink, because I had a bout of diarrhoea too.'

And the preparations paid dividends! Cancellara travelled to the start of the prologue of the Tour de Suisse and did what he almost always did at the time: he won the prologue of just under eight kilometres, beating the Czech Roman Kreuziger by no less than nineteen seconds. 'Team leader Kim Andersen and Bjarne tried to persuade me bit by bit that it was possible to go for the general classification. After all, the race ended with a long time trial in my own city, Bern. If I could limit the damage in the mountain stages, I might be able to win the Tour de Suisse.'

Cancellara can still call to mind all the stages. 'I hadn't even examined the course in advance but the more I looked at the profiles of the stages, the more I too became convinced that there were possibilities. I

51

Fabian Cancellara dominates to win the final time trial in Bern, the city where he grew up and continues to live. He can even afford to finish with his hands in the air.

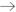

The home crowd goes crazy as Cancellara rides triumphantly through the streets of Bern.

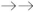

"I had to pay a fine because I was adamant I was going to ride through my own city wearing the Swiss champion's jersey."

grew in the race and was even able to stick with the stronger riders on the uphill stages. On the evening of the final time trial in Bern, I was in second place and just four seconds behind the leader Valjavec. In the final time trial, there was no stopping me. Tony Martin, who finished second, was more than a minute behind. I remember that I was actually supposed to ride that time trial wearing the points classification jersey. I refused and had to pay a fine because I was adamant I was going to ride through my own city wearing the Swiss champion's jersey. Eventually I won the overall classification, beating Tony Martin by more than two minutes.'

Winning the Tour de Suisse in his own city… Cancellara continues to regard this as one of the highlights of his career. 'It certainly wasn't the toughest course imaginable, but I thought it was a shame that afterwards some people claimed that the organisation had planned the route to suit me. I didn't ask them to make the stages easier. Everything just came together: I was in top form, the competition was perhaps less strong, the course was in my favour. The fact that, to the surprise of many, I won a tricky Tour prologue in Monaco two weeks later, proved how good I was at that time and how well I was riding uphill.'

CHASING AFTER
KOBLET AND KÜBLER

Cancellara won a total of eleven stage victories in the Tour de Suisse, the last of which – a prologue, of course – during his last participation in the race in 2016. The fact that this puts him on a par with Hugo Koblet and Ferdi Kübler is more than just a detail for Cancellara. Kübler and Koblet both won the Tour de France in the early fifties and are still regarded as the greatest Swiss cyclists ever. 'It's an honour for me to be mentioned in the same breath as them,' he says. 'They didn't ever win in Flanders or Roubaix but they won the Tour de France. Both epitomise the most successful period in Swiss cycling history. Being able to stand alongside them with eleven stage victories in the tour of our country fills me with pride. As a non-classification rider I still managed to win eleven stages. That makes me part of Swiss cycling history.'

The Swiss had to wait a long time for his eleventh stage victory. In 2011 he achieved his ninth and tenth victories, but he had to wait no less than five years to draw level with his two illustrious compatriots. 'There was always some problem or other. Either I was unwell, or I fell during training just before the race. Or I had bad luck with the wind, like

in Quinto. Yes, it was frustrating not to win for such a long time. I was always expected to finish on the podium in the time trials and prologues, especially in front of home spectators. The fact that I had to wait so long for that eleventh stage made me absolutely determined to win in my last race. And I very nearly didn't, again because of the weather. The course was wet in sections for me, while most of the others came through on drier roads. I honestly thought I wouldn't succeed. Eventually I won by a single second over Jürgen Roelandts. I felt such tremendous relief. It was my last chance to win a stage and I had taken it.'

The Tour de Suisse will always occupy a special place in Cancellara's career. 'Not only was it the tour of my own country, it was also considered the hardest stage race after the three Grand Tours. The fact that I've been able to stamp my mark on a race of this calibre, including by winning it once, is an achievement I'm proud of.'

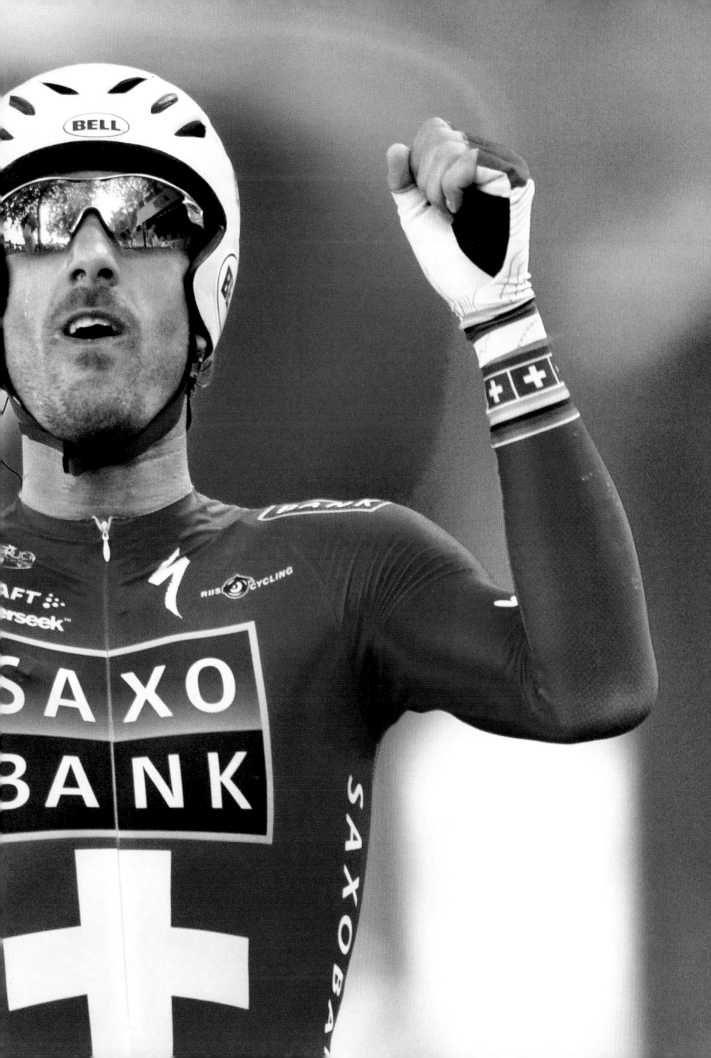

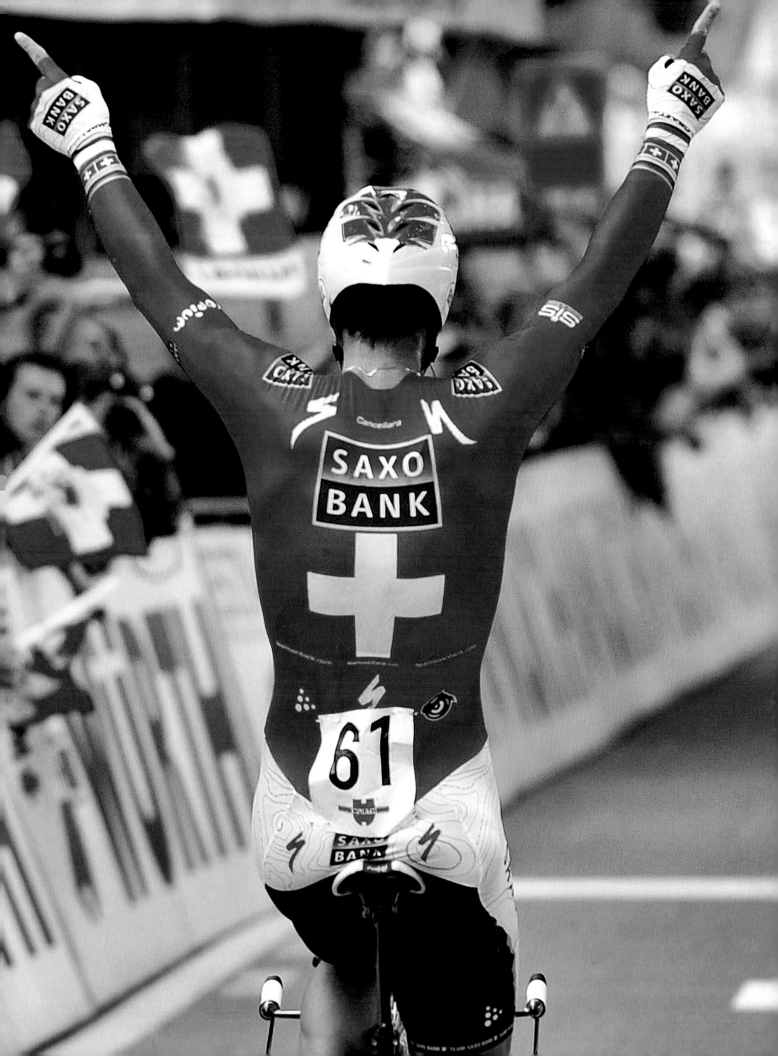

12 THE ROAD WORLD CHAMPIONSHIPS: A GAP IN THE PALMARES

Cancellara on his way to his third World Time Trial title in front of his own countrymen and women in Mendrisio.
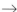

Fabian Cancellara won the world time trial title four times, making him the most successful time trialist ever. But he didn't ever manage to go one better and win the rainbow jersey in the individual road race. In 2009, however, the odds looked good. The course in Mendrisio was favourable and he hoped to be able to achieve his dream for his country. Cancellara was by far the strongest man in the race but was undone by his own enthusiasm.

Fabian Cancellara didn't ever manage to win the world road title. 'I don't think it's so bad,' he says. 'Michele Bartoli was a great rider and he was never world champion, and he's always impressed on me that that missed title didn't change his life. Of course I would have liked to become world champion, but the circumstances were always against it. Because I focused mainly on the time trial during my first years, I always missed out on the road race. Maybe it was due to decompression after winning the time trial. I don't know. Later, when I gave the time trial less attention, it just didn't work on the road. I've never performed well at the world championships. Of course as a rider you always want to win everything, but I don't really see it as a gaping hole in my palmares. The world title might be missing from my palmares, but I'm satisfied with the wins I have achieved. The lack of a world title hasn't changed my life. I'd rather have seven monument wins than one world road title. And no, I wouldn't have been willing to trade one of my four world time trial titles for the other world title.'

All the same, Cancellara did his best to win the road race too, especially in 2009, when the world championships were held in Mendrisio in Switzerland. 'After a difficult spring, Mendrisio was to be the highlight of my season. Although I'd won the Tour de Suisse, and was the best in the prologue of the Tour de France and wore the yellow jersey for seven days, my main focus was on Mendrisio.'

As part of his preparation for the world championships, he started in the Vuelta, which kicked off in Assen in the Netherlands. After a tough Tour, he was still mentally and physically fatigued. 'I thought I'd need the three stages through the Netherlands and Belgium to get into the rhythm. I wasn't interested in the prologue of the Vuelta. I barely warmed up, rode the prologue and... won.'

240 KM TRAINING RIDE

This shows how good Cancellara was at the time. He went on to win the long time trial in Valencia too, before dropping out of the Vuelta to set his sights entirely on Mendrisio. 'I did absolutely everything I could to be good. The Saturday before the World Championships, I went on a 240-kilometre training ride with Bjarne. Behind the motorbike, in the rain. I was riding for more than seven hours. My wife was worried and

even called me to ask where I was. It proves how determined I was. I just had to be good in Mendrisio. Just before I got home, I saw two rainbows in the sky: what better sign could there be? Everything was perfect: the bike, the shape I was in, the home advantage... I was ready for my first world title on the road.'

But first there was the time trial. As the reigning Olympic champion in the discipline, the Swiss obviously started as the favourite. 'It wasn't an option to skip the time trial in order to save myself for the road race. I rode for my country and had the chance to be the world champion for the third time. I had to grab that chance.'

And Cancellara won, finishing almost 90 seconds ahead of his CSC teammate Gustav Larsson. 'Even though I rode the last hundred metres with my arms in the air, waving to the Swiss public. Becoming world champion like that, in front of a home crowd, is still for me one of the highlights of my career.'

Five days later, Cancellara was also the favourite for the road race. The opposition came mainly from Spanish riders: the course in Mendrisio was also perfect for Valverde, Rodriguez and Olympic champion Sanchez.

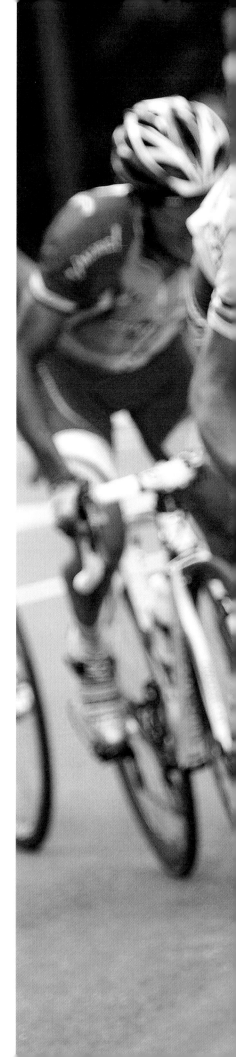

Cancellara tries to drop Philippe Gilbert as they enter the final lap. The Swiss would have to pay for the effort later on.
→

The Belgians were relying primarily on Philippe Gilbert. The decisive move came in the last lap, with Cancellara playing a leading role. 'That day I lost the race myself. I was solely responsible for the defeat. I was strong but not smart. I attacked too early and when a group of three slipped away just before the final climb, I wasn't with them. Cadel Evans had stayed in the background for the whole race, but broke away from a select lead group at the right moment, together with Kolobnev and Rodriguez.'

With two Spaniards, Valverde and Sanchez, on his wheel like watchdogs, and the other opponents relying on him to close the gap, Cancellara was trapped in his own web. 'On the last climb, I tried to catch the leaders, but nobody wanted to help me. Eventually I pulled away with Sanchez on the descent to the finish, but I only managed fifth place.'

INSTRUCTIVE DEFEAT

An exhausted but primarily disappointed Cancellara sprawled out on the asphalt. The knowledge that he was the strongest man in the race made it difficult to accept the defeat. 'Until then I'd always won my races by bending and then breaking the opposition. That day in Mendrisio I learned that the strongest man in the race doesn't always win and that sometimes you have to be cunning too. Everyone rode against me. It sounds strange, but thanks to the defeat in Mendrisio I was able to win races like Harelbeke and the Tour of Flanders the following year, something I hadn't managed before. Mendrisio was by far the most instructive defeat of my career. Although I was massively disappointed at the time, it gave me the key to win in subsequent races. Although I'd already won San Remo and Roubaix a few times before the world championships in Mendrisio, I'd lost more often than not.

Mendrisio gave me the experience that you need to win a race like the Tour of Flanders or Paris-Roubaix on a regular basis.'

Oddly enough, Cancellara got another shot at a world championship medal two years after Mendrisio. The course in the Danish capital Copenhagen was as flat as a pool table and produced an inevitable bunch sprint, albeit with a slightly sloping finishing section. Cavendish beat Matthew Goss and Andre Greipel. Cancellara was fourth. 'In Copenhagen I basically handed over the medal. I couldn't threaten Cavendish or Goss, but due to a lack of sprinting experience I had to leave the bronze to Andre Greipel. I raced like an amateur, with my hands on top of the handlebars. Because I hadn't taken part in many bunch sprints, I didn't know what to do. I really regretted the lack of experience. I was fast, that much I knew. You can't get onto the podium in Milan-San Remo if you're not fast. But there we always sprinted with a depleted group, whereas in Copenhagen there was still a large peloton. What's more, I almost always sprinted with my hands on top of the handlebars, which obviously isn't the ideal position. The lack of aerodynamics cost me the medal. On the other hand, I didn't have any ambitions that day. So it wasn't actually that bad.'

One element has never played in Cancellara's favour. As a relatively small cycling country, Switzerland was never allowed to send nine riders to the World Championships. Cancellara always had fewer teammates than, say, the Spanish, the Italians or the Belgians. Even in Mendrisio, the host nation Switzerland had only six riders at the start, compared to nine for the top countries. 'But I don't want to hide behind that. With fewer teammates you have a reason to ride more defensively. I've always been proud to ride in a Swiss jersey. I do regret that I didn't ever win the world title for my country. But I haven't lost any sleep over it.'

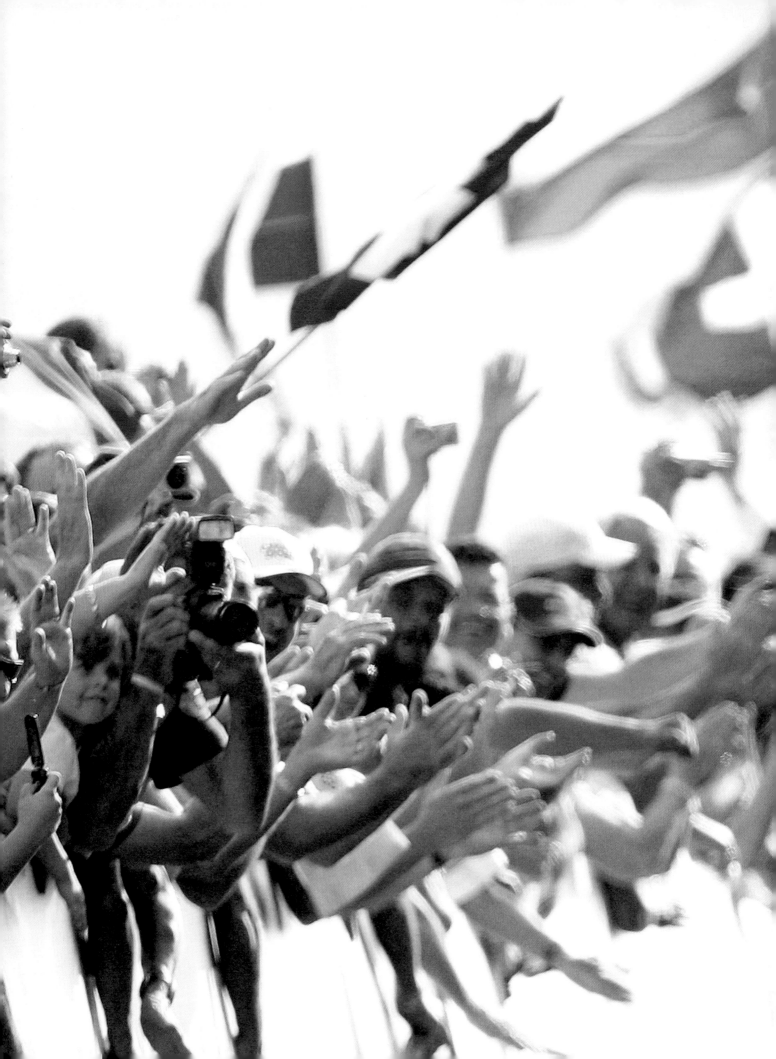

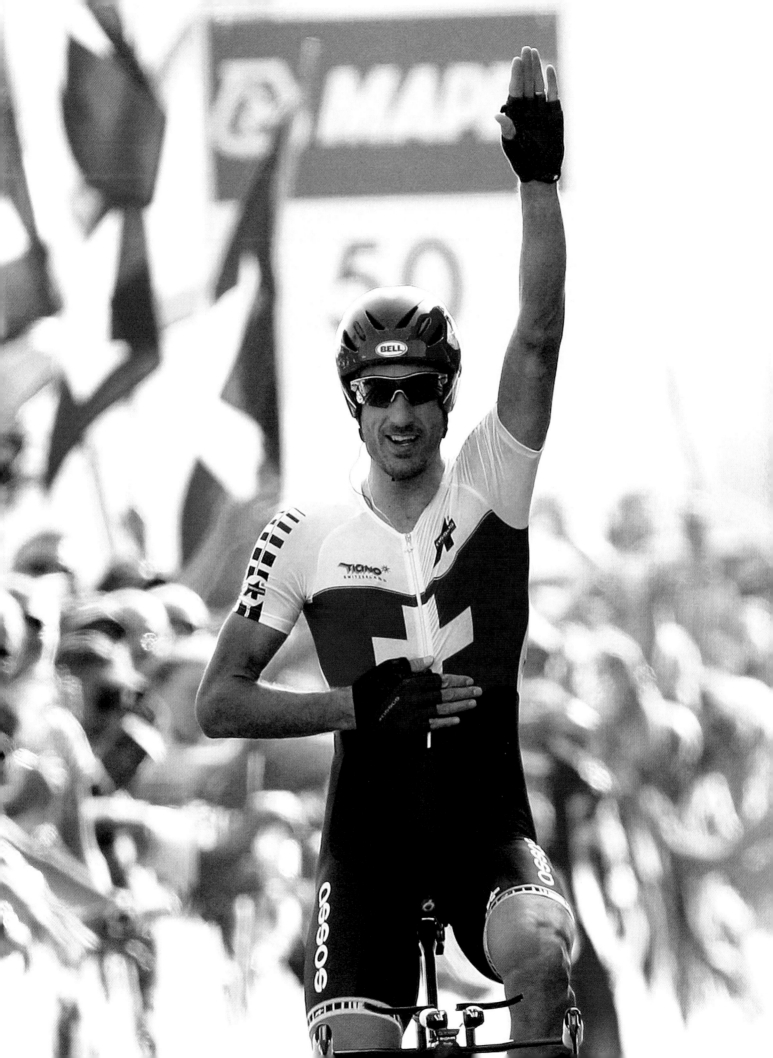

Fortunately for Cancellara, he still wins gold in the time trial after another impressive performance.

←

13 FINALLY FLANDRIEN: VICTORY IN THE TOUR OF FLANDERS

The famous acceleration on the Wall of Geraardsbergen. Cancellara rides solo to the finish line in Meerbeke.

On Easter Sunday 2010, Fabian Cancellara wrote one of the best pages of his career by winning the Tour of Flanders for the first time. And in style! During the ascent of the Wall of Geraardsbergen, he skilfully took the upper hand in a duel with Tom Boonen, and steamed like a locomotive towards Meerbeke. He was finally a Flandrien! A huge burden fell from the Swiss cyclist's shoulders. At last he could win top races in Flanders too. And he went on to do it several more times.

Anyone who might think it was love at first sight between Cancellara and Flanders is mistaken. When he made his professional debut, the Swiss couldn't get his head around the narrow roads and nasty cobbled climbs. But as a member of Mapei he was sent to Flanders repeatedly. 'I celebrated my twentieth birthday all alone in a hotel in Ghent,' he recalls. 'I was outside for a few minutes and then back inside. Sad, very sad! No, I didn't fall head over heels in love with Flanders. It always rained when I was there too.'

Nevertheless, it soon became clear that he had an aptitude for the Flemish job. As a member of Fassa Bortolo, he rode in the great Flemish spring classics, and pretty quickly achieved good results, especially in Gent-Wevelgem. 'I don't remember very much about it,' he says. 'Was I eleventh in Gent-Wevelgem in 2003? I can hardly believe it. I only remember Nico Mattan's infamous victory, when I finished fourth. Later on, Gent-Wevelgem became less and less important for me personally. I saw it more as a training ride on the way to the Tour of Flanders.'

The real breakthrough in the cobbled classics came in 2006. Cancellara won Paris-Roubaix after finishing sixth in the Tour of Flanders the week before, when he was too far back to catch the eventual winner Tom Boonen and second-place finisher Leif Hoste. 'I learned that in Flanders, it's best to break first, because the engines can play a key role in widening the gap. But the main thing I learned that day was that the Tour of Flanders was within my capabilities.'

Except the Swiss didn't yet have the necessary race insight. Early efforts generally proved fatal for him in the final stages, witness his useless raid in 2007, when he broke away from the favourites far too early with Gert Steegmans on his wheel. 'The World Championships in Mendrisio in 2009 opened my eyes. Suddenly I realised that it's not always the strongest rider who wins the race, that you sometimes have to be a bit cunning too.'

Cancellara went to Flanders in 2010 with the firm intention of claiming at least one spring classic. 'The spring, from San Remo to Roubaix, became the most important part of the season. I felt much more emotionally involved in the spring than in the Tour, for example. I rated the Harelbeke-Flanders-Roubaix triptych extremely highly in particular. An additional element was that I wasn't devoting myself entirely to the time trial anymore. I'd achieved everything I wanted to achieve in that discipline. I trained less with my time trial bike; the classics were becoming increasingly important to me.'

The dream eventually began with a win in 2010 in the E3 Harelbeke, a race that has over the years become the dress rehearsal for the Tour of Flanders. Cancellara got away with Tom Boonen and the Spaniard Flecha in the finishing stages. 'It was a masterpiece, even if I say so myself,' he laughs. 'I realised I wouldn't be able to accelerate with Tom on my wheel, because he wouldn't give me an inch. So I attacked with the last kilometre in sight, just before a tight left turn, at a time when Tom was in the lead and I had Flecha on my wheel. I just knew that Flecha would react first and that Tom would have to get past Flecha to get on my wheel. My plan was based entirely on intuition, but it worked brilliantly.'

Cancellara rode solo over the finish line, followed closely by Boonen. He'd finally bagged his first Flemish spring victory. 'It was a weight off my mind,' he remembers. 'Not just the win but also the way I did it,

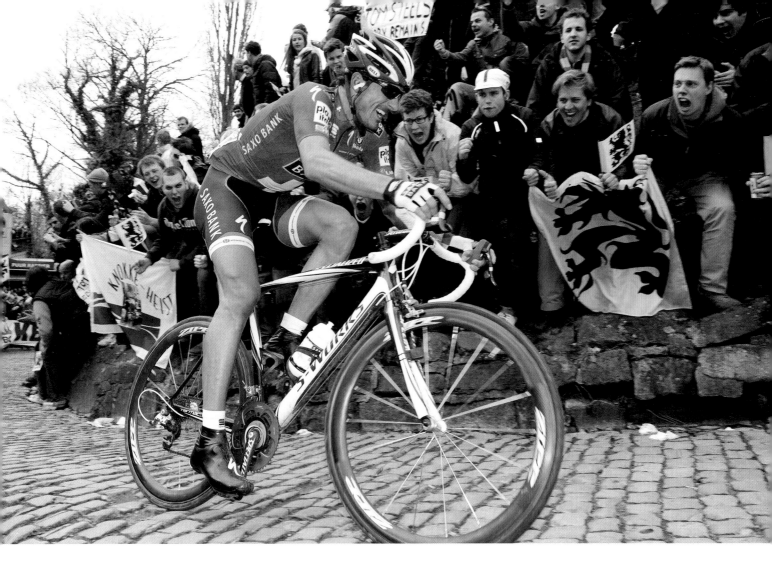

against Tom Boonen in the Belgian champion's jersey. In previous years I'd always been in the mix at the finale but I'd never managed to win. That night I went back to the hotel a relieved man.'

WITHOUT AN ELECTRIC MOTOR

The Tour of Flanders was Cancellara's next target. The Swiss was relaxed after his victory in Harelbeke but he also realised that the time had come to win his first Tour. 'I wanted to know what it felt like to be a Flandrien and the best way to find out was to win the Tour of Flanders. Not that you're automatically a Flandrien if you win the Tour. You're only a Flandrien if the Flemings accept you as one of them because of who you are, what you do and how you race. I can say that Flanders accepted me because of the person I was, because of the rider I was. As a rider, to be able to call yourself a Flandrien you also need to understand and embrace Flemish cycling culture, frites and beer included. That much I'd managed. All I had to do was win the Tour and I'd be a Flandrien.'

Cancellara's finale was marked by a mechanical problem. 'My front brake came loose, which forced me to change bike. I carried on on my spare bike while my first bike was fixed, and we arranged to swap the bikes back again further around the course. That bike swap was filmed and afterwards led to the accusation that I had a motor in my bike.'

The accusations arose a few weeks later at the start of the Giro. An Italian video demonstrated how you could equip a racing bike with an electric motor that provided extra power at a few well-chosen moments. The journalist in the video pointed to Cancellara's acceleration on the Wall. 'Those accusations hurt me. I think mechanical doping is as deplorable as regular doping. Some people said I should see the allegations as a compliment: I was so strong that people thought I was using a motor. Sadly I couldn't see it that way. Thankfully the storm died down reasonably quickly, but I still get comments about it.'

After the chaos of switching bikes, Cancellara managed to rejoin the lead group, and decided to accelerate on the Molenberg. It was more than 40 kilometres to the finish. 'That attack was completely unplanned. I just looked around, felt good and decided to

attack. I had no idea that Tom would be the only one to follow me.'

It was the beginning of an epic duel that would be settled on the flanks of the Wall of Geraardsbergen. 'Of course it was a dream scenario for the public. But again, that attack on the Wall wasn't planned. I just wanted to get up the Wall as fast as possible, because I feared that riders would come back and attack. The difference with Tom was spectacular, but I'm still convinced to this day that he was plagued by cramps. I know Tom, I know how fast he can ride up the Wall. That wasn't the normal Boonen.'

Cancellara didn't even notice that his Belgian opponent had fallen behind. 'It wasn't until after the Wall that I saw there was a gap with Tom. At first I had ten seconds on him, which soon became twenty. I only had one task left: to ride to Meerbeke as quickly as possible. I rode like a man possessed. Two kilometres from the finish, on the penultimate right bend, I knew that the race was in the bag.'

The Swiss found the time to enjoy the moment to the full. Before going into the last kilometre, he pulled a small golden charm from his pocket and held it up to the

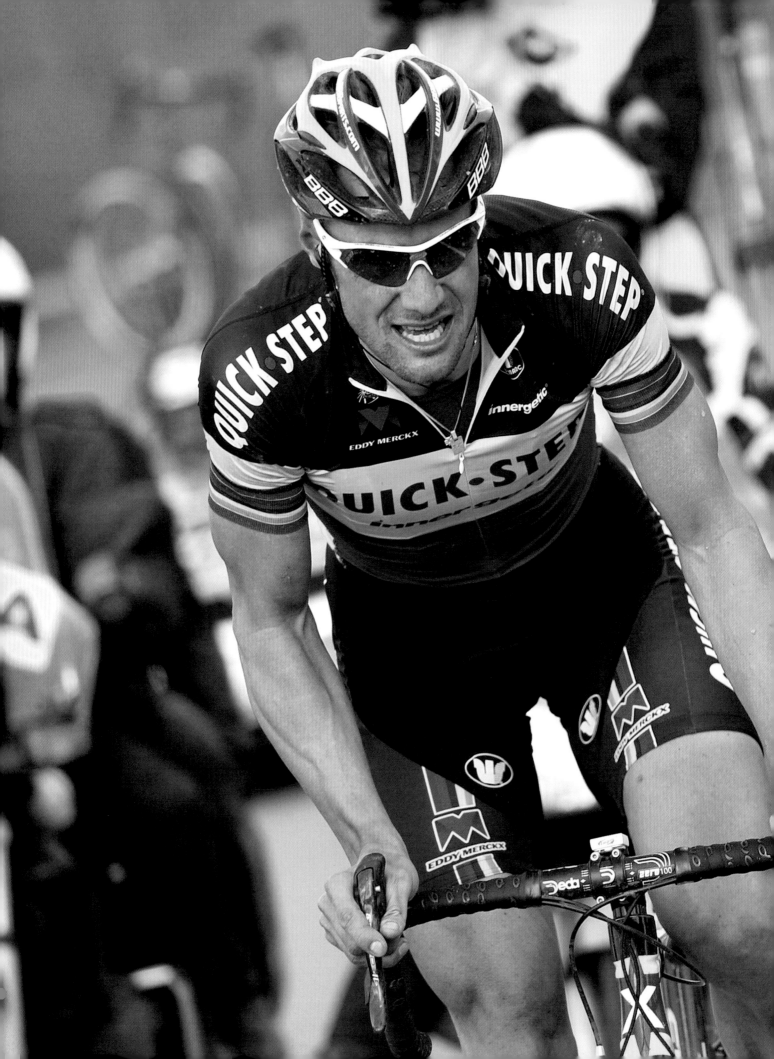

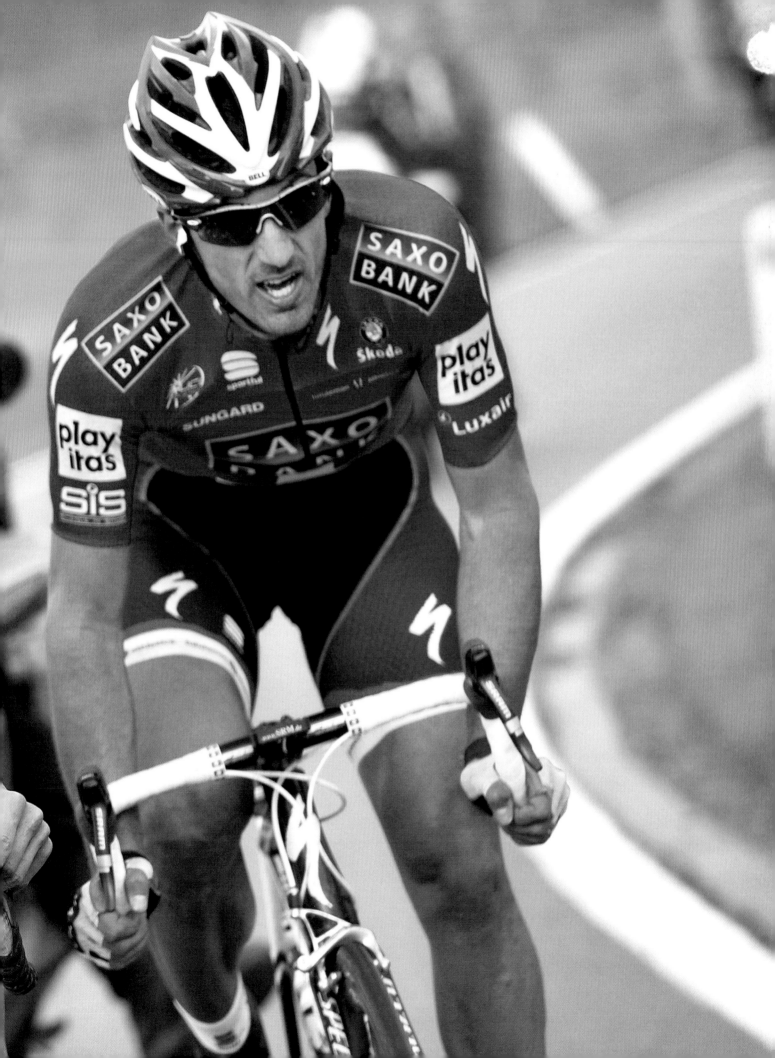

The two stars of the spring on their way to Geraardsbergen, where Tom Boonen is left for dead by his Swiss rival.

It's in the bag. Fabian Cancellara wins the Tour of Flanders and can finally call himself a Flandrien.

cameras. 'That morning, before the start of the race, Stefanie had urged me not to forget my angel. *Ah yes, that angel.* I stuck it quickly in my back pocket, as a good luck charm. I should show it, I thought. Everything was so unplanned that day. I saw someone with a Swiss flag at the side of the road and I took it. It was like in a film.'

AN ACTRESS AS FLOWER GIRL

Funnily enough, it was actually a film. Although the riders didn't know it, a Flemish fiction series was being filmed that day, *De Ronde*, in which some of the characters were being followed on the day of the Tour. Cancellara didn't find out until afterwards that one of the podium girls was an actress. 'Unbelievable, huh. I watched the series later on and have to admit it was brilliantly done. At the time it completely escaped me that she was crying on the podium. I found out afterwards that initially the organisation hadn't wanted an actress on the podium. But eventually they caved in and I must admit it delivered some amazing images. The final scene, in which I kiss my lucky charm in a hotel room, was filmed one year later. Fabian Cancellara the actor, such a thing could only happen in Flanders.'

Cancellara won the Tour of Flanders a total of three times and is the joint record holder. Each victory has a special significance. 'For me, 2013 was the best because of the problems I'd had the year before. The falls in 2012, the intense winter after-

wards... It was also the first time my family was properly there: my wife, my kids. Riding solo to victory before their eyes meant a huge amount to me. In 2014, I didn't think I would win. I very nearly lost the three Belgians, Van Avermaet, Vandenbergh and Vanmarcke, but fortunately I was able to catch them. I only had one chance and that was when the four of us were riding towards the finish line, because I knew the three Belgians wouldn't give each other the victory. And so it happened. Personally I was completely knackered, I can admit it. The only way I stood a chance was in a sprint between the four of us. And I took that chance. That day it was the experience that won, not the power.'

A SECOND HOME

With three wins in the Tour of Flanders, the E3 Harelbeke and Paris-Roubaix, Cancellara secured divine status in Flanders. Admirers set up a Cancellara fan club, which meets – unsurprisingly – in the Tour of Flanders Centre in Oudenaarde, the current finish of the Tour. He'll never forget the crowd's farewell cheers at the end of his last Tour of Flanders. 'I didn't win but I was still celebrated as if I was the winner. It filled me with pride. That night I experienced once again the extent of the respect between me and Flanders. I regard it now as my second homeland; I've made friends for life there. The Flemings liked me because I'm just a normal bloke, I haven't let my success go to my head. The fact that I raised 120,000 euros

for charity in my farewell year by giving away my last Tour of Flanders bike says it all.'

For Cancellara, the Tour will always be one of the greatest cycling events. Yet he's not without criticism. 'The start line in Bruges was the best in road racing. The atmosphere was unique. The streets leading to the Grote Markt, the podium. At my last appearance, I actually wiped away a tear. The Grote Markt in Bruges, that was our arena, that was where our fight began. As Spartacus, I felt at home in an arena like that. I can't understand why they're moving the start to Antwerp. I couldn't understand why they moved the finish line from Meerbeke to Oudenaarde either to begin with, but I resigned myself to it relatively quickly, given that Oudenaarde is in the heart of the Flemish Ardennes. But Antwerp, that's the Scheldeprijs, not the Tour of Flanders. Antwerp was chosen for political and economic reasons and those are the wrong reasons.'

Even though his professional career has ended, the Swiss will still be in Flanders when the Tour is taking place. 'I expect there'll be people who'll want to see me. If not, then I'll just drink beer and eat frites. As befits a Flandrien.'

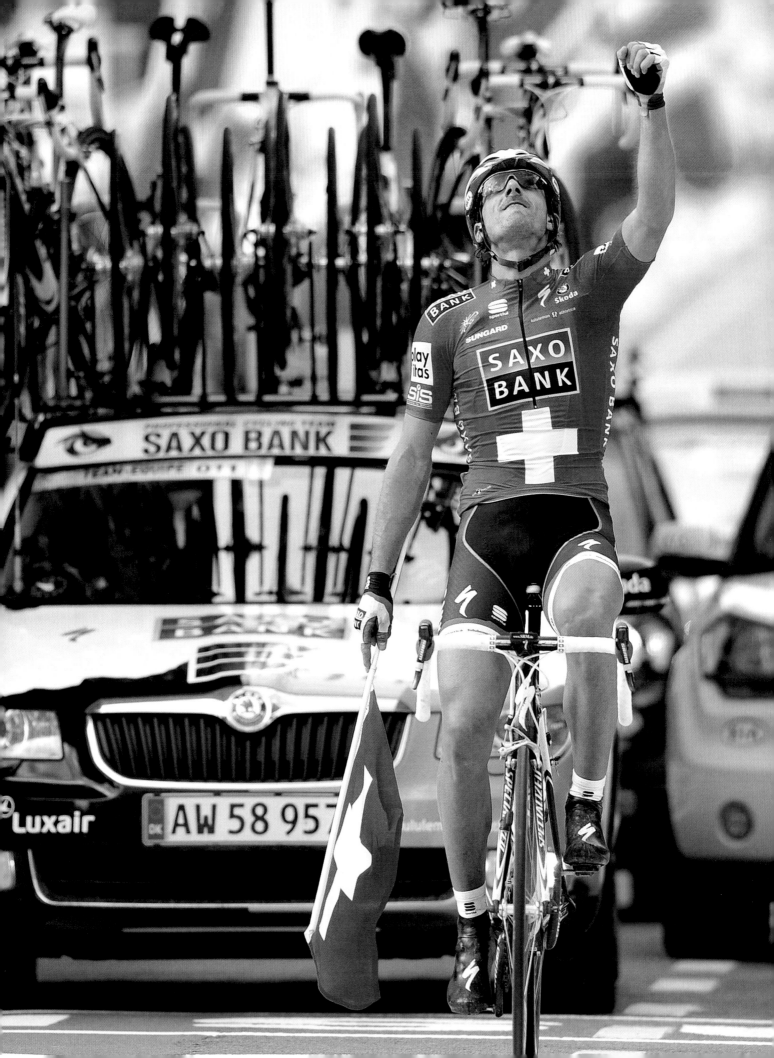

14 NEW BROOMS DON'T ALWAYS SWEEP CLEAN

At the end of 2010, Cancellara decided to leave Bjarne Riis and joined the Schleck brothers at Leopard-Trek, a Luxembourg cycling project. Cancellara knew what he wanted and steadily increased his influence on the development of the team. Unfortunately, the project was already on its last gasp after just one season. Leopard-Trek merged with RadioShack, the team headed up by Lance Armstrong's former mentor Johan Bruyneel. It turned out to be a turbulent period.

Why would you change employer if you'd just ridden your most successful season ever? It seems a strange step. Fabian Cancellara explains: 'I want to emphasise first and foremost that my five years with Bjarne gave me enormous satisfaction. But towards the end of 2010, Saxobank began to fall apart little by little and I watched as many of my teammates and other people I trusted decided to join a new project: Leopard-Trek. Roger, my regular mechanic, had already left. My regular *soigneurs* also made the switch, as did team leaders Torsten Schmidt and Kim Andersen. I had the feeling it was just me left with Bjarne and that was a situation I'd never experienced before. The people who you work with directly – team managers, mechanics, *soigneurs* – are ultimately more important than the team manager, who you're not in daily contact with.'

Cancellara decided to take the plunge himself. A calculated risk, he admits now. 'I needed a new environment and that was Leopard-Trek, despite the presence of some very familiar faces. I invested time in developing the team. After almost ten years as a professional I wanted to share my experience with the team. At the same time I was rated very highly by the owner, the Luxembourger Flavio Becca. He gave me responsibility for developing the new team, and to begin with I embraced this challenge. That was a risk, but changing team is always a risk. In retrospect, it's clear mistakes were made

due to a lack of experience and a difference in vision. Not everyone was in the right place, as it turned out. Some personalities just couldn't get along. But then in other areas I felt Leopard-Trek was way ahead of the competition. I was also reunited with Luca Guercilena, my first coach at Mapei. He was appointed as *directeur sportif*. To begin with we didn't work together very often, but that changed later on, and he became increasingly important to me. From 2011 he was my *directeur sportif*, team manager and even the Swiss coach. Prior to every big race, it was him who took me out for my last big training session behind the motorbike.'

LACK OF SUPPORT

In the spring of 2011, Cancellara's sole victory was in the E3 Harelbeke. Yet that wasn't because he was investing too much energy in developing the team. 'The fact is, the team wasn't strong enough to support me. Some riders didn't perform as expected, which meant I was often on my own in the final stages. I myself reached the desired level, but my teammates didn't. That was the reality and I accepted it. At the same time I realised at the start of 2011 that it would be very difficult or even impossible to repeat my performances of 2010. Still, I wasn't dissatisfied with 2011. All that was missing was the icing on the cake.'

The Swiss was convinced that Leopard-Trek had a bright future. Little by little the team overcame its teething problems and the expectation was that the second year could only be better. Unfortunately, there was no second year. Owner Flavio Becca failed to find a valid sponsor and was unwilling to provide the lion's share of the budget again. He went in search of partners and at the end of August it was announced that Leopard-Trek was merging with RadioShack, the American team led by Johan Bruyneel. RadioShack and Trek were to be the main sponsors, alongside Nissan. 'I was sorry that the Leopard project ended so soon,' says Cancellara. 'I was also sceptical about the arrival of Bruyneel. I associated him with Armstrong. A lot of the people he brought were still working with Lance. Johan's situation became increasingly difficult during the course of the year.'

WORKING WITH BRUYNEEL

Armstrong finally confessed to doping in January 2013. Bruyneel had already found himself in hot water a few months earlier following the publication of the investigation by USADA (the United States Anti-Doping Agency). In October 2012, he left his position as team manager of RadioShack-Nissan-Trek by mutual consent and was replaced by Luca Guercilena. However, Cancellara still worked almost a full season under Bruyneel's wing.

"A cycling team is like a small family. If someone dies, it's like losing a relative. Wouter Weylandt's death had a massive effect on both me and Stefanie."

'It's never easy when two teams merge,' says Cancellara. 'It's basically a consolidation of two different cultures. They had their way of working, we had ours. Besides, I hardly knew anyone at RadioShack. Our first meeting took place in a hotel overlooking the Spa-Francorchamps Formula 1 circuit. Everyone was invited to speak freely, Johan wanted to know what we thought of the merger. That conversation gave me a good feeling and changed my opinion of Johan. The image I had of him was strongly influenced by Lance, but the more I talked to Johan, the more I understood and appreciated him and his way of working. He expected his leaders to work hard, but he also made sure we had everything we needed. Professionally it was nice to work with Johan. I can look back positively on those few months when he ran the team, but the further the season progressed, the more he came under fire because of the whole Lance affair. That ruined him in the end. But those few months taught me one thing at least: Johan Bruyneel is not a bad person.'

In the end, Cancellara changed team twice in as many years: first from Saxobank to Leopard-Trek, a year later from Leopard-Trek to RadioShack-Nissan-Trek. 'Those changes certainly had an impact on my career. It was impossible to have a long-term plan, to establish anything. But I don't think that's the reason why I didn't win a monument in 2011 or 2012. I had the freedom to

do what I wanted in both 2011 and 2012, but it just didn't work. I don't consider those two seasons a failure. Although I didn't win a monument in 2011, I stood on plenty of podiums. The following year I wasn't able to defend my chances in the spring after that crash in the Tour of Flanders, but believe me, I was good. A few months later I fell again during the Games in London, but in between I did win the prologue of the Tour and I rode in yellow for seven days. So not bad for a 'bad' year!'

**THE DEATH OF
WOUTER WEYLANDT**

On 9 May, 2011, Leopard teammate Wouter Weylandt crashed while descending the Passo del Bocco in stage 3 of the Giro d'Italia, suffering a fatal injury. A truly black day, Cancellara confesses. 'I was at home when I heard the news. I felt like I'd been hit by a sledgehammer, so did my wife. Wouter was an extremely popular member of the group. A very talented young rider and a real live wire. He was someone who enjoyed life and at the same time did everything possible to deliver the performances expected of him. We clicked immediately. I couldn't believe he was Belgian and yet he didn't like beer. The fact that An-Sophie was pregnant when he died makes the whole thing even more tragic.'

Cancellara visited An-Sophie and her daughter Alizée in 2013, after his win in the

E3 Harelbeke. He insisted on laying flowers on his late teammate's grave, far away from all the cameras. 'Even now it's still hard to talk about it. Wouter's sister Elke went on to become a press officer at Trek. Whenever I see her, I see Wouter. I've tried to come to terms with Wouter's death, but it isn't easy. A cycling team is like a small family. If someone dies, it's like losing a relative. Wouter's death had a massive effect on both me and Stefanie.'

15 THE STRONGEST DOESN'T ALWAYS WIN

Fabian Cancellara congratulates Johan Vansummeren on his victory in Roubaix. Cancellara wasn't able to close the gap with the Belgian because of the other competitors' defensive race tactics.

→

The strongest man in the race doesn't always end up on the top step of the podium. Fabian Cancellara was repeatedly confronted with that difficult truth throughout 2011. The Swiss started as favourite for the classics and was in everyone's sights as a result. He achieved plenty of top-three finishes, but the great victory he wanted to give his new employer Leopard-Trek failed to materialise. Sometimes the harder you knock, the more likely you are to get the door slammed in your face. Yet he still managed to get onto the podium at Milan-San Remo, the Tour of Flanders and Paris-Roubaix.

After his performance in spring 2010, everyone assumed Cancellara would strike just as mercilessly in 2011. But that isn't how things work in cycling. 'I already knew in the winter that I wouldn't be able to match 2010,' says the Swiss. 'I'd moved to another team and I was going to have to give the team time to grow. Also, not all of my teammates reached the level that was expected of them. I knew that as a rider in my thirties I couldn't afford a lost year, but the situation was what it was and I couldn't change it.'

The final stage time trial in the Tirreno-Adriatico was Cancellara's first victory for his new employer. Four days later, Milan-San Remo was on the programme, the first monument of the year. Cancellara was present in the finale, unlike many other favourites who missed the boat. A breakaway by Greg Van Avermaet on the Poggio was neutralised

and a handful of riders sprinted for victory. 'Losing to Matthew Goss in a sprint is no disgrace,' says Cancellara. 'San Remo took on a double meaning for me during that period. It was a race I wanted to win, but at the same time it was also a race that I needed in order to be good for the cobbled classics. I may not have won, but that second place gave me confidence. I knew I was on top form.'

Cancellara did go on to win one semiclassic that spring. There was no stopping the Swiss in Harelbeke. With an eye on their World Tour rankings, many riders – including Tom Boonen – preferred to save themselves for Gent-Wevelgem, in which they could earn points. Cancellara didn't care about the points and was set on doing well in Harelbeke, his dress rehearsal for the Tour of Flanders. 'I never considered Gent-Wevelgem a fully-fledged classic,' says Cancel-

lara. 'The course has a lot to do with that. Gent-Wevelgem didn't suit me. I preferred Dwars door Vlaanderen in Waregem. But I particularly wanted to be good in Harelbeke, as a test for the Tour of Flanders.'

However, it looked like the 2011 edition was going to turn into a nightmare for Cancellara. 'I spent almost as much time standing next to my bike as I did sitting on it,' he says. 'After suffering three punctures, I assumed my race was over, but because of the Tour of Flanders I decided to make the best of it. With Stuart O'Grady's help I rode from group to group and eventually re-joined the leaders, much to my own surprise.'

The rest is history. Seventeen kilometres from the finish, Cancellara exploded and left everyone behind, going on to win by over a minute ahead of his closest pursuers. 'In Harelbeke I always wanted to test myself. I

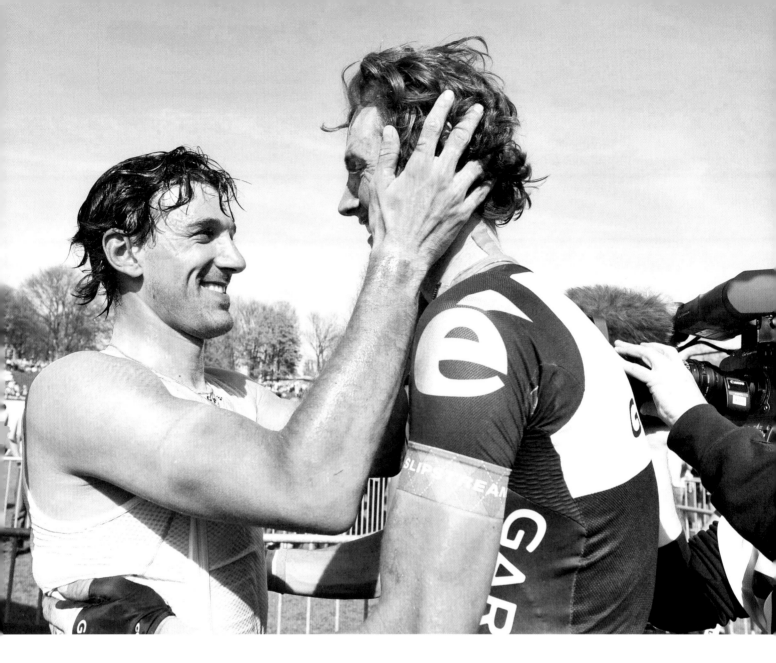

thought it was a fantastic victory. Harelbeke doesn't have the same prestige as the Tour of Flanders, but all the same I rated my victory very highly because of the way I won. I knew I was ready for the Tour.'

RACE NUMBER 1

For the first time in his career, Cancellara started in the Tour of Flanders with race number 1 on his back. Tom Boonen was considered his biggest competitor and it was the last time the race would finish in Meerbeke. What followed was one of the most spectacular races ever, with Cancellara playing a leading role. 'Because I was isolated quite early on because of a lack of teammates, I got the feeling that everyone was riding against me. So there was only one thing I could do: anticipate. Everyone was

constantly looking at me. Chavanel had been ahead for some time and on the Leberg I felt my time had come.'

After accelerating away from the contenders on the Leberg, Cancellara joined Chavanel, who decided not to lead anymore. 'Chavanel could have won himself, so I was hoping he would take his turn at leading, but Quick Step were playing the Boonen card as always.'

Driven by Cancellara, the duo quickly built a one-minute advantage, but in the streets of Geraardsbergen, just before the ascent of the legendary Muur, the vanguard of the peloton caught up. 'It looked like a spectacular collapse, but it wasn't,' says Cancellara. 'Chavanel had been on my wheel for several kilometres, and I guessed he was going to drop me on the Wall. I wanted to avoid that at all costs, so I decided to take a

little break. It was clear by now that it was me versus the rest. That was the price I paid for the way in which I'd won both Flanders and Roubaix the previous year. However, I didn't feel like I was a class above the rest. In fact I didn't feel as good as the year before.'

The Swiss struggled on and refused to throw in the towel. He survived the last hill of the day and set off in the direction of Meerbeke with the lead group. With four kilometres to go, Cancellara attacked again, only this time Chavanel and the Belgian Nick Nuyens went with him. 'That attack was purely intuitive. It was all or nothing. I didn't expect Chavanel to get on my wheel again. Nick Nuyens was a surprise too, the invisible man who'd hidden away all day and was suddenly up front. But I still believed in the victory and that was why I attacked.'

Cancellara in Hell: here he drafts behind Vansummeren, who nearly misjudges the bend.

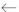

The trio went into the last kilometre with a small lead. Both Cancellara and Nuyens realised that Tom Boonen, Chavanel's teammate, was coming back. 'And then I forgot to play it smart and I decided, stubborn as I am, to launch my sprint, even though I was too far out. I was starting to feel cramps and decided it would be better to sprint from far out. That way I would at least secure my podium finish.'

Cancellara eventually finished third, behind the winner Chavanel and second-placed Nuyens. 'Of course I was disappointed. If you ride to win you're not going to be happy with third place. But I was in a lose-lose situation. Anything but winning was a disappointment. Winning the Tour the first time around was difficult, but winning the Tour a second time was much more difficult, as it turned out, because then they will really ride on your wheel.'

SAME SCENARIO

The following week the peloton was in Compiègne at the start of Paris-Roubaix. 'It was exactly the same scenario: everyone against Cancellara!' Cancellara recalls. 'Because I was isolated quite early on again, I couldn't respond to everything and I ended up in a difficult position.'

Over the course of the race a lead group of around 20 emerged, which included the Belgian Johan Vansummeren. With 40 kilometres to go, Cancellara put in a savage burst. 'The only ones who could follow were Hushovd and Ballan, but they weren't allowed to take part in the chase because they had someone at the front. I couldn't understand it: this was Hushovd's favourite race, he'd never won it, and yet he wasn't allowed to work. So I refused to pull Hushovd and Ballan, even though we'd halved the gap on the leading bunch.'

Australian champion Simon Gerrans beats Cancellara in the sprint at Milan-San Remo. The Australian took full advantage of Cancellara's efforts in the final kilometres.

→

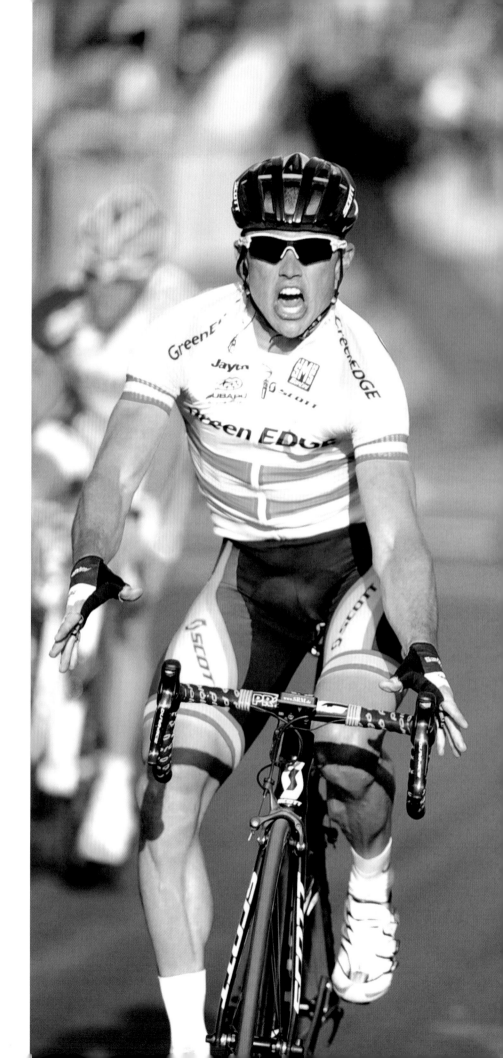

In the final stage, Cancellara swallowed up everyone except the escapee Vansummeren. The Swiss sprinted to second place in the knowledge that he was by far the strongest man in the race. 'Those sorts of finales are basically tactical battles. I knew that Hushovd wanted to win and that Vansummeren shouldn't be at the front. At times like that you have to be mentally strong and not give in to the urge to close the gap yourself. Then the race becomes a chess game. But unfortunately my tactical plan wasn't right that time. Eventually I came in 19 seconds behind Vansummeren. Just nineteen seconds! Once again I was left disillusioned.'

At the end of spring 2011, the conclusion was clear: both races had been won by an outsider. If either Chavanel in the Tour of Flanders or Hushovd in Paris-Roubaix had been prepared to cooperate with Cancellara, we would have had two different finales, presumably with a different winner. 'I rode strong finales in both the Tour of Flanders and Paris-Roubaix but I had to compete almost on my own against a whole peloton. And then of course it's almost impossible to win. It was a pity I couldn't win a monument, but I didn't blame myself.'

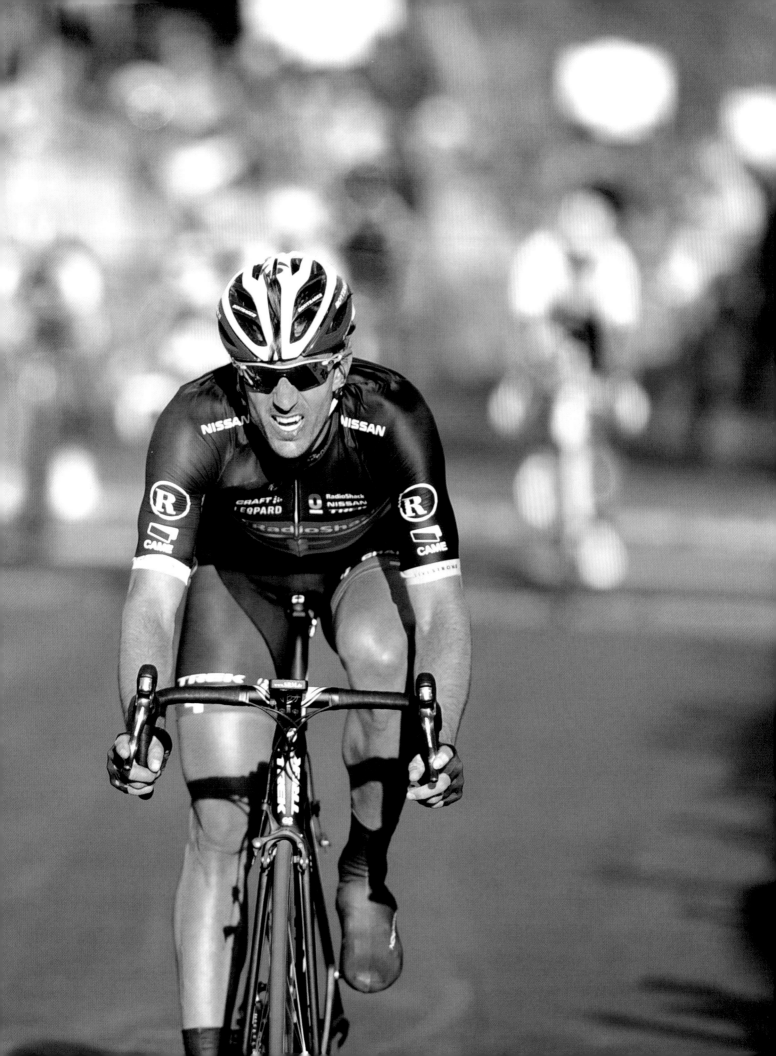

16 FALLING DOWN WITHOUT GETTING UP AGAIN IN *ANNUS HORRIBILIS*

London 2012: a silly crash in the Olympic road race is deeply disappointing for Cancellara. His injuries mean he is unable to properly defend his time trial title, and he finishes seventh.

\rightarrow

The Swiss lies exhausted on the ground: he can't believe it.

$\rightarrow \rightarrow$

Unfortunately when it comes to road racing, falling off is an occupational hazard. In a professional career spanning fourteen years, Fabian Cancellara suffered his fair share of setbacks, with 2012 a particularly painful low point. A crash in the Tour of Flanders resulted in a complicated collarbone fracture, while a fall during the Olympic road race in London led to disillusionment and doubts.

After a dominant but pretty unsuccessful 2011, Fabian Cancellara expected his fortunes to improve. Through the merger with RadioShack, he suddenly had experienced teammates such as Popovych, Irizar and fellow Swiss Gregory Rast by his side for the classics work. Team manager Johan Bruyneel was also keen to get results in the spring, and Cancellara clicked with *directeur sportif* Dirk Demol straight away. Demol was himself a former winner of Paris-Roubaix and knew the Flemish races like no other. 'The core group for the classics, of which I was the leader, was given a huge amount of freedom by Johan. He trusted us and I had confidence in the guys around me.'

COMPLICATED FRACTURE

The first few weeks of the season went perfectly. Cancellara won the Strade Bianche and the closing time trial of the Tirreno-Adriatico, and finished second in Milan-San Remo, only because the Australian Simon Gerrans sat patiently on his wheel. 'Unfortunately it went wrong in the Tour of Flanders and that was my own fault,' Cancellara confesses. 'At the feed zone 60 kilome-

tres from the finish, I was too far back in the thinned-out peloton. A schoolboy error. It's better to be at the front of the peloton when you're riding into the feed zone to avoid hitting discarded water bottles and other objects. I still don't understand why I was so far back. There can only be one reason: I was on top of my game that day, and when I'm at the top of my game, I sometimes get nonchalant. That nonchalance caused a lack of concentration, so I fell. When I'm at the top of my game, I make mistakes and things happen that shouldn't happen. When I'm only riding at 90 per cent, I'm very focused because I know I can't afford any mistakes. When I'm in top form at 110 per cent, then I make mistakes I shouldn't really ever make.'

The consequences were serious. The Swiss broke his collarbone in several places and flew back to Switzerland that evening. 'I hit a bad patch mentally. Yet again all my sacrifices had been in vain and I found that pretty difficult to deal with. After my surgery I didn't feel like crawling back on my bike straight away. Because of the complexity of the break it was a long time before the pain disappeared completely. It turned out that I hadn't just broken my collarbone, but that

my whole shoulder had taken the blow. That explained the long-lasting pain. It was a long time before I was able to start training again.'

Yet barely five days after his fall Cancellara gave a press conference in Basel, Switzerland. 'Everyone wanted to know what the situation was with me. It was the first time I missed the spring because of an injury. In order to minimise disruption for myself and my pregnant wife, so we could get the rest we needed, I wanted to speak to everyone at the same time. Stefanie was going through a difficult period too. Not just because she was pregnant, but also because she was upset for me. It was even a confusing time for our daughter Giuliana. Daddy was at home but he couldn't play with her. I had a hard time with that too.'

OLYMPIC DREAM

Gradually Cancellara began to feel like getting back on his bike. He started in the Tour of Bavaria, came second in two stages of the Tour of Switzerland, and looked set to be ready in time for the Tour de France and, more importantly, the Games in London. 'That was the last year I won a Tour prologue,'

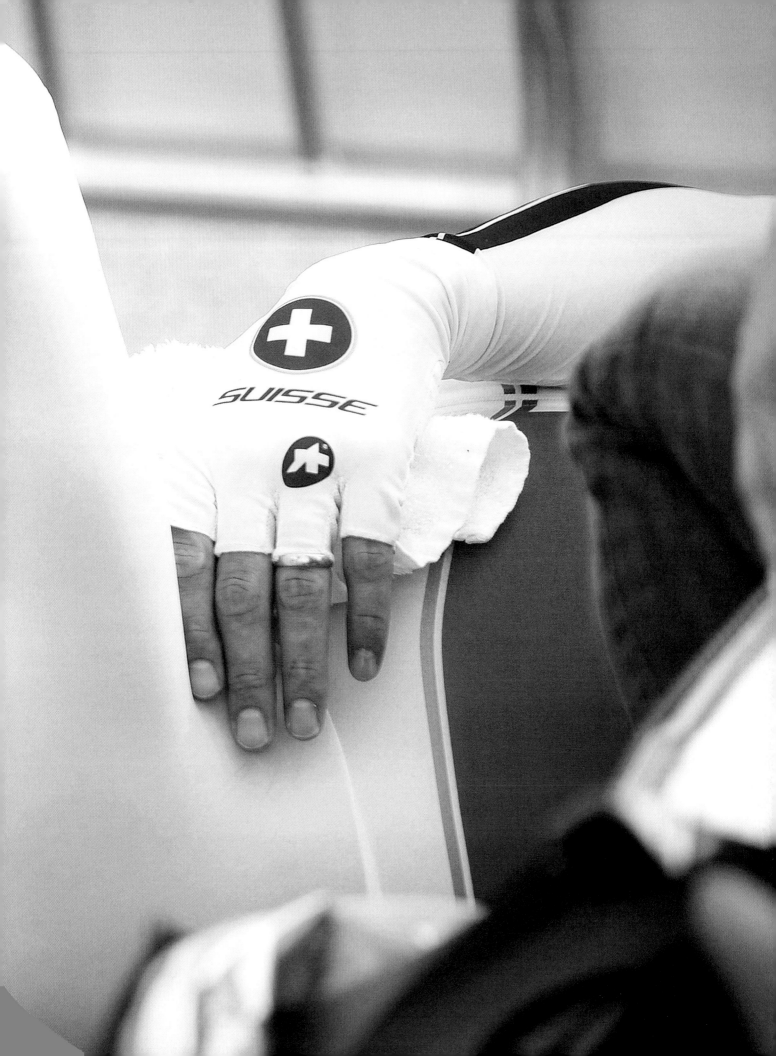

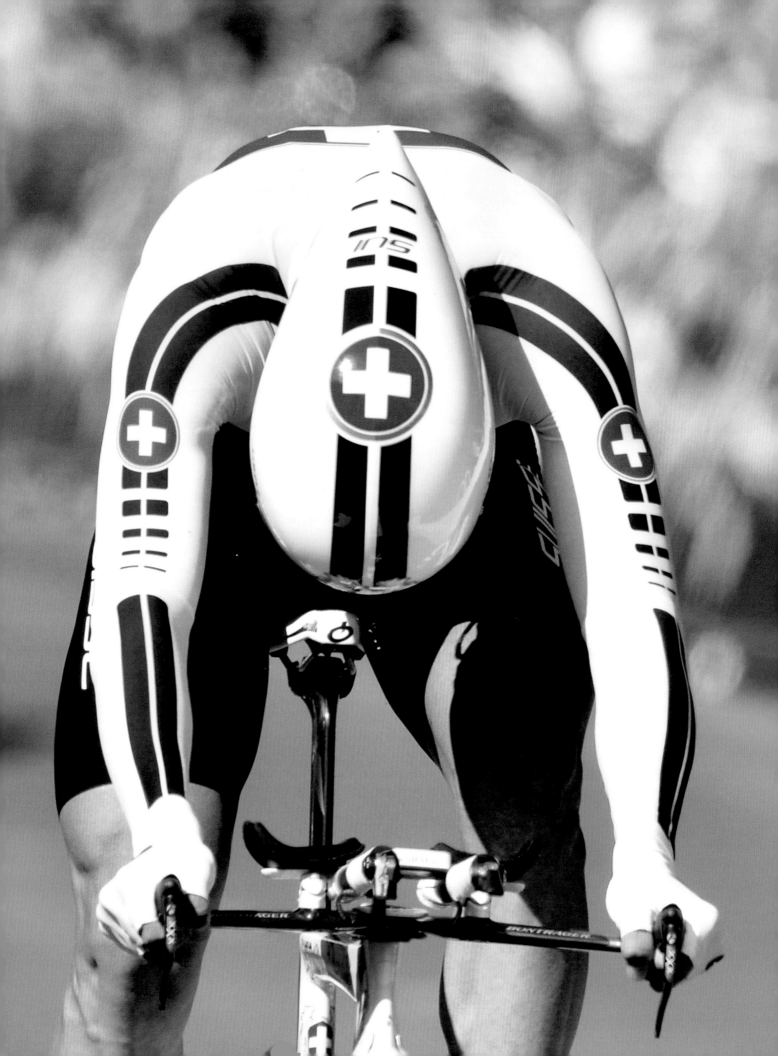

Cancellara in the last few hundred metres of his time trial. He realises there's nothing doing and bows his head.

he says. 'Eight years after my first Tour prologue victory, in Liège, here I was back in Liège, still on top. I went on to wear the yellow jersey for seven days. Still, it wasn't an easy period. Johan got into hot water over the Armstrong affair, our wages were paid late, Fränk and Andy Schleck had their own problems... Anyway, I tried to focus primarily on myself during that turbulent period.'

After all, the Swiss had only one goal: to win another Olympic medal in London, and preferably gold. In the meantime, Luca Guercilena had begun to play an increasingly important role in the team. Later in the season he was promoted to the position of general manager, and Cancellara ushered him in as the new coach of the elite men's national team at the Swiss Cycling Federation. 'I was obviously happy that I would be able to work with Luca in the future. On the other hand, my wife had had a difficult time during the last month of her pregnancy, and the first days after the birth weren't very easy. I left the Tour to be at Elina's birth. However, three days later she was back in hospital. As I prepared for the Olympics, my newborn daughter was in hospital with all sorts of drips and tubes coming out of her body. Obviously that was difficult for me. Still, working with Luca I managed to prepare for the Games in London. It wasn't necessary to acclimatise so we were able to travel relatively late to London. I was ready for a new quest for gold.'

Alas, London turned out to be a repeat of the Tour of Flanders. In the finale of the road race, Cancellara failed to negotiate a corner that he had scouted out a hundred times. To his great dismay, the Swiss hit the asphalt again. 'Same again, my own fault. The Swiss press had fun: for a while I was 'Johnny Head-in-the-Air', a storybook character who never looks where he's going and one day falls into a river. I came in to that corner too quickly. Afterwards I said that if I hadn't fallen, I almost certainly would have won a medal, and I stand by that. London was my day, I knew where and how to attack until all of a sudden I came a cropper. I'd never been so disappointed. The road race in London was the painful culmination of a cursed year. The fall in Flanders, the problems with the team, Stefanie's difficult pregnancy... I lacked

stability, and that brought me down quite literally in London. The time trial a few days later was a waste of time. At the first time check I still had the best time, but after that my body collapsed. I only managed seventh place. Maybe I shouldn't have started in the competition, but a warrior never gives up!'

PSYCHOLOGICAL ASSISTANCE

The consequences of the fall were disastrous. Cancellara didn't ride again in 2012. 'After London, I'd had my fill of cycling. Despite the repeated requests of the team management, I didn't take part in any more races. I asked the team management to leave me alone. The fall in London had done me more physical damage than originally thought. The impact caused an inflammation the size of a tennis ball on my already traumatised collarbone. But more than anything I was through mentally. I needed time for myself and my family, and for the first time in my life I sought psychological help.'

Timely help, as Cancellara soon realised. 'I was burnt out. My body and mind were tired, I couldn't motivate myself. I didn't even sit on my bike for two months. Everything was negative, even at home. It's hard to say whether it was burnout or just a lack of motivation, but it was a period that did me a power of good. I took a step back from sport for a while. My body had time to recover, and mentally I allowed myself the time I needed to completely recharge my batteries. I finally had peace, no stress.'

In hindsight, the psychological assistance proved particularly invaluable. 'I didn't do it just for Fabian Cancellara the athlete, but more for Fabian Cancellara the person. I wanted to know what was wrong. I wanted to know if I'd made mistakes. I'd come to a point where I could no longer talk about it with my wife, my family or the team. Stefanie had made it clear to me that she couldn't help me anymore. Taking that first step towards getting professional help was difficult. Nowadays if you admit you have a problem you're often regarded as weak, and nobody wants that. It was hard for me to convince myself that I needed help. In hindsight, however, it didn't cost me anything, it just helped me move on. I can't say how it helped me, but the

sessions gave me the space and the energy to process certain things. We didn't talk about my falls, which weren't the problem. My problem was that I'd been performing at a high level for too long, and that had brought me down psychologically. I learned to give myself time to process certain events. You can liken it to a grieving process, when you lose someone close to you. If you give yourself time to mourn, one day you'll put an end to the grieving process and pick up the thread of your life again. If you don't allow yourself time to mourn, you won't process the parting. That's something I'll take with me into the rest of my career: allow yourself time to process.'

Suddenly cycling was placed in a different perspective. Cancellara: 'Riders are supposed to be good all the time. And I was. Between 2006 and 2012 I won everything that was within my capabilities, with the exception of the world road title. Suddenly I realised that it was impossible to win everything. And at that moment my body brought me to a halt. You often see riders who come back after a long injury stronger than before. They were forced to take a step back from the bike too. It wasn't going to be any different for me.'

In November 2012, the Swiss decided to get his bike out again. 'Because I felt like it. I felt liberated, I remembered preparing for my first races as a young teenager. The bike gave me pleasure again and that was what I needed. That day I realised I would return to the highest level in 2013. Those two months without a bike were decisive for the subsequent course of my career.'

17 A RETURN AT THE HIGHEST LEVEL
—

Fabian Cancellara begins his 2013 season in the Tour of Qatar, laying the foundations for a successful spring.

After a hard 2012, Fabian Cancellara was determined to return at the highest level. He was feeling positive again and was in better physical shape than ever. Cancellara succeeded in his mission, winning the E3 Harelbeke, the Tour of Flanders and Paris-Roubaix. Emotions ran high in Flanders in particular, when for the first time his wife Stefanie was waiting for him at the finish line of his favourite classic.

At the beginning of October 2012, Cancellara invited a select group of journalists to the train station beneath the Jungfraujoch, a col located between the imposing peaks of the Bernese Oberland. At 3454 metres above sea level, it is the highest train station in Europe. 'The location was chosen for a reason,' Cancellara explains. 'As a cyclist, I wanted to reach the top again, and there was no better place to make that clear. That day I closed a dark chapter in my life. I didn't want to repeat the mistakes I'd made in 2012.'

Cancellara started to prepare for the new season with a clear head. His goal was certain. 'I wanted to return to the highest level,' he says. 'I wanted to win monuments again. My place was at the front of the peloton, not somewhere hidden in its belly. To achieve this, I began my preparations with a clear focus. I used all my past experience to ensure I would be at the top of my game when I came to race.'

And the approach worked. At his first race – Milan-San Remo – he was back on the podium, finishing third behind Gerald Ciolek and Peter Sagan in an edition marred by poor weather conditions. 'Mentally, I needed that performance. In San Remo I knew I was ready for the cobbled classics.'

STEFANIE AT THE FINISHING LINE

Confirmation came one week later, with a decisive win in the E3 Harelbeke. Peter Sagan, his closest pursuer, finished more than a minute behind the powerhouse from Bern. There could be no doubt that Cancellara had returned to the top. One week later came the icing on the cake, as the Swiss won the Tour of Flanders for the second time. 'From an emotional point of view it was the most important win of my career, at least prior to Rio. The fact that my wife was standing at the finish in Oudenaarde for the first time made it even more special. She knew how low I'd been, she knew what I'd achieved before. I'd made huge sacrifices to get to the highest level again, including with regard to my family. That moment after the finish was for us. She understood how important that race was for me. Three years after my first win I was finally able to win again in Flanders. I'd come out unscathed and on top for the second time.'

The Swiss recognises his wife's contribution to his success. 'I can't say whether I would have had the same career without Stefanie,' says Cancellara. 'I know my stable home life has played a major role in the development of my career. My wife and my children all played a part in my palmares. If I was preparing for a new season during the winter, it was often at the expense of time at home. I was often away for competitions or training. They accepted all that. At the same time, my family gave me a place where I could relax. My home played an important role over the years, it was the place I needed. It's not about me there, it's about the children. As far as raising the children is concerned, my point of view is clear: I chose to have children with Stefanie, so it's only logical that we share the parenting.'

Top athletes have a reputation for being selfish, but Cancellara combined his career with his duties as a husband and father. 'I steered a middle course,' he explains. 'I could be demanding but at the same time I knew I didn't want to be alone. I needed someone I could rely on. Just thinking of myself wasn't an option for me. That's not my nature.'

ONE AGAINST THE REST AGAIN

One week after the Tour of Flanders, Cancellara went on to win Paris-Roubaix, his third victory in the cobbled classic. However, preparations didn't run smoothly: he suffered two crashes, one during the

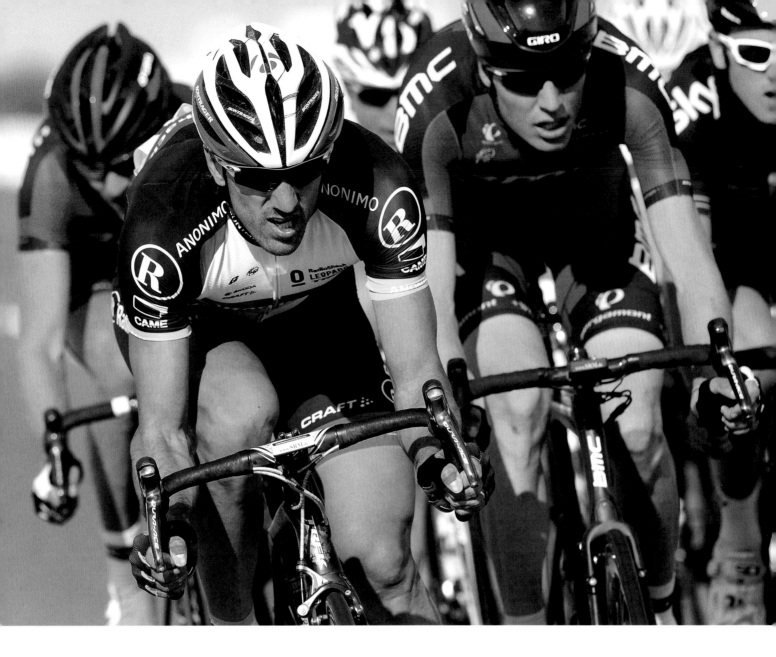

Scheldeprijs and one on a Paris-Roubaix reconnaissance ride. He dragged himself to the velodrome in Roubaix. 'For a long time I thought I didn't have a chance of winning,' the Swiss explains. 'With Tom Boonen absent it was another case of everyone against Cancellara. At one point Stijn Vandenbergh made a break with Sep Vanmarcke, among others. Everyone looked at me and I thought for a moment that my race was over. But eventually I found the strength to respond.'

Cancellara steamrolled up to the leaders in the company of Zdeněk Štybar. The Czech and his Quick-Step teammate Stijn Vandenbergh literally fell by the wayside, leaving Cancellara and Vanmarcke. 'Whereas years ago I lost my first sprint for victory on the Roubaix track because of a beginner's error, this time I could draw on my experience and use the slopes. I won, but it was a hell of a fight.'

Cancellara collapsed exhausted onto the grass in the middle of the track and lay there for several minutes recovering. 'That was partly due to physical exhaustion but mainly due to mental exhaustion. I'd been working towards that moment since October. Compared to my first "hat-trick" in 2010, it was much more difficult. After 2010, everyone rode against me, everyone against Cancellara. The fact that I'd still managed to win my three main spring races despite the adversity gave me a lot of satisfaction. I'd shown that I could still do it. I left Roubaix and returned home to Switzerland feeling immensely happy: I'd got the job done.'

LAST CONTRACT

At the end of 2013, Cancellara's contract with RadioShack-Trek came to an end. Trek was to take over sole sponsorship of the team from 2014. Negotiations on a new contract began immediately after the end of the spring classics. 'I'd already decided that this would be my last contract. The team offered me a three-year contract and I accepted it. I didn't really think about retiring at the time, not even during the negotiations. During the three years that followed, I continued to be successful. The outside world seemed unaware that I'd signed my last contract and that I was going to retire from cycling at the end of 2016. But that was indeed the case. The funny thing is that in the winter of 2015, Swiss television suddenly announced that I was going to retire at the end of the season, even though this had been decided years earlier. Old news suddenly became world news.'

Win in Paris-Roubaix: Fabian Cancellara
recovers from the emotion and effort.

86

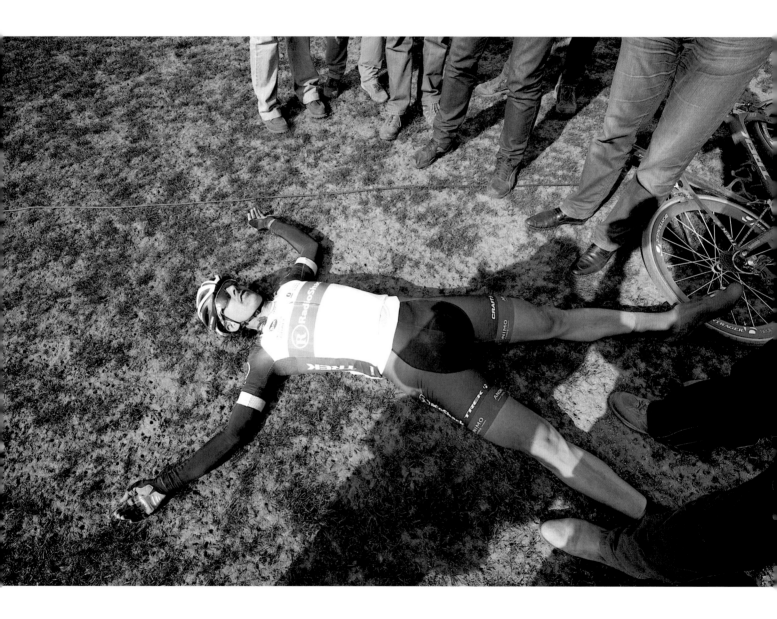

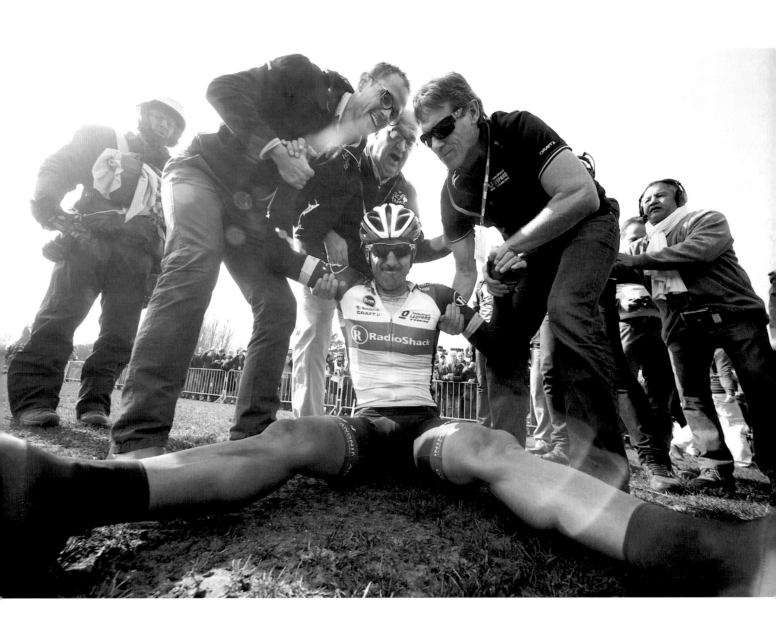

Directeur sportif Dirk Demol and press officer Tim Vanderjeugd try to help their exhausted team leader to his feet.

HIGHS AND LOWS IN 2014 AND 2015

2014 and 2015 were perfect illustrations of Fabian Cancellara's last years as a cyclist. Lofty peaks, such as victory in the Tour of Flanders in 2014, were interspersed with deep valleys. In 2015, he missed almost the entire spring because of a fall in the E3 Harelbeke, and he left the Tour in yellow following a monster crash on the stage from Antwerp to Huy.

The majority of the peloton would give their lives for a victory in the Tour of Flanders, second place in Milan-San Remo and third place in Paris-Roubaix. Over a period of three weeks in 2014, Fabian Cancellara achieved what only a handful of riders achieve in an entire career. Yet he was left with a sour taste in his mouth. '2014 wasn't exactly a *grand cru*', he says. 'Every year has a highlight, and in 2014 it was clearly my win in the Tour of Flanders, which made me the joint record holder. But it could have been better. All too often I felt like a target, for example in Paris-Roubaix, when Terpstra won. Perhaps I set the bar too high after the hugely successful 2013.'

In 2015, it became clear that things could get much worse. 'That was the year of the disastrous crashes that were nothing to do with me,' says Cancellara. 'In the E3 Harelbeke there was a crash on the cobbled descent of the Haaghoek and I went down along with numerous others. Two broken vertebrae in my lower back saw to it that my spring was over.'

CRASHING OUT IN YELLOW

And things could get even worse. A few months later, Cancellara surprised the Etixx team in the second stage of the Tour by beating Mark Cavendish in the sprint finish

and claiming enough bonus seconds to keep Tony Martin out of yellow. The next day, in the stage from Antwerp to the Mur de Huy, disaster struck again. In the middle of the descent into the Meuse valley, part of the peloton hit the asphalt at high speed. Cancellara was among the victims and was forced to abandon the race, again after suffering two fractures to the vertebrae in his lower back. 'The way to process something like that is to accept it as something that comes with the race,' says Cancellara. 'But as I grew older I noticed it became increasingly difficult to recover from a fall, both physically and mentally. When you're young, you're less concerned when you fall because you have your whole career ahead of you. But when you're in the last years of your career, you realise you don't have any more time to lose.'

Here Cancellara reveals his philosophical side. Speaking in interviews, the Swiss has often compared his career to a book, with one chapter closing and another one opening. At the end of the ride, he can look back on his career with a great deal of satisfaction. 'There wasn't a single season of my professional career when I didn't achieve a victory, and I'm proud of that. What's more, almost every victory was slightly different, whether it was a time trial, a stage in the Tour of Mallorca or a monument like the Tour of Flanders or Paris-Roubaix. Over the

years, I've always offered the fans something to remember, with my time trial victory in Rio being the last – and for me the absolute – highlight.'

THE ART OF PUTTING THINGS INTO PERSPECTIVE

He's also been able to accept most defeats, he admits. 'Take Paris-Roubaix in 2014. Niki Terpstra won, I finished third. Given the circumstances, I outperformed myself that day, and so I could live with that third place. Sometimes I lost because I made stupid decisions – think of 2011 – but just as often I brought some excitement.'

Over the years, Cancellara has become better at seeing things in relation to others. 'In my first years as a pro, I found it more difficult to put things into perspective. I wanted victories to order, and usually I got them too. Later came the crashes. I didn't fall very often, but when I did, they had an impact. You start to ride differently. The older you get, the more you think. You even race differently. Defensively, more with your head. My third victory in the Tour of Flanders, in 2014, is the best example of that. I rode in front with three Belgians – Van Avermaet, Vanmarcke and Vandenbergh – and I won because I read the race. None of them had ever won a monument and they were all desperate to

win, especially in front of their home crowd. I figured that the situation would lead them to make tactical errors, that they'd ride behind one another. And that's what happened. They all kept responding to each other while I looked on quietly, knowing that I'd won the Tour of Flanders twice. That victory is a perfect example of how I'd evolved from someone who wasted his energies too often into a rider who could keep a cool head.'

ALWAYS THE BEST...

Cancellara sees 2011 as having been a turning point. 'I left CSC and Bjarne Riis, and began to stand on my own two feet a lot more. Increasingly I was the one who decided how often I trained, which programme would be best to follow. With Bjarne everything was organised for me, but in the years afterwards I organised everything myself, not only for myself but also often for others. One thing remained the same: I always wanted the best. The best equipment, the best nutrition... That was Bjarne's legacy. He had the great advantage that he owned the team and wasn't answerable to a board of directors. My subsequent employers didn't have Bjarne's freedom. As a result, I occasionally came up against the sponsors' limits. Because of certain contracts we couldn't always get the best equipment. That isn't a reproach, just an observation. Teams used to have much more freedom in the choice of equipment or whatever. I realise I was demanding during my last few years, I often insisted on things

to make sure we got the best. Because I felt I had a right: after all, I'd achieved so many successes. At the same time I gradually became aware that I couldn't always have the best. Marketing was becoming increasingly important and sometimes even seemed to come before performance. I don't blame anyone, because that's how cycling works today, but it did sometimes sap my motivation.'

However, there was no shortage of motivation as he entered the final year of his contract. 'In winter I began training for the season just like normal. Actually, it rarely occurred to me that I was preparing for the last period of my active career. And that was fine.'

Fabian Cancellara recovers
from another supreme effort.
→

"In my first years as a pro, I found it more difficult to put things into perspective. I wanted victories to order, and usually I got them too. Later came the crashes. I didn't fall very often, but when I did, they had an impact. You start to ride differently. The older you get, the more you think."

His last yellow jersey in the Tour de France, worn during the stage from Antwerp to Huy. Fate strikes with 58 kilometres of the stage remaining: Fabian Cancellara is involved in a massive crash and has to leave the race in yellow.

→

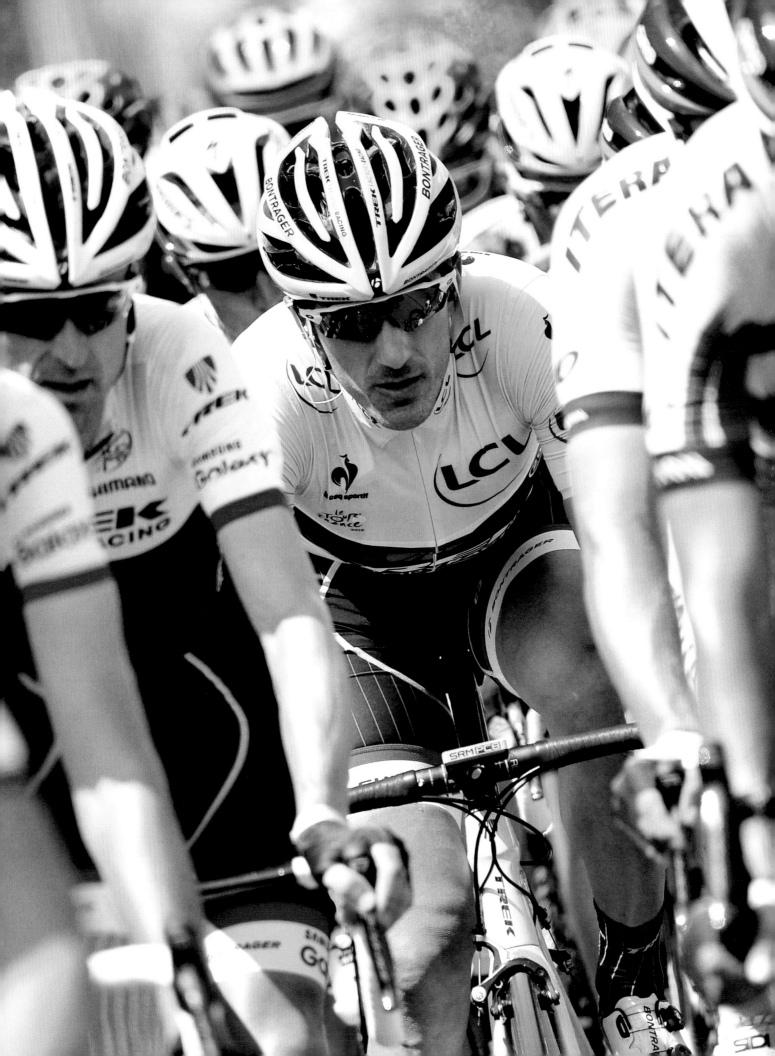

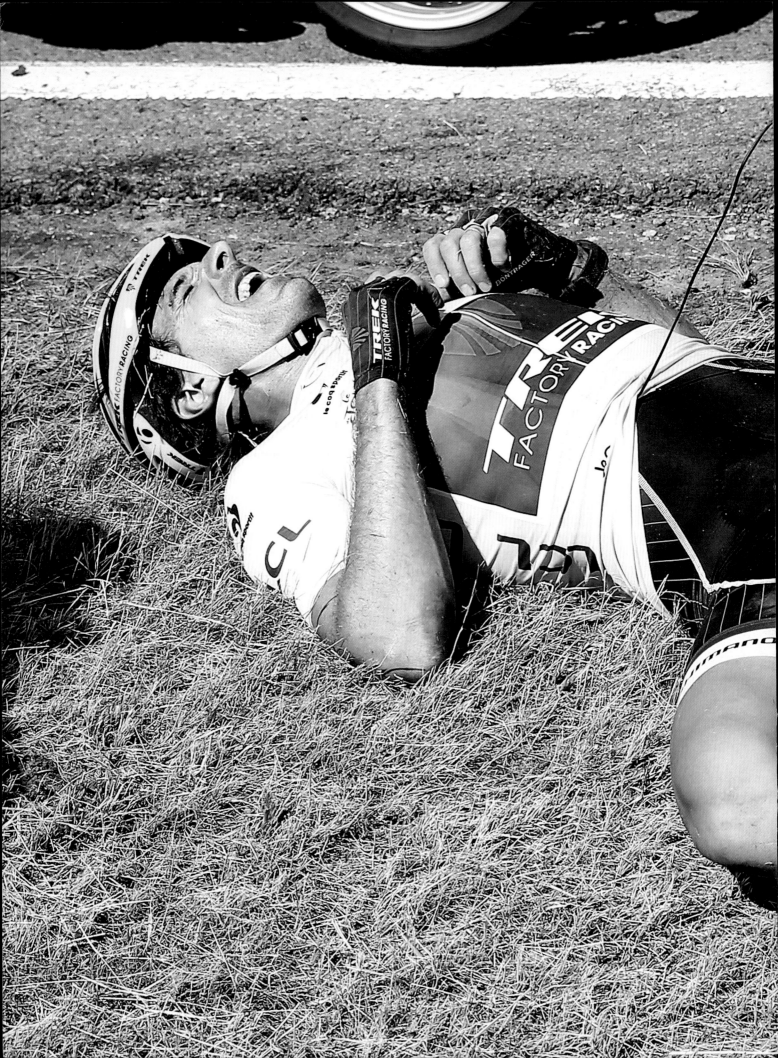

THE LAST SPRING

Unlucky in his last Paris-Roubaix, Cancellara's bike slips and he crashes, taking Dutch champion Niki Terpstra with him.

\rightarrow

On 28 January, 2016, Fabian 'Spartacus' Cancellara began his final season as a professional cyclist. After a difficult end to 2015 – the fall in the Tour, having to pull out of the Vuelta because of illness – he came back recharged and fired up for his last campaign. 'Spartacus is a warrior and a warrior always prepares himself for battle,' says the Swiss.

Where does the name Spartacus come from? 'The name dates back to my time at Fassa Bortolo,' laughs Cancellara. 'My former teammate Roberto Petito gave me that name. As far as he was concerned I was half Italian, and with my broad shoulders and style of riding he thought I looked like a gladiator. So my nickname became "Spartacus", in a way only Petito could say.'

Cancellara adopted the name. 'The only thing that didn't appeal to me about the character was the fact that he dies in the arena at the end of the story. But apart from that I could recognise myself in him. Spartacus was a leader who cared about the fate of others. I've often been like that too, looking after others first before myself. He was an example to his peers, a hero too. I was happy to compare myself to him. That name gave me something heroic.'

Yet it's only in recent years that Cancellara has grown into the Spartacus he is today. 'The name went out of fashion for a while. When I swapped Fassa Bortolo for CSC I was suddenly Tony Montana from the movie *Scarface*. In Belgium they had other nicknames: the Steamroller, the Red Hammer... But bit by bit Spartacus won the day, especially after 2010. It was also my personal

favourite because I thought it was the name that suited me best. Just like Eddy Merckx was the Cannibal, I was Spartacus.'

BRAVADO IN THE STRADE BIANCHE

It was this Spartacus who began his last 'war campaign' in January 2016 on the Spanish island of Mallorca. In top form. 'My big goal was to win the Tour of Flanders for the fourth time in order to become the sole record holder. I was still extremely motivated. With the help of an Indian summer in Switzerland the year before, I was in much better shape and had a much lower body fat percentage than in other years. I'd hardly taken a holiday. I did fun things in my training sessions – mountain biking, cyclo-cross, jogging – and my weight was on point. I didn't train with a knife to my own throat, because I wasn't afraid of the last season. I knew I didn't want to turn it into a farewell tour and that performance was paramount. The result was that I'd never been in such top form in January before. But I soon realised I wasn't the only one.'

It wasn't long before he saw the fruits of his labour, receiving the winner's bouquet in

the third stage of the Mallorca Challenge. 'It was a difficult stage and I didn't even intend to compete for the win. But suddenly I was in the right escape group and on one of the many descents I rode off alone. It was special to win so early on in the season. What's more, it was a relief. I was on schedule fitness-wise. At the same time, the competition knew I still wanted to play a leading role, even in my last season. They saw that I wanted to perform.'

Cancellara then took advantage of all his experience. He realised that being in top condition too soon could also have negative consequences, and decided to take a break after the Tour of Oman. 'Giuliana was on holiday and we went to the mountains for a few days to enjoy the snow. Afterwards I began the second stage of my preparation, winning the long individual time trial in the Tour of the Algarve. That was a long time ago too.'

The real work could begin. Due to his excellent results, the Swiss set off for Italy in early March as the favourite for the start of the Strade Bianche/Tirreno-Adriatico/Milan-San Remo triptych. He set his sights primarily on the one-day races, and immediately hit jackpot in the Strade Bianche. 'I'd won this relatively young race twice already

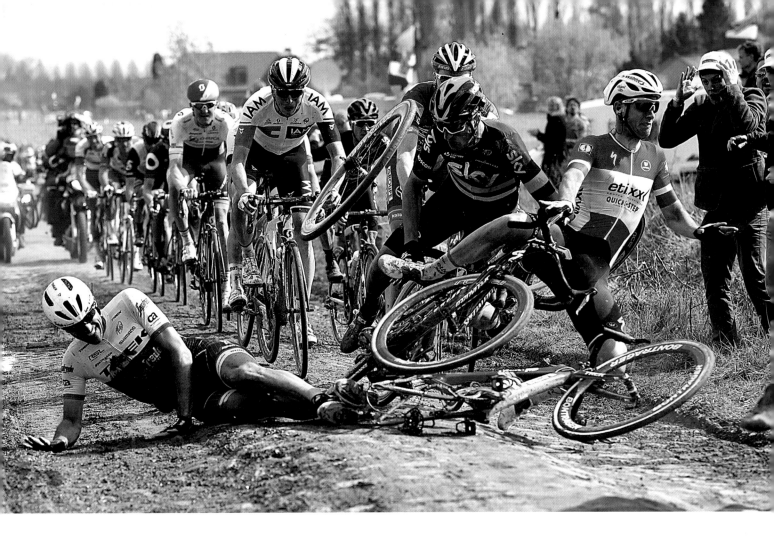

and was keen to attempt a third victory. But the route of the finish in Siena was a lot more difficult than when I won. It favoured punchers.'

Yet Cancellara won. And what a finish! The Swiss rode himself into a four-man lead group that included world champion Peter Sagan and the Etixx teammates Stybar and Gianluca Brambilla. 'Brambilla attacked before the final climb but he'd already ridden ahead that day. I let him simmer away in the knowledge that he must be tired. A few hundred metres from the finish I responded at the end of the steepest stretch. Stybar tried to cut inside me on the corner but I didn't let him past. Once I knew Stybar was behind me, it couldn't go wrong. I won the Strade Bianche for the third time and I was very happy, especially because I knew then that the new bike I was riding, my Trek Domane, was up to the job. I was ready for the most important races.'

THE REAL WORK

It's worth noting that by the beginning of March, Cancellara already had three victories to his name, and went on to win the individual time trial in the Tirreno-Adri-

atico, before he began the real monuments. Milan-San Remo was to be the first appointment. One victory in 2008 and four consecutive podium finishes had ensured that Cancellara was always put forward as a favourite for La Primavera, the first major classic race of the season. 'After Tirreno-Adriatico, I had six spring classics on the calendar and was confident I would win at least one, although which one exactly was difficult to predict. Milan-San Remo would be hard, that I knew. In recent years it had become increasingly difficult for me to leave my mark on the finale.'

Yet Cancellara was in the mix. After the descent of the Poggio, he closed the final metres on the escapee Kwiatkowski, and even in the sprint he thought he was in with a chance. 'Who knows what would have happened if Gaviria hadn't crashed at the start of the sprint. I had to brake and was just happy that I could stay upright, but I could forget about a result. That was unfortunate, but with the prospect of the Flemish classics, I was still happy with the mileage I'd ridden.'

Six days later, Spartacus began his final Flemish campaign. First up was the Record Bank E3 Harelbeke, a race Cancellara had won three times and which, after the Tour of

Flanders, was by far his favourite on Flemish soil. Unfortunately, it wasn't to be his day. 'Everything went well until, 70 kilometres from the end, I had a mechanical issue and the team car was nowhere to be seen.'

Cancellara stood in a garden at the side of the road for more than two minutes waiting for a new bike, much to the bewilderment of a pair of onlookers. 'I thought my race was over. But because I needed the kilometres, I decided to give chase. If this had happened in a different race, I would have given up, but I couldn't afford to there. My body needed it so I could test my limits. And after all, why not give it a go? I'd had a similar setback in 2011 and I still won.'

There was no chance of winning this time. Cancellara made his way back to the lead group but couldn't respond when Sagan and subsequent winner Kwiatkowski accelerated. 'I was disappointed because I didn't win, but I was glad to see that I was in top form. I still finished fourth, just ahead of my young teammate Jasper Stuyven. That made me happy.'

Cancellara realised that he was ready for the Tour of Flanders, but first it was Gent-Wevelgem. 'As I said before, I was never particularly keen on that race. I saw it primarily as a training ride. Still, after the

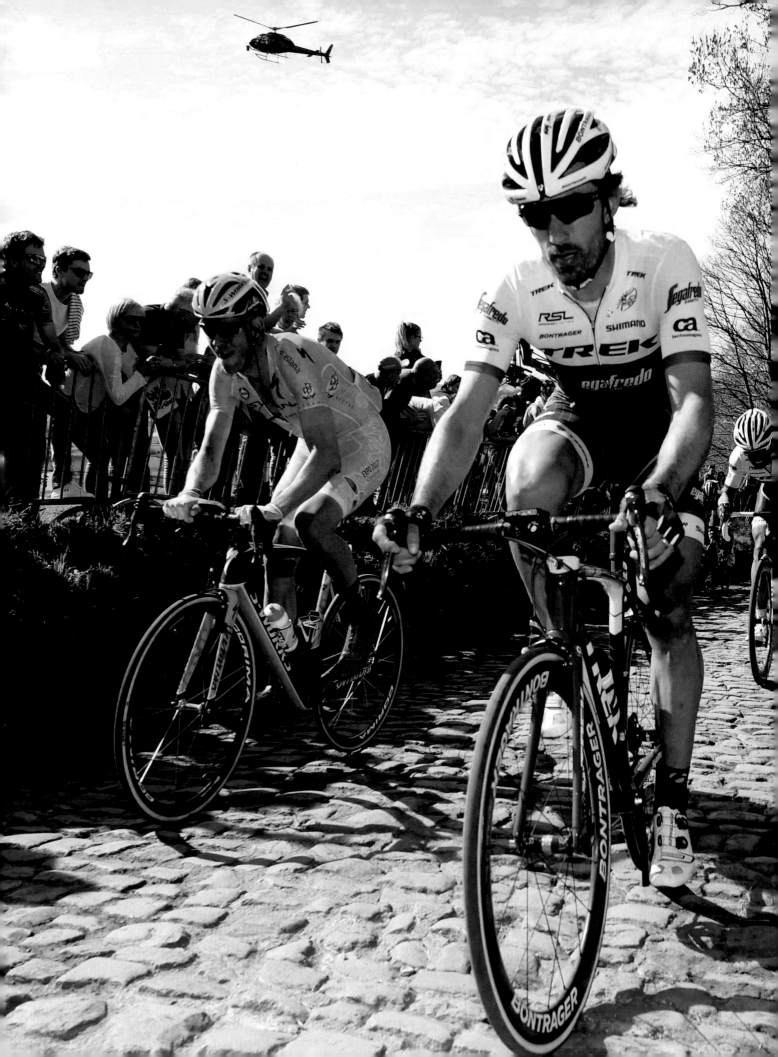

Cancellara during his last Tour of Flanders with world champion Sagan on his wheel. The Slovak surprises Cancellara with an early attack and manages to hang on until the finish.

last climb of the Kemmelberg, I managed to get in front with a very select group. Unfortunately I didn't have the right attitude. I never went into that race with the determination to win, and that cost me a good result that Sunday. Although I finished fourth, I should have done better.'

TEARS AFTER THE TOUR OF FLANDERS

Not to worry, because Sunday 3 April was the day when it would all happen. In what would be the centenary edition of the Tour of Flanders, Cancellara sought to set a new record. A fourth victory would give him a place in the history books. 'After Wevelgem, I went back to Switzerland as normal to escape from the frenzied atmosphere of Flanders. That gave me the opportunity to recharge my batteries mentally. The weather was bad in Bern so I went to Ticino to train for a few days. On the Friday I then returned to Flanders for the big event.'

That day was the first time it hit home that he was lining up at the start of a race for the last time. 'It was the first time I actively thought about my retirement. I didn't expect to feel so emotional at the presentation in the Grote Markt in Bruges. It cost me energy.'

'I can't say that's why I made a mistake in the finale and allowed the Kwiatkowski-Sagan duo to get away. If I'd responded, then someone else would have attacked. I knew I couldn't react to everything and figured that the gap wouldn't be too big and that I'd be able to rectify the situation on the Kwaremont and the Paterberg.'

However, the Sagan-Kwiatkowski duo, subsequently caught by Sep Vanmarcke and a couple of other early escapees, went too far for Cancellara. His response on the Oude Kwaremont was too late. 'Sagan was the

Fabian Cancellara at the start of his last Tour of Flanders in Bruges. A very emotionally charged moment, as he realises afterwards.

→

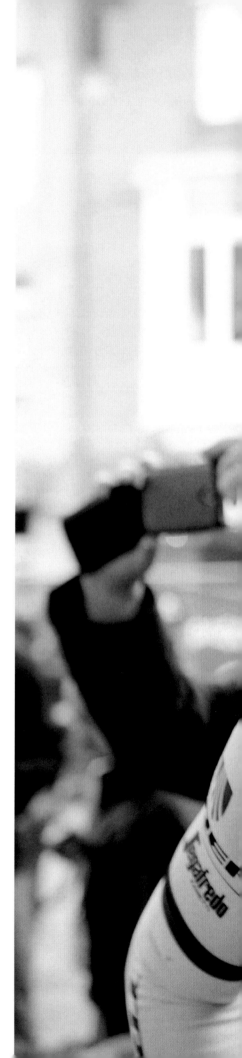

strongest that day. I swallowed up everyone; Peter was the only one I couldn't reach. Even on top of the Paterberg, with a dozen kilometres to go, I thought we'd catch him. But we failed. He really deserved to win.'

Cancellara came to terms with his second place. 'Immediately after the race, I was severely disappointed. I came to win and I didn't win. That meant I lost. But afterwards I came to realise that I'd got the best out of the situation. How many riders dream of a second place in the Tour of Flanders and never achieve their dream? So I had to be satisfied. But the farewell that the Flemish fans gave me did me a lot of good. I was celebrated as if I'd won. Afterwards we held a small party in Bruges, together with the family and some friends from Switzerland. That helped me get over it mentally. Although I won't deny that I shed a few tears that Sunday.'

THE LAST COBBLES

Cancellara had one more chance: Paris-Roubaix. Another opportunity to make history. A fourth victory would bring him level with record holders Tom Boonen and Roger De Vlaeminck. 'I realised I was starting my last spring classic, but I was indifferent, as opposed to the previous week in Bruges. There was no stress, no extra adrenaline. I was still good.'

However, the three-time winner wasn't to feature in the race this time. Held up in a crash ahead of the famous Arenberg Forest section, he ended up chasing a group that included Tom Boonen. 'In hindsight, I was perhaps too far back, but Sagan was with me and the gap was never large. I still believed I had a chance, but my crash on the crucial Mons-en-Pévèle stretch, about 40 kilometres from the finish, put the lid on it.'

The gap was at that time just a minute and everything still seemed possible for Cancellara. But his front wheel slipped. 'I don't consider that fall a personal mistake. How does something like that happen? One millimetre more to the left or right and I might have been OK. I haven't had many crashes in Paris-Roubaix, but that skid was fatal. I carried on riding, but increasingly came to realise that I wouldn't be able to return to the front. The last kilometres were difficult, very difficult. But I wanted to finish on the track in front of my fans and family. I had already accepted the defeat before I came onto the track in Roubaix and just wanted to enjoy my last half lap in front of family and friends. Then there was that stupid fall when I stopped to take a Swiss flag. Oh well, I could laugh about it afterwards, it did look funny.'

His departure from the track hit him hard. Never again would cyclist Fabian Cancellara ride a spring classic. 'That realisation made me emotional,' he confesses. 'The cycling track was like an arena, Spartacus' arena, and I had to say goodbye to it. I realised only too well that at that moment I was drawing a line under something that had influenced my life tremendously and given it direction. I was closing a chapter and that made me sad. I didn't know then that I would write another amazing chapter in Rio.'

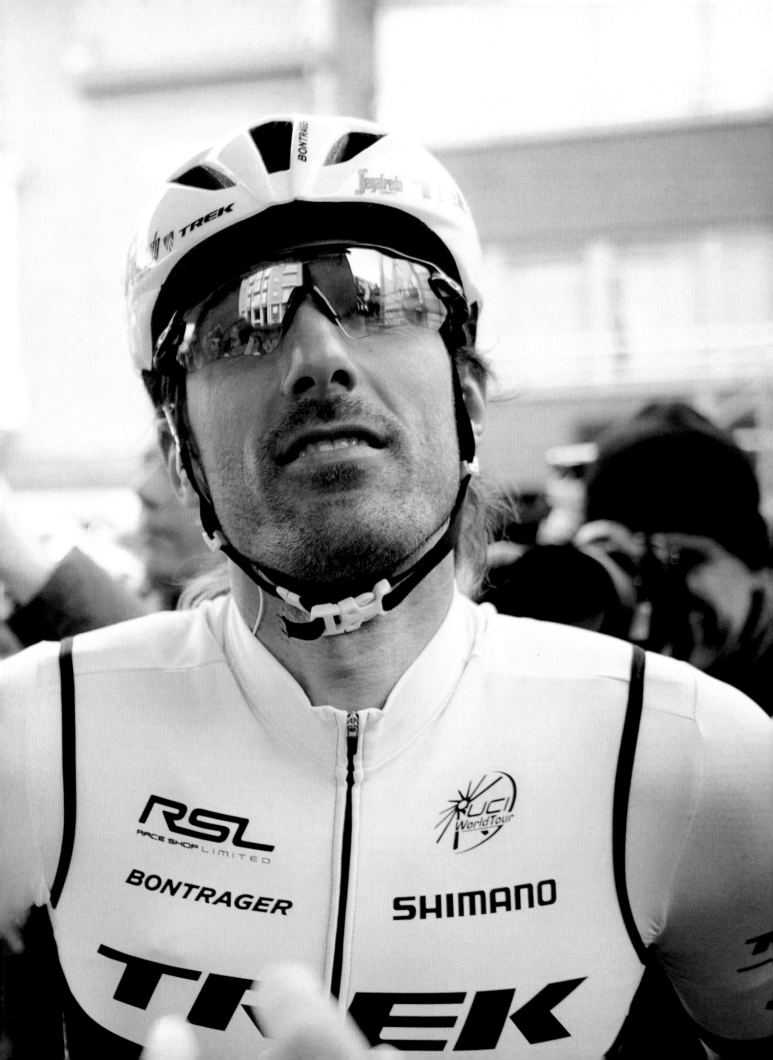

20 GOLDEN FAREWELL IN RIO

Is it possible to imagine a better farewell from cycling than Fabian Cancellara's swansong on 10 August, 2016? In his last major race, the Swiss crowned his career with a victory in the Olympic time trial. At the age of 35, Fabian Cancellara managed to do what few had thought possible – one of his strongest performances ever, he says afterwards.

Cancellara's Olympic gold in Rio came as a surprise. His last world time trial title dated from 2010, and since then the Swiss had stopped focusing on the discipline. What's more, the course in Rio de Janeiro was rock hard and more suited to specialists and climbers such as Froome and Dumoulin. Cancellara himself had doubts.

The Swiss held off announcing whether or not he would be travelling to Rio for his fourth Olympics until the end of June. 'I was told by all sides that the course would be too difficult for me,' the Swiss begins. 'But I really wanted to go to Rio. I asked myself whether I was doing the right thing, but I couldn't afford to say goodbye with an anonymous race. And the more information I gathered, the more I realised that the time trial was within my capabilities. I'd have to be in tip-top condition and everything would have to be perfect right down to the last detail if I wanted to be in with a chance. But I felt the urge to be part of one more big event. I was looking for a final challenge and that was Rio.'

Yet the outside world had the impression that he was undecided about whether or not to go. 'That wasn't entirely true,' refutes Cancellara. 'Actually, I decided pretty quickly that I would go, but I didn't communicate the decision because there was still so much that could happen. If I won the Tour of Flanders or Paris-Roubaix, I would have put an end to my career immediately. In retrospect, I'm glad I didn't win either of those monuments.'

ANONYMOUS TOUR

But the doubts didn't disappear completely. 'Even during the Tour I was unsure about my participation. If my body didn't send me positive signals during the Tour, would it make sense to travel to Rio? I was looking for confirmation from my body, but at the same time I tried to think about Rio as little as possible during the Tour, because I had work to do in the service of leader Bauke Mollema. And then there was the finish in Bern and everything that came with it.'

All in all, Cancellara had an anonymous Tour, only sprinting for victory in Bern. 'I never had the feeling that I was ready for Rio,' he says. 'In the first week I warmed up, in the second week I felt good and in Bern I took everything I could get. The welcome in my hometown cost me a lot of emotional energy. Maybe I was expecting too much from that stage.'

The Swiss went on to ride one more stage after the finish in Bern before leaving the Tour. 'I wrestled with that too. Would it be better to carry on to Paris? It was, after all, my last Tour. But I felt that my body needed rest. If I wanted to fit in a training camp in the run-up to Rio, I couldn't afford to continue to Paris.'

Cancellara did what he had to do: he left the Tour, rested for a few days and gradually resumed training. After the Tour he received a visit from his team manager and Swiss national coach Luca Guercilena. 'The first days after I pulled out were bizarre: I was listless, slept from eleven o'clock at night to eleven o'clock in the morning for three days in a row and couldn't produce any tension in my muscles. That's why I decided in the end to get back on my bike. I went cycling for an hour in the morning before breakfast in the hope of losing a little weight. And then Luca came. We did a training session behind the motorbike. Near my house we worked out a course that was similar to the time trial course in Rio, with similar hills. Luca got me to cycle up them as quickly as possible. That hurt, but it taught me that I'd recovered well from the Tour. Luca was stunned by the results I achieved, and I was too to be honest. I felt like there was tension in my muscles again, I could put pressure on the pedals.'

TRICKY BUT DOABLE

On Monday 1 August, Cancellara flew from Zurich to Rio. The road race was scheduled for the following Saturday, the time trial for Wednesday 10 August. He was obliged to compete in the road race event in order to be allowed to compete in the time trial. 'I went to Brazil with the feeling I'd done everything I could and should do. I was relaxed. My body sent positive signals and I was full of confidence. I boarded the plane with the ambition to win a medal. Gold, silver or bronze, I didn't mind which colour. Gold would be difficult, I realised that, but my competitors had their own problems too. Tony Martin

was struggling with his knee, Tom Dumoulin had fractured his wrist in the Tour and Chris Froome had ridden flat out until Paris. And anyone who won the Tour would get some sort of decompression afterwards, I guessed. But there were still many other opponents: the Spaniards, the unpredictable Taylor Phinney...'

Once in Rio, Cancellara familiarised himself with the dreaded course along Brazil's magnificent coastline. 'Frankly, I thought it was going to be worse,' he says. 'Of course it was difficult, but I thought it was doable. Until the next day, my second day in Rio, when I began a longer training session. I rode up the Vista Chinesa for the first time and stopped at the top. Rarely have I felt so bad on a bike. If I could, I would have flown straight home. It couldn't be jetlag, because I'd adjusted my body clock beforehand. Back in Switzerland, I'd started going to bed and getting up later, and training later too. I didn't think that could be the reason. Fortunately, Luca insisted that I went round again, and the second climb was a lot smoother. My body had adapted in that short space of time; the effort made sure it woke up.'

Suddenly his confidence hit the roof. Regular mechanic Roger went to work on the time trial bike one last time. 'My result in the road race wasn't anything to write home about, but I was very pleased with my performance all the same. Working for Sébastien Reichenbach, I led the peloton to the foot of the last climb. After that I'd exhausted all my energy, but I knew how good I was.'

There were three full days between the road race and the time trial. Days to recover, but also to think. The night before the time trial Cancellara had a panic attack. 'I was alone in my room and suddenly I saw ten Fabians around me. They started asking me questions: "Have you really done enough preparation?", "Are you ready for your last big race?", "Will you be able to handle it emotionally?" My alter ego wasn't ready apparently; I started to worry.'

Fortunately for Cancellara, the Swiss Olympic Committee had provided for athletes in psychological distress. The travelling sports psychologist was summoned to save him from his demons. 'We talked together for half an hour and I told him about my fears: it was my last race, I wanted to make history, I wanted to win a medal. It was as if my body was blocked under all those thoughts. The proposed remedy was simple: I was to focus on the race and nothing else, on the 54 kilometres I had to put behind me. I wasn't allowed to think about my opponents, medals, or anything else. With that advice in the back of my mind, I set off for

the trial the following morning. I concentrated on my race, I knew it would hurt, but I also knew that it wouldn't be as painful as my last training sessions in Switzerland. In Rio I had to stay below my maximum heart rate during the climbs.'

NAIL BITING IN THE HOT SEAT

The Olympic champion from Beijing started in the second wave, but not in the very last group of top favourites. Cancellara had Rohan Dennis ahead of him, the Australian widely expected to spring a surprise. 'In the first of the two laps, I received little or no information. At the first checkpoint, I was just slightly faster than Dennis, but didn't know how I stood with regard to Froome and Dumoulin. Tactically, the plan was to ride the first lap at less than one hundred per cent. I had to keep strength and energy for the second lap. At the start of the second lap, I went up a gear and squeezed every last drop of energy out of my body. And it worked! There are no words to describe what it's like competing for an Olympic medal. Some guys get overwhelmed by the situation, others just perform better. Presumably I belong to the second category.'

Cancellara finished the course over a minute ahead of Rohan Dennis, who suffered a mechanical failure. The Swiss took the compulsory place in the hot seat, a beach chair reserved for the rider with the fastest time. And then the nail biting began. 'I was still convinced that someone else would record a faster time. I kept one eye on the clock as I got changed. One by one the favourites came unstuck. I could hardly believe it when I won, and everyone was super happy. That gold medal was a complete shock to me too. I had hoped for a medal, but I hadn't expected gold.'

HAPPY AS A CHILD

The Swiss was beside himself with joy. Everyone who came near him got a bear hug. 'There's nothing like an Olympic medal. I've achieved a lot of great victories in my career, but Rio 2016 will always be the best. Olympic gold is better than anything else. Cycling history is written in races like the Tour of Flanders and Paris-Roubaix, but sporting history is written at the Olympic Games.'

During the podium ceremony, an intensely happy Cancellara literally jumped onto the highest step. 'That jump hid many emotions. I was as happy as a little kid. I stepped down from the world stage of elite sport with the finest possible performance. It seemed like a fairy tale. Up until Rio, I was

mainly known as the classics man, the man with the Tom Boonen rivalry. Now I'll always be remembered as the man who retired with an Olympic gold medal. My ultimate dream – go out on a high – was fulfilled. I realised I'd ridden my last big race but I was too happy to mind.'

What followed was a rollercoaster of emotions. Cancellara was led from one interview or celebration to another. 'There were tears, I'm not going to deny it. But it wasn't just me. Even some journalists shed a tear. One interviewer from Swiss television said he didn't know what to ask me and instead just thanked me for my performance, my career, for everything I'd meant to Swiss sport. I was speechless; neither of us said another word. Suddenly it dawned on me: my career was over...'

When asked which gold medal is his favourite, the one he won in Beijing or the one he won in Rio, Cancellara's response is as follows: 'When I won my first gold medal, in 2008, it was during my best years as a time trialist. And the podium ceremony in Beijing was also much better than in Brazil. But Rio was so unexpected. At the end of the day there's no question: Rio is above everything else. Above Beijing and above the Flanders-Roubaix double.'

WEDDING ANNIVERSARY

Not long after his last race, Cancellara flew back to Switzerland because he had a wedding anniversary to celebrate. The short period between his golden race and the return flight was intense. 'Of course there were the official duties – a visit to the House of Switzerland, radio and television interviews in the three national languages – but the most intense moment came when I was back in my room. Suddenly I was alone. Both my phone mailboxes were full, I was bombarded with messages of congratulations. I got in touch with family and friends, tried to gauge how my victory was going down in Switzerland. Silvan Dillier came into the room and asked if I was sad that I had to return home so soon, but I couldn't stay another day in Rio. My wife and two children were waiting at home. Stefanie and I had been married for ten years and that had to be celebrated.'

The reception in Switzerland was overwhelming. 'I slept for nearly the whole flight, they woke me up half an hour before we were due to land. A lot went through my head during that last half hour on the plane and I had another mental wobble. What was in store for me? Luckily my immediate family were brought straight to the plane, so I could

"I went to Brazil with the feeling I'd done everything I could and should do. I was relaxed. My body sent positive signals and I was full of confidence. I boarded the plane with the ambition to win a medal. Gold, silver or bronze, I didn't mind which colour."

see them all there. There were tears, lots of emotions. Those five minutes with just my family meant a lot to me. The airport itself was mad. Photos, more interviews, all those people who had come for me... Of course I was happy to do it, but I was also happy when I could finally go home. Stefanie had arranged for a helicopter to fly us home as an anniversary present. We walked the last few hundred metres and then suddenly I had another lightbulb moment: my wife, the kids, the cat and me... at last I would find peace. Or so I thought. The lift door to our apartment opened and instead of the expected peace and quiet there were thirty people in our living room. Even Luca and *soigneur* Sabine, who had made their excuses in Zurich and sped to Bern to be here. For a moment I cursed them, but when I saw the fridge full of Belgian beer, I quickly changed my mind [laughs]. I didn't get to bed until three o'clock that night.'

For the first few days after his home-coming, life was a whirlwind for Cancellara. Wherever he showed his face, an audience gathered. 'Everywhere I went, people wanted to shake my hand. I was congratulated on my sporting performance, but mainly on managing to finish my career in such a fantastic way. People were also impressed that I'd returned home to my family so quickly. But everything has a downside: I hardly had time or space for myself or my family. That's why I also declined the offer to return to Rio for the closing ceremony. That would have meant travelling for another four days. It had been good, but my career was over now. The last battle of Spartacus was fought.'

Achieving the impossible: Fabian Cancellara wins his second Olympic gold in Rio de Janeiro, after a victory in the time trial.

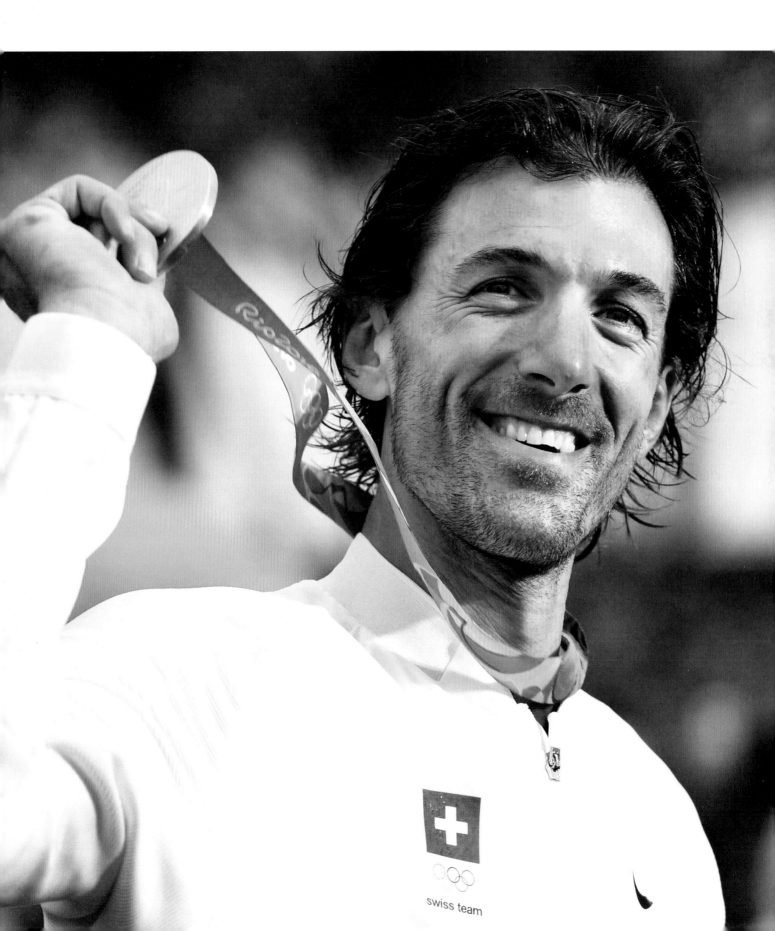

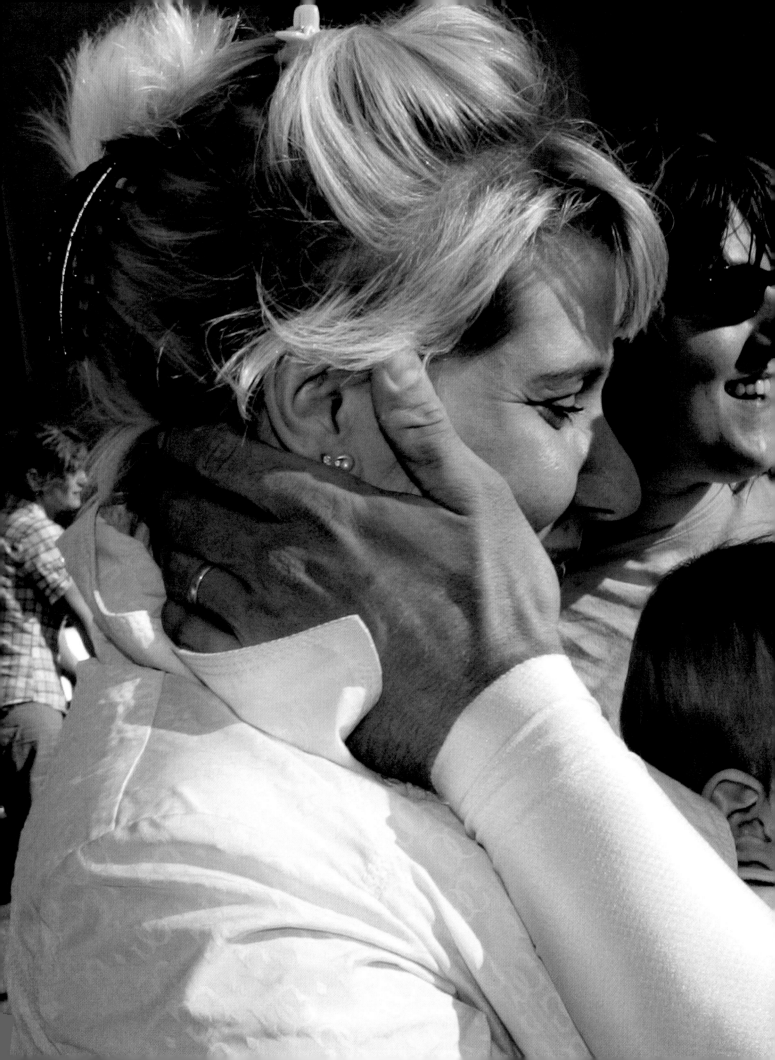

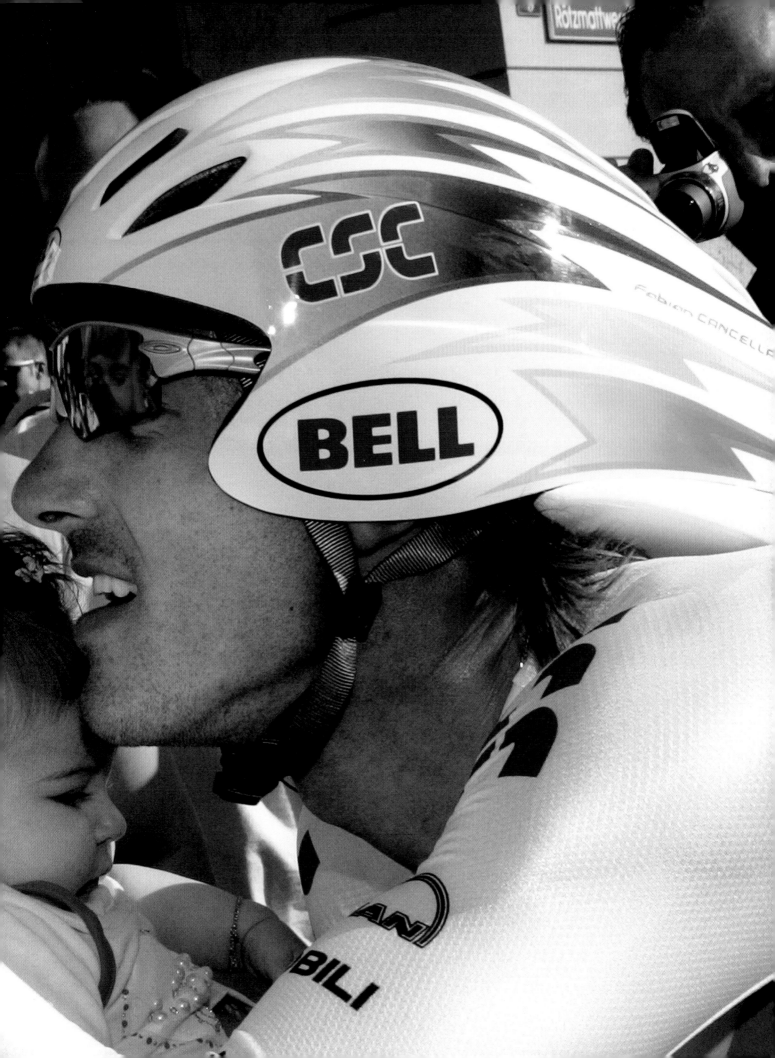

"Spartacus? My former teammate Roberto Petito gave me that name. As far as he was concerned I was half Italian, and with my broad shoulders and style of riding he thought I looked like a gladiator."

Complete concentration before the start of a race.
←

Spartacus grew into a cult figure over the years.
→

The elements have little effect on motivation.

Cancellara and Boonen side by side in full throttle
during the Tour of Qatar. The two riders have locked
horns throughout their careers, always with mutual
respect.

"There wasn't a single season of my professional career when I didn't achieve a victory, and I'm proud of that. Over the years, I've always offered the fans something to remember, with my time trial victory in Rio being the last – and for me the absolute – highlight."

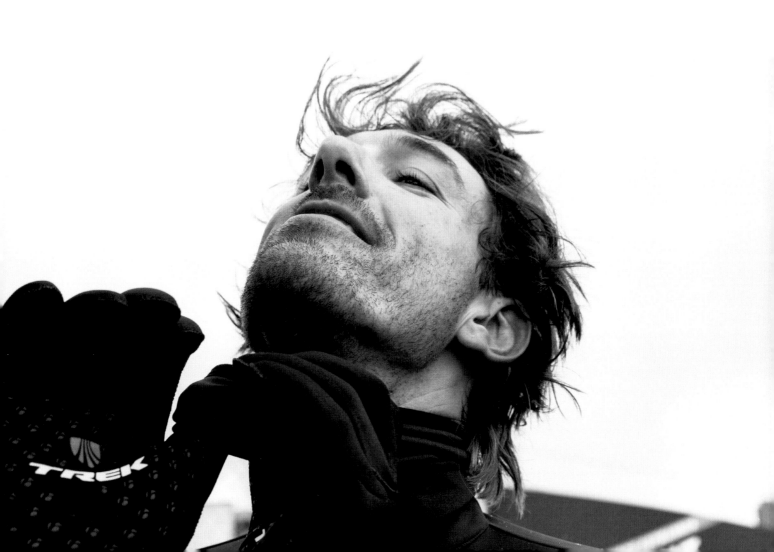

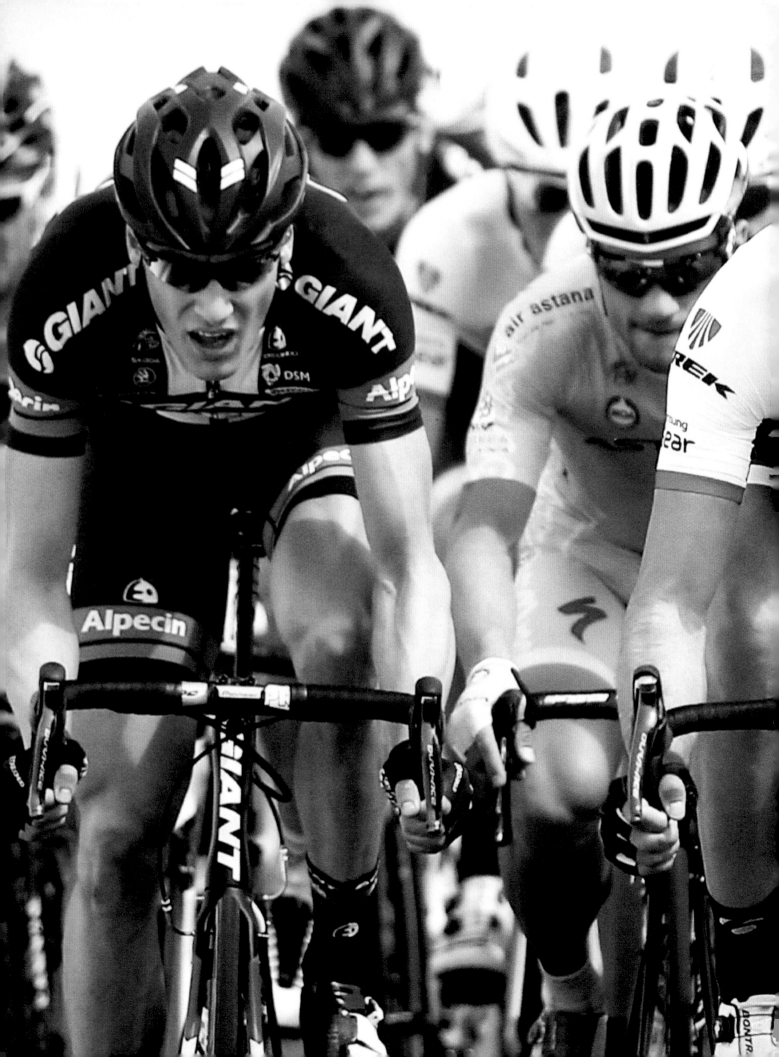

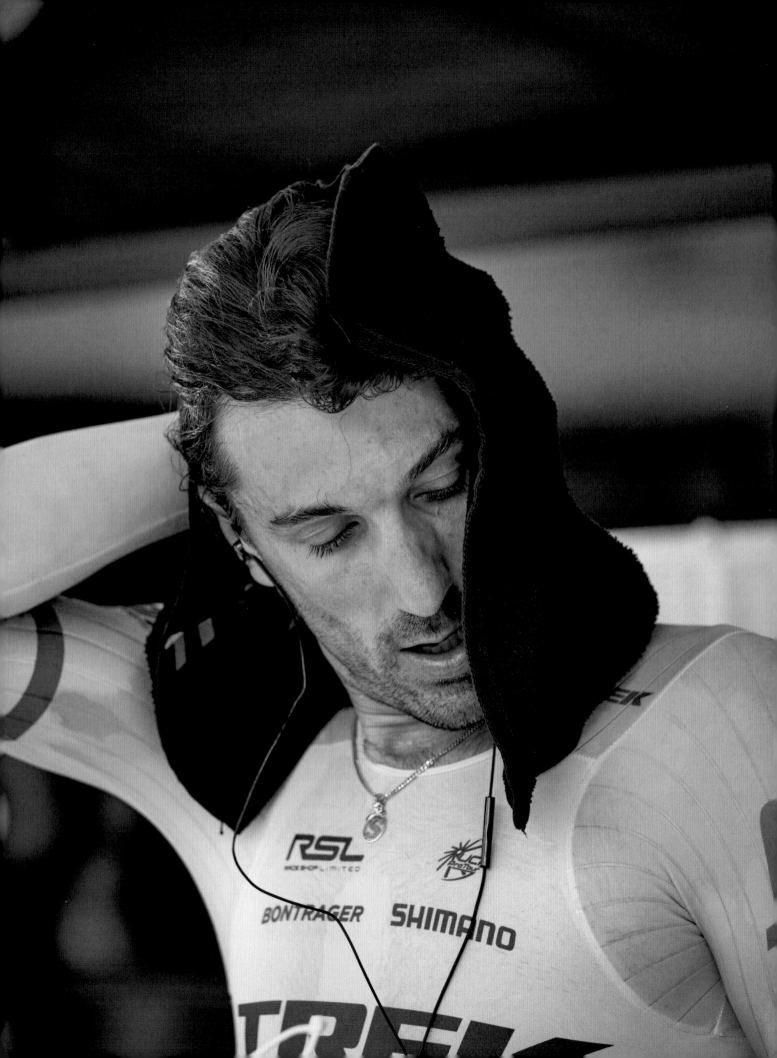

Cancellara after his fall in the E3 Harelbeke.

Three shots of Cancellara, three different pictures: training hard, recuperating and lost in thought.

←
→

"There will always be guys who choose the wrong path. But cycling in the year 2016 has come a long way, even for those who want to win a grand tour: more specific training, better nutrition, optimal support. Even a simple measure like cycling on rollers at the end of a stage promotes recovery. If the classification riders had known that before, they might have been less quick to reach for the drugs."

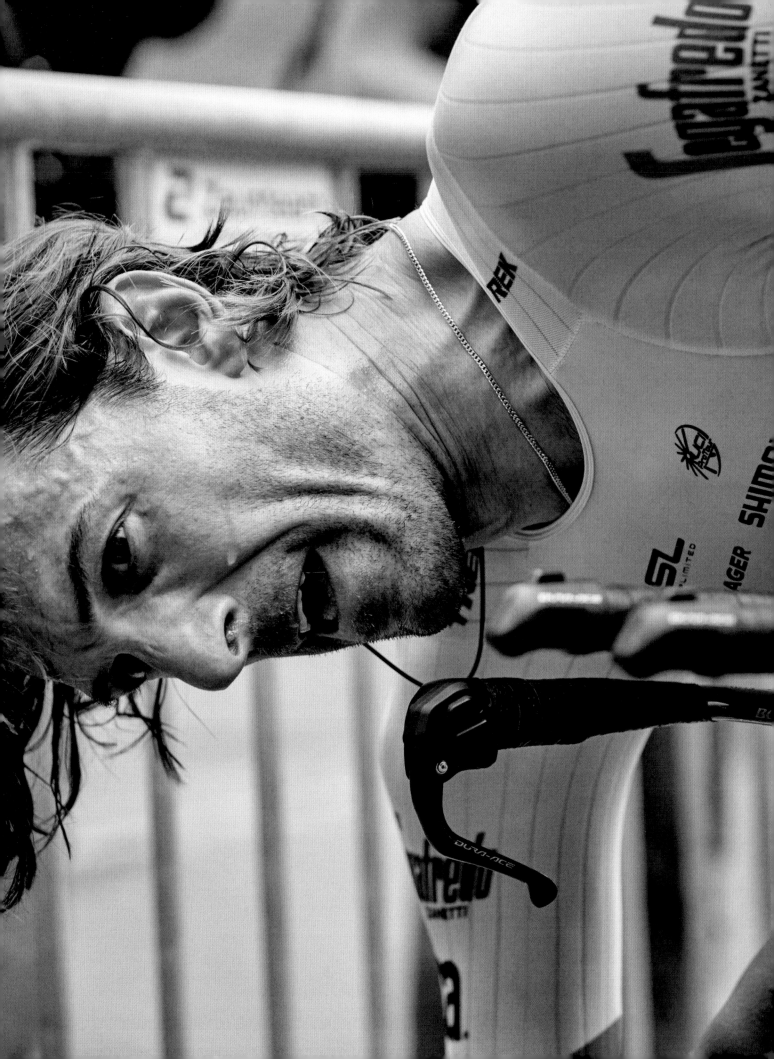

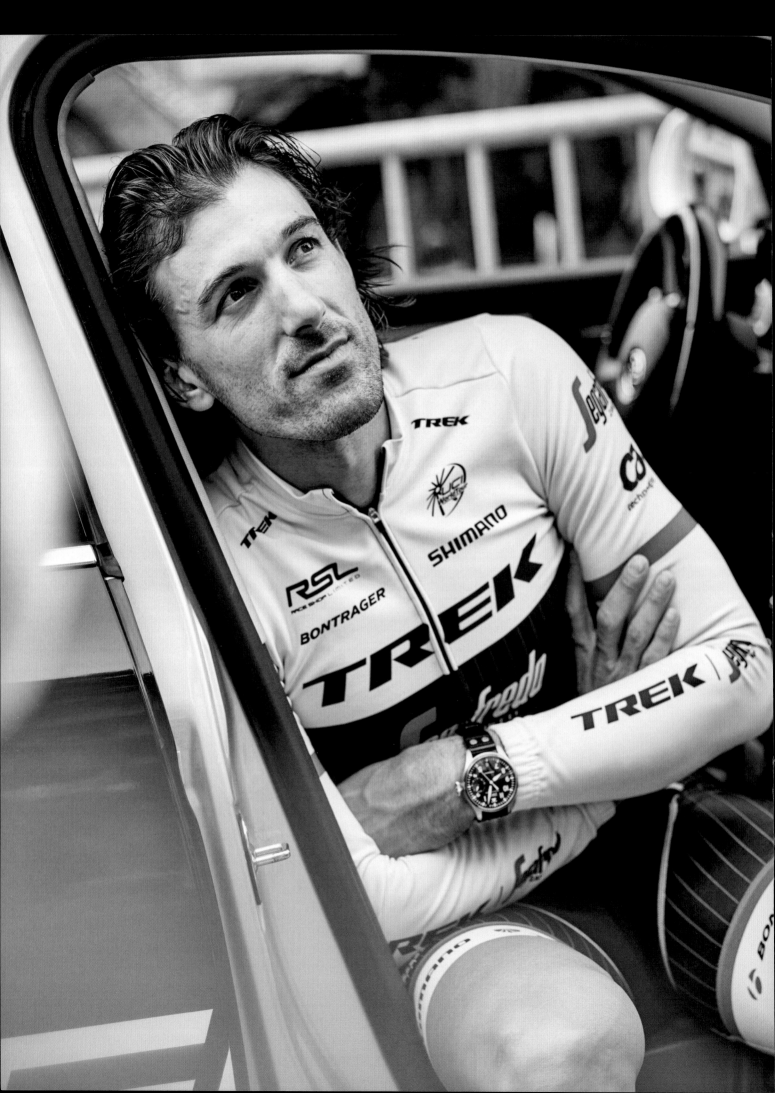

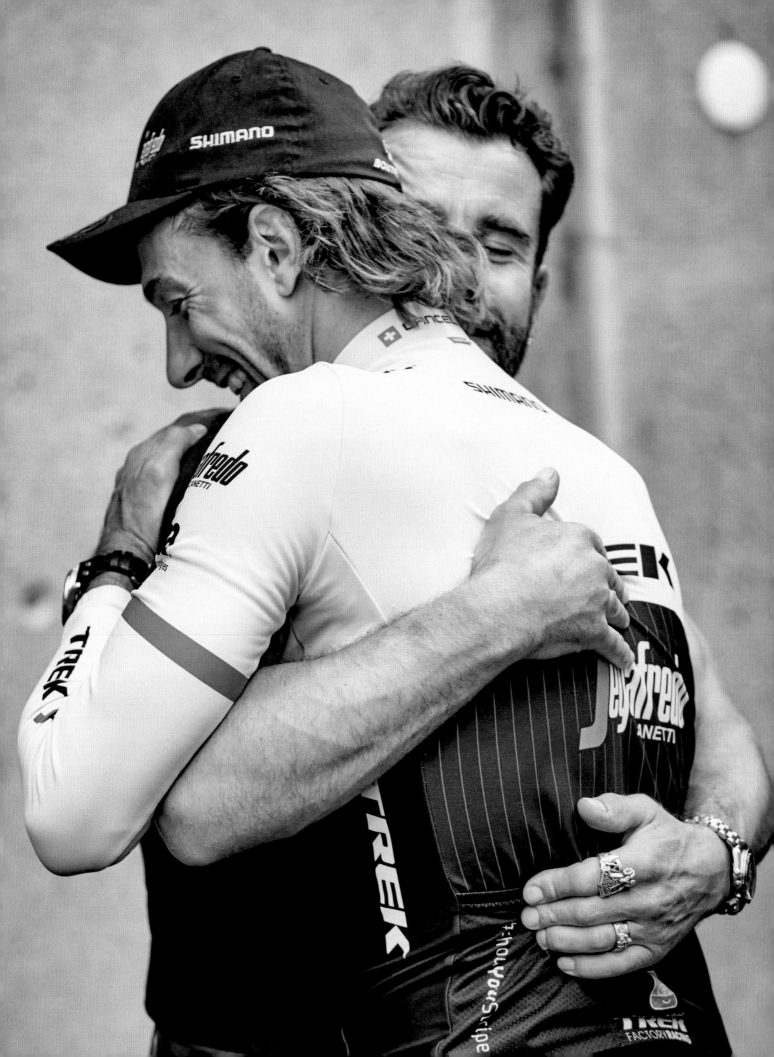

"I realise I was demanding
during my last few years,
I often insisted on things to
make sure we got the best.
Because I felt I had a right:
after all, I'd achieved so
many successes."

Cancellara after another strenuous effort: if
things go to plan, the joy is shared, as here
with mechanic Roger.
←

Total concentration on the team bus: in order
to ensure he's completely focused, Cancellara
shuts himself off from the outside world.
→

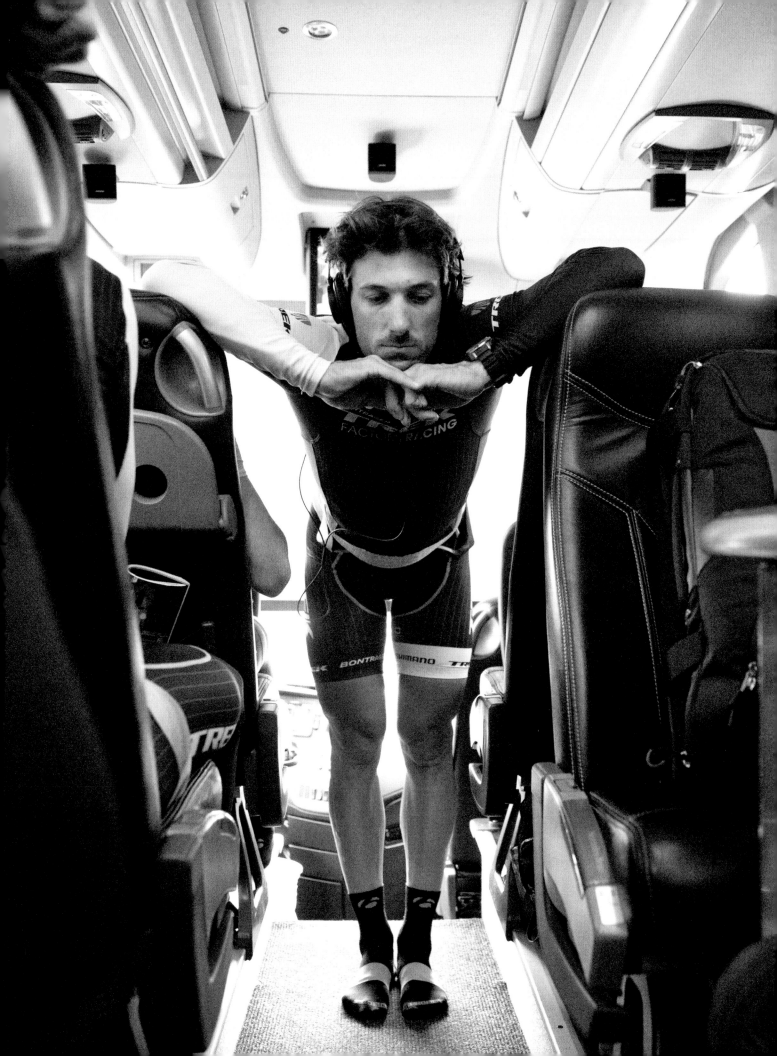

Cancellara looks out at the spectators from behind the tinted windows at the start of a race in Flanders. His relationship with the Belgian fans has always been very affectionate.

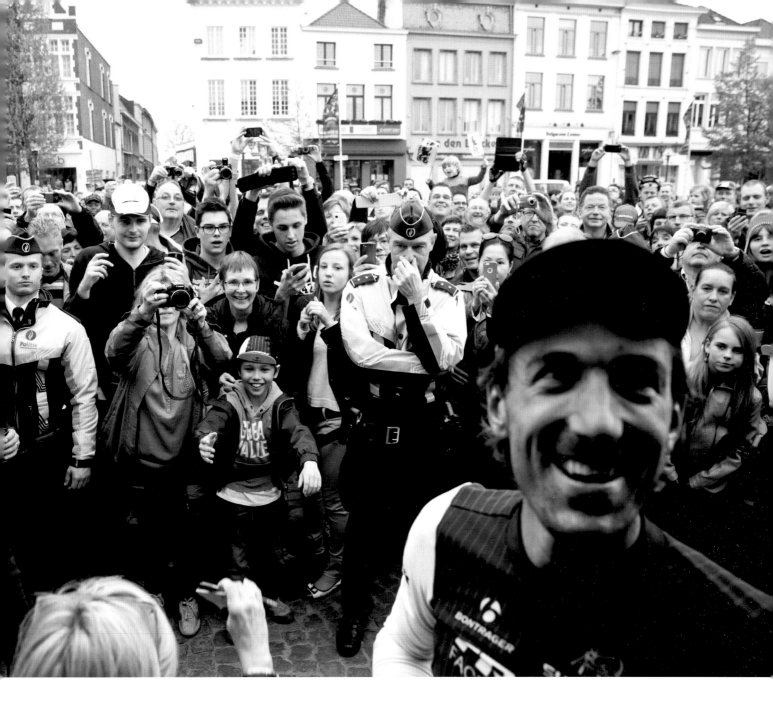

A selfie with crowds of supporters in the background.

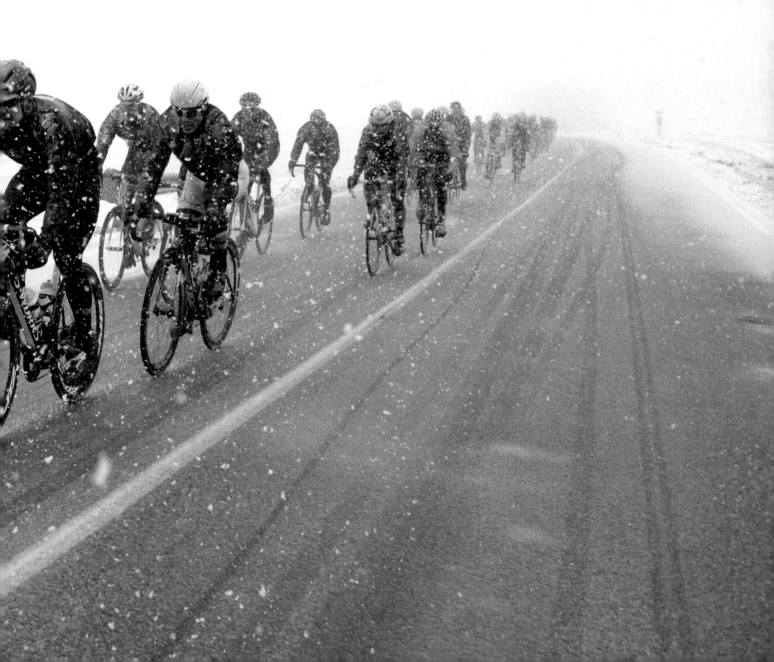

Anyone who wants to make it as a rider must occasionally be willing to brave the elements, snow and cold temperatures included.

An exhausted Cancellara after
yet another time trial.

→

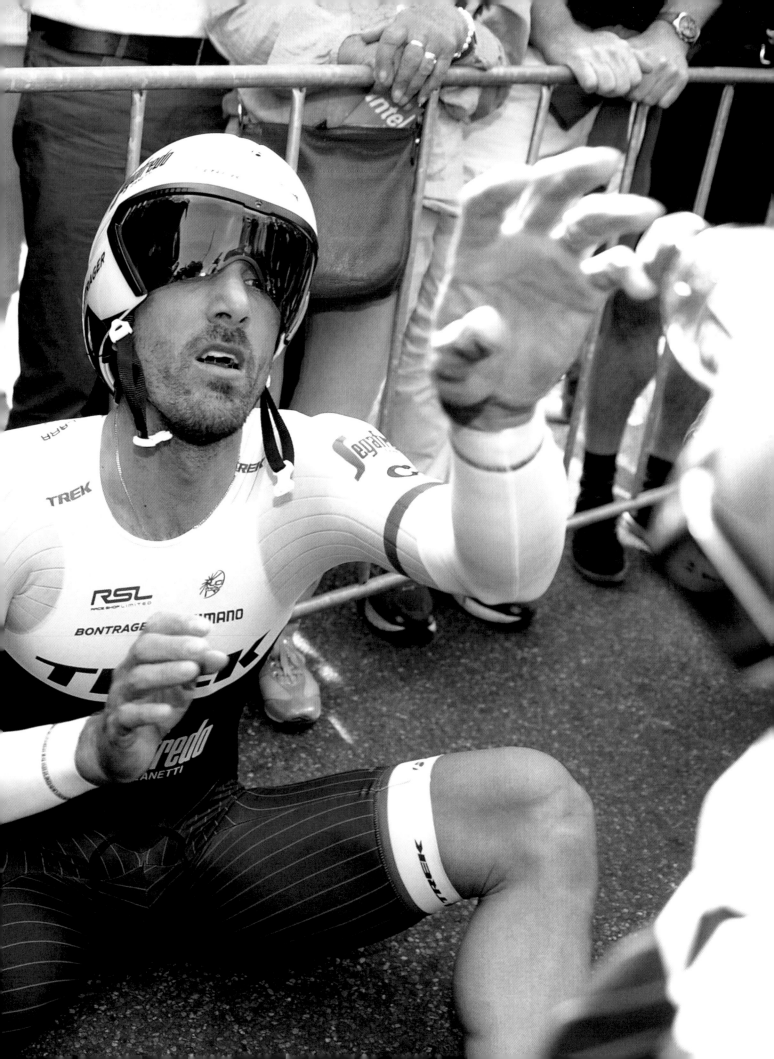

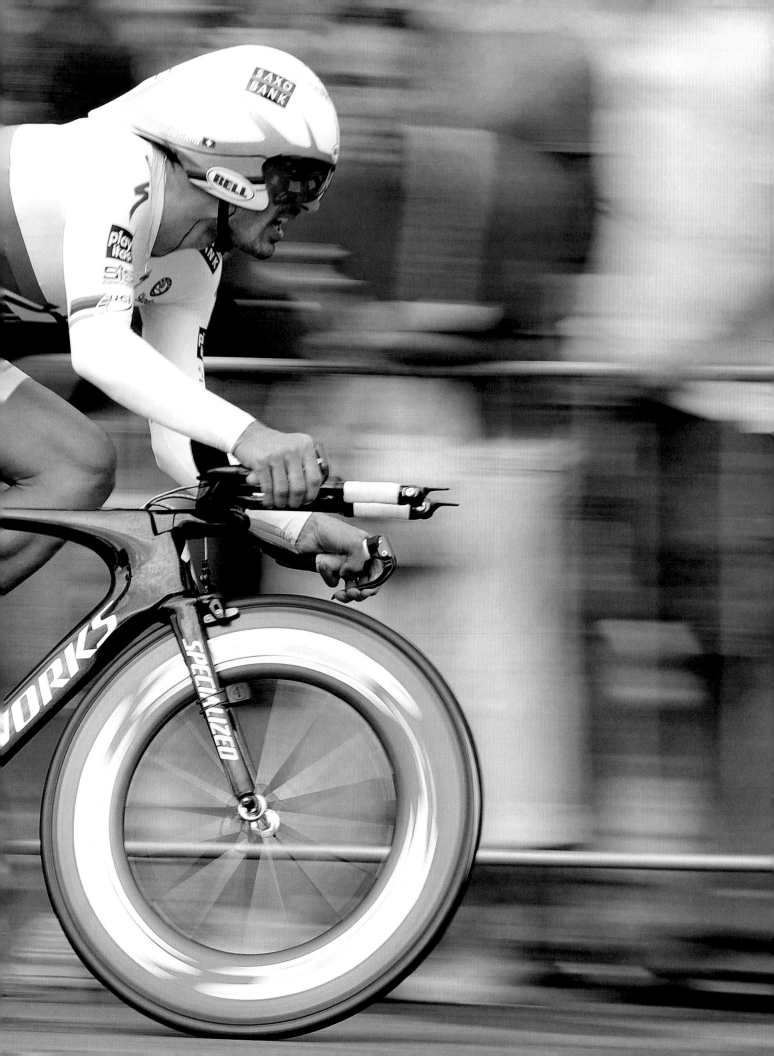

"At the end of the day I didn't care how much I beat him by. Winning was the main thing for me. I had fulfilled my Olympic dream."

In action as World Time Trial champion.
←

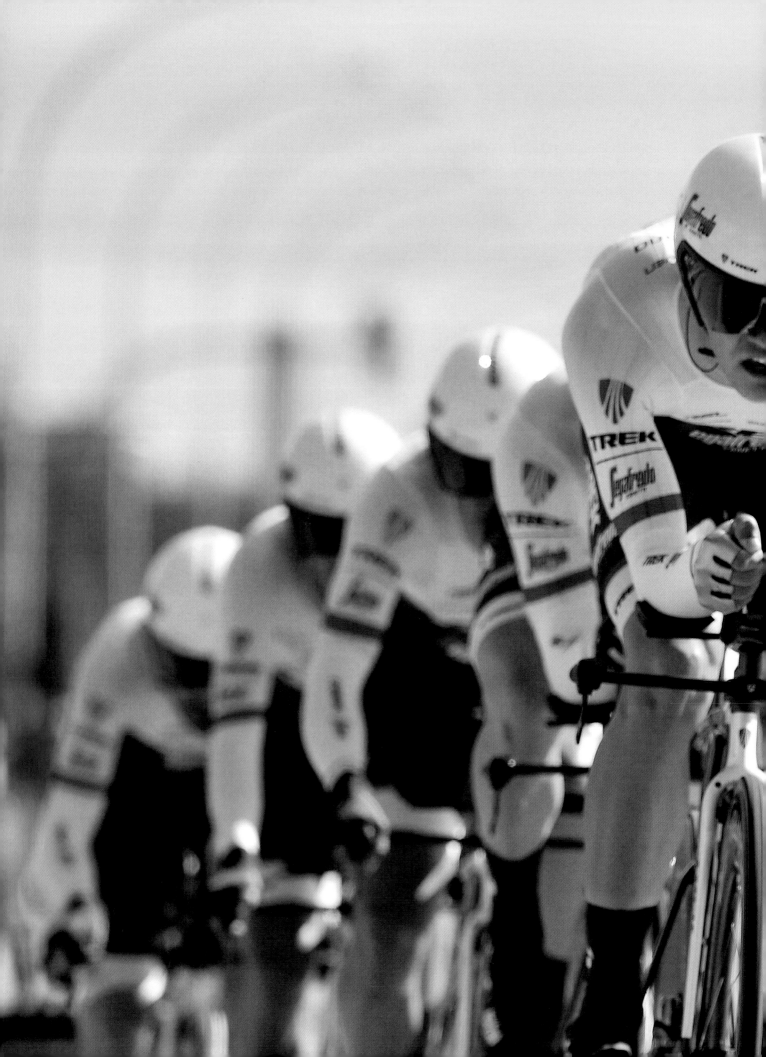

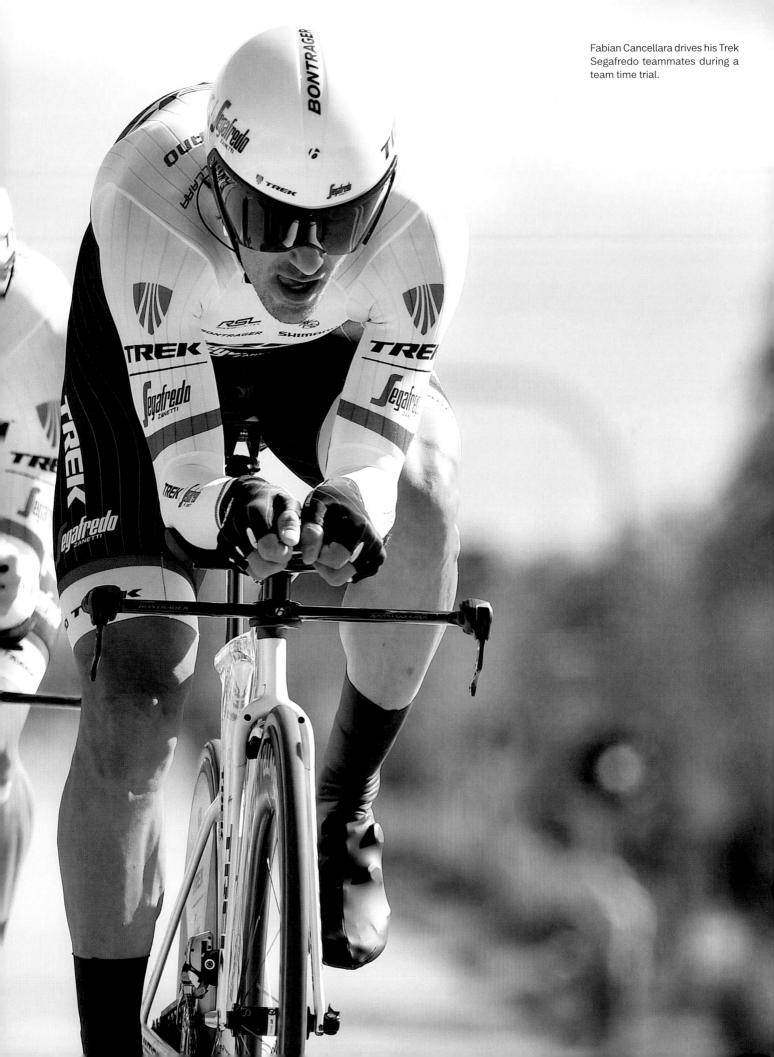

Fabian Cancellara drives his Trek Segafredo teammates during a team time trial.

Fabian Cancellara wore the Tour de France yellow jersey for a total of 29 days.

"I won the Strade Bianche for the third time and I was very happy, especially because I knew then that the new bike I was riding, my Trek Domane, was up to the job. I was ready for the most important races."

Cancellara leads the peloton in the Tour of Switzerland.

Cancellara wins the Strade Bianche in 2016.
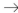

Chatting with teammate and fellow Swiss Gregory Rast.

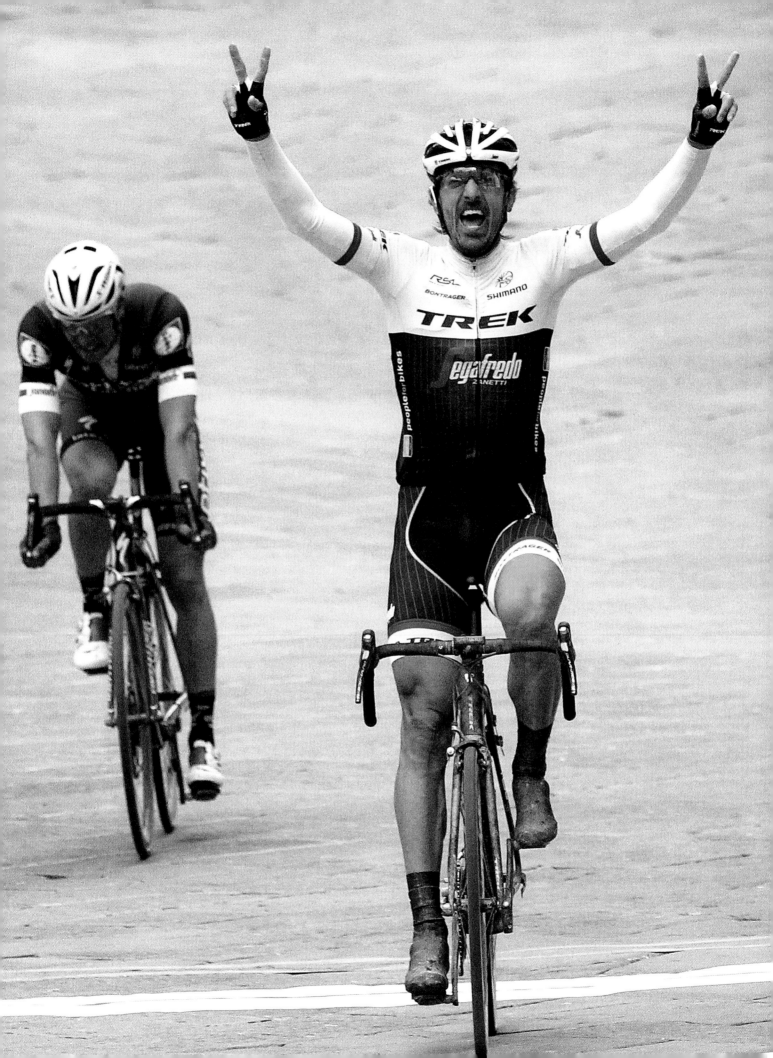

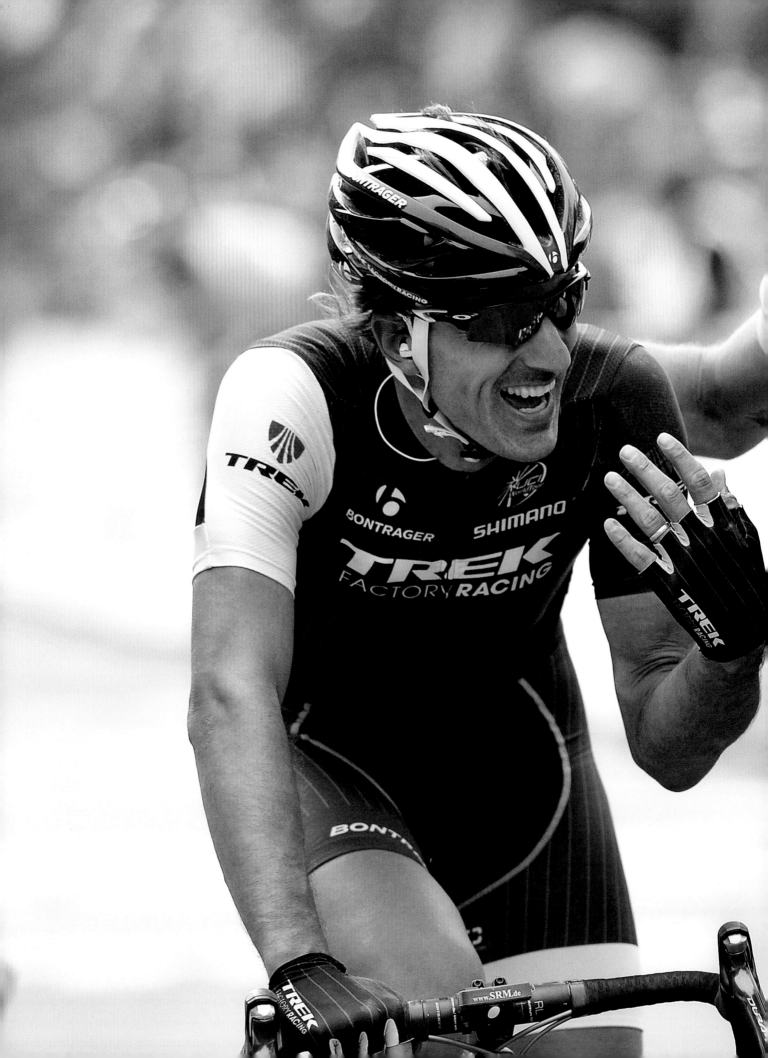

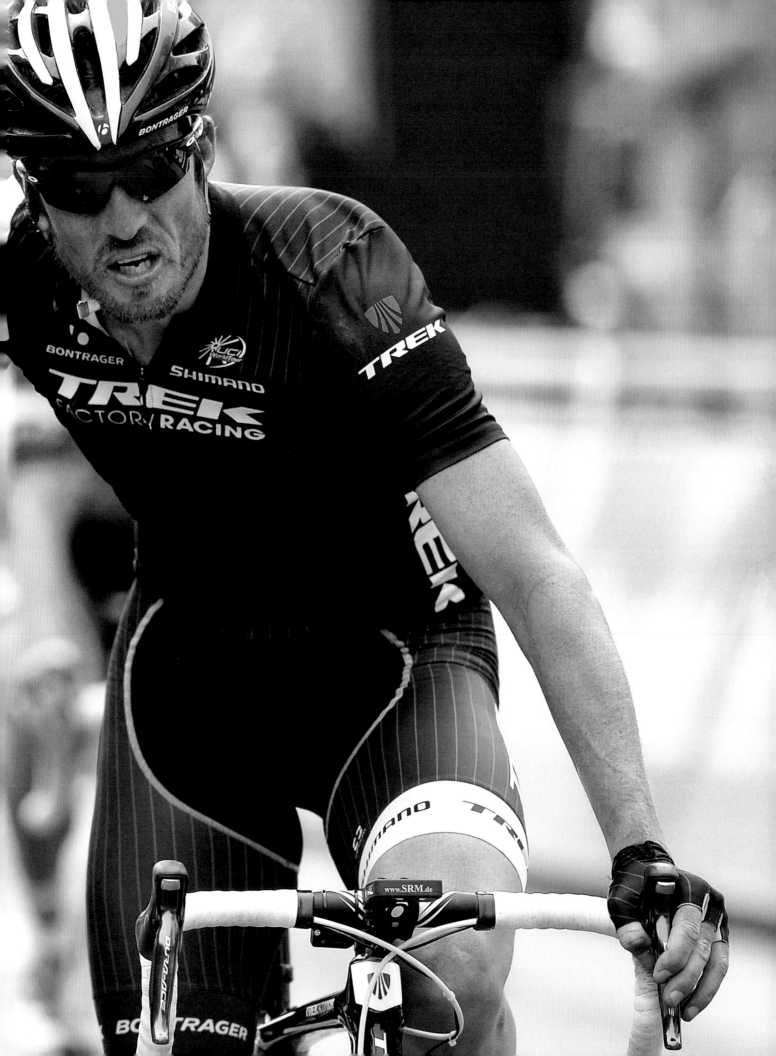

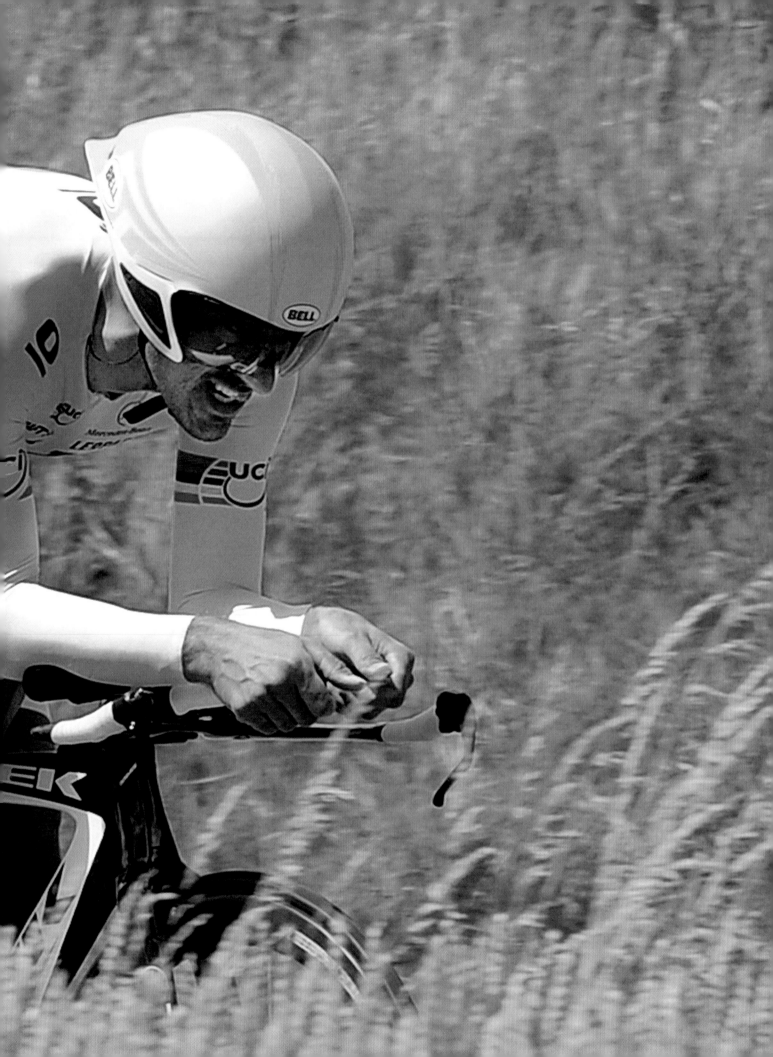

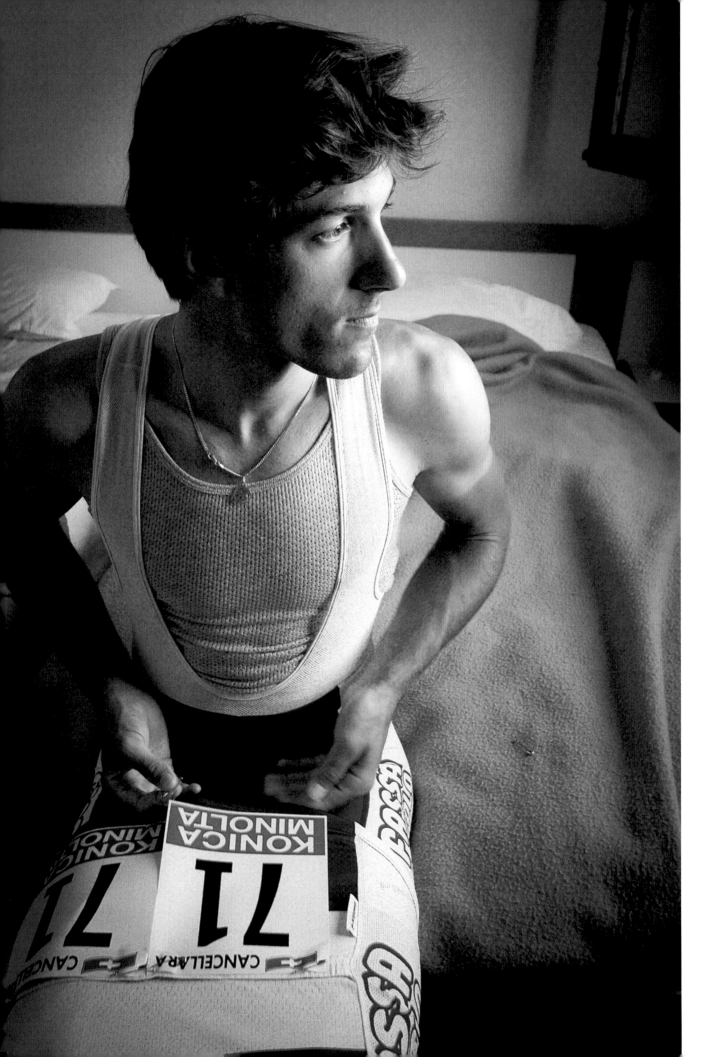

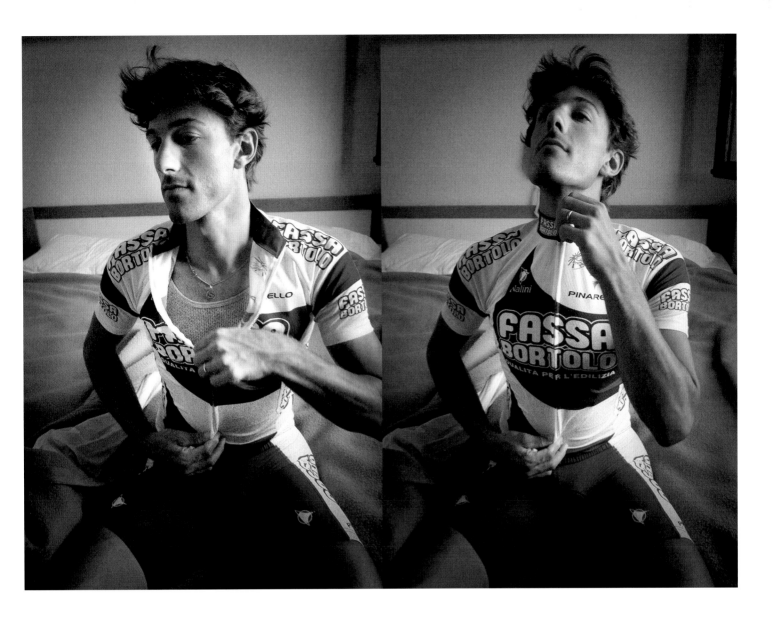

"Ferretti's will was law at Fassa Bortolo's. Everyone involved in the team listened to him."

The unity of man and machine.

 ← ←

A young Fabian Cancellara pins his race number to his jersey at the start of the Tour in 2005.

 ←

"I'd already decided that this would be my last contract. The team offered me a three-year contract and I accepted it. I didn't really think about retiring at the time, not even during the negotiations. During the three years that followed, I continued to be successful."

The different faces of Fabian Cancellara: relaxed, exhausted, exchanging words with his *directeur sportif* during the race, and always having time for fans. In team time trials, he often cracks the whip over his teammates, but also over himself.

→

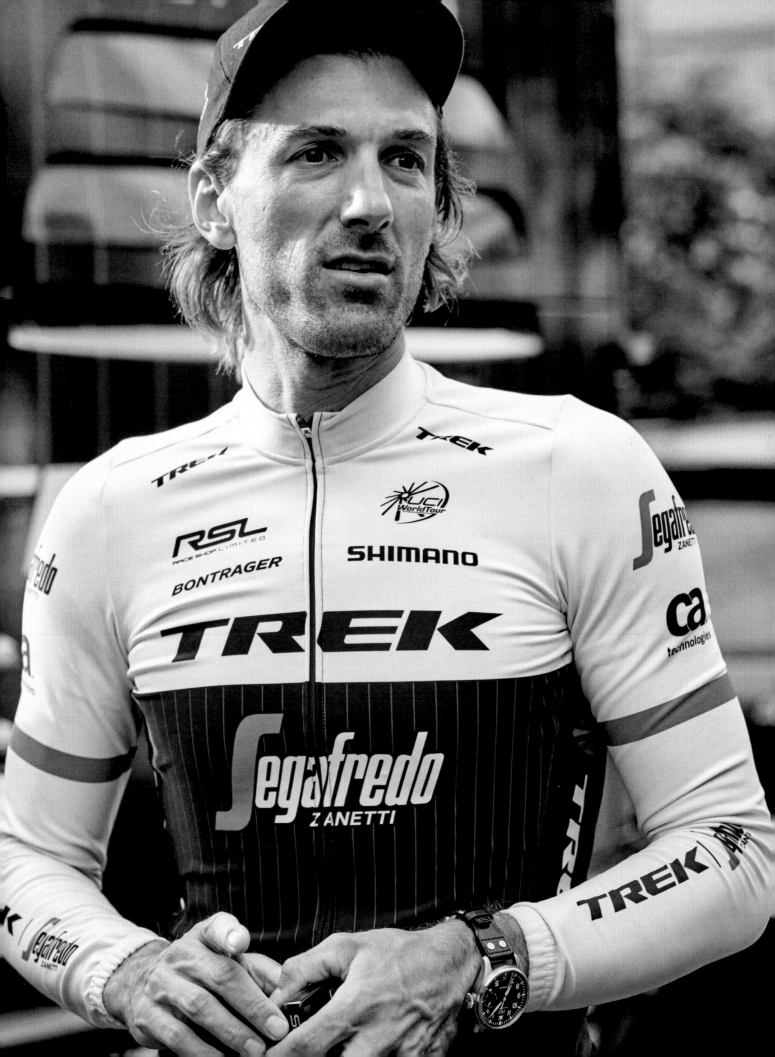

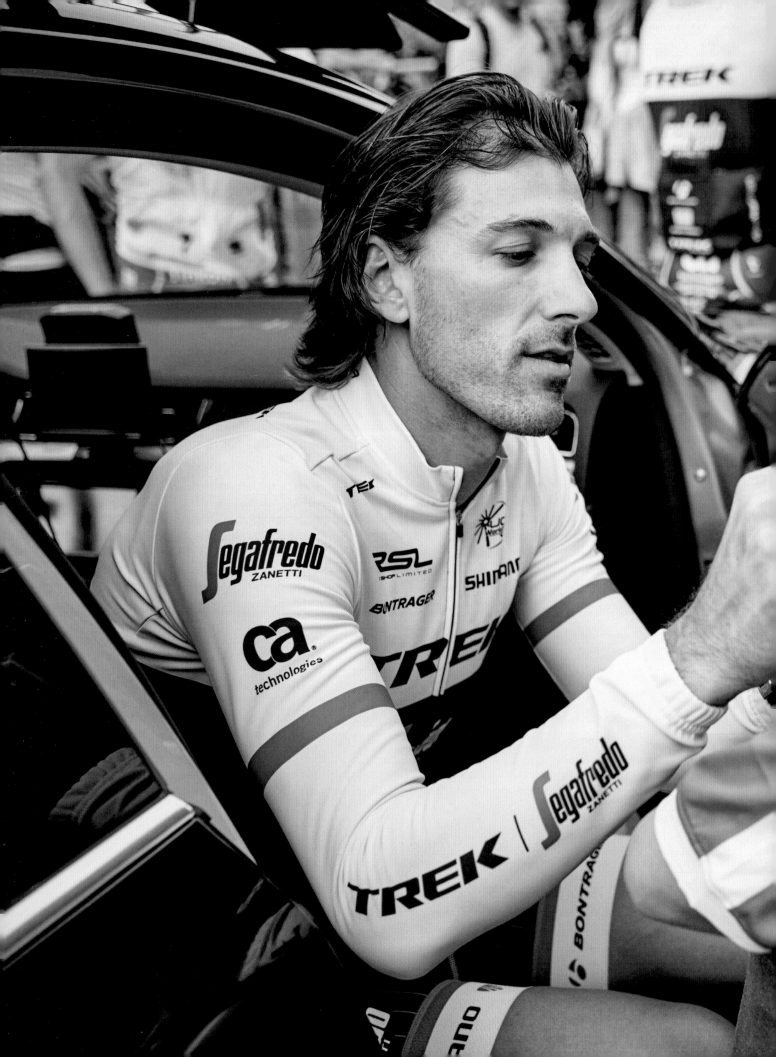

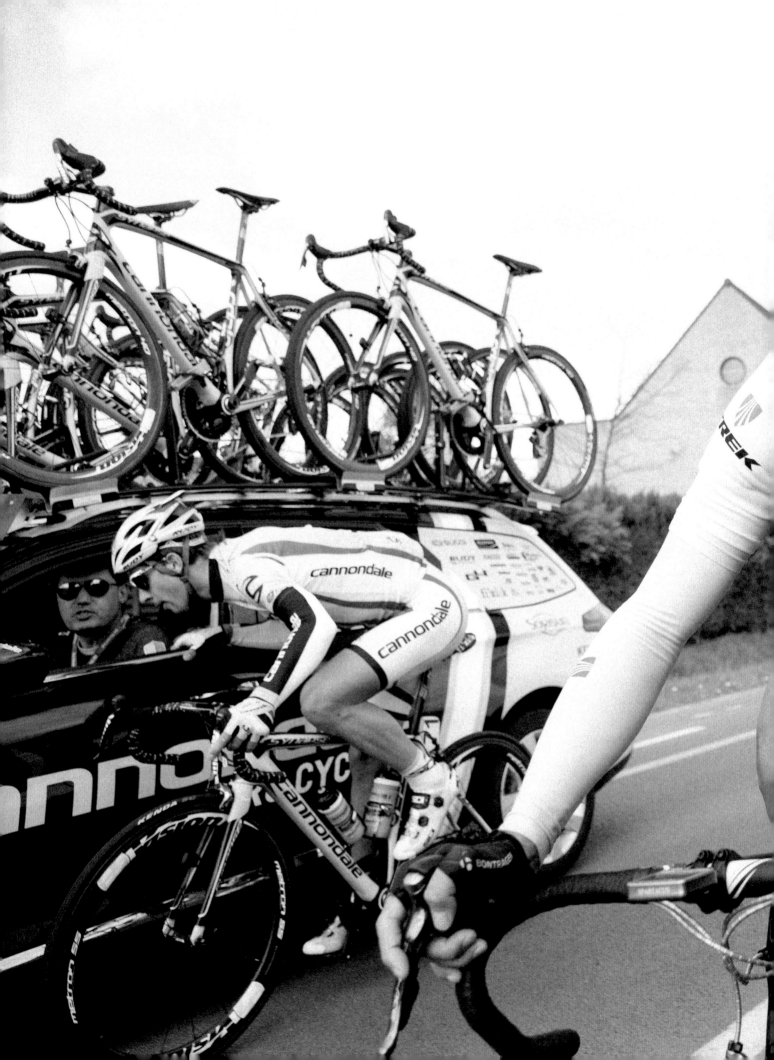

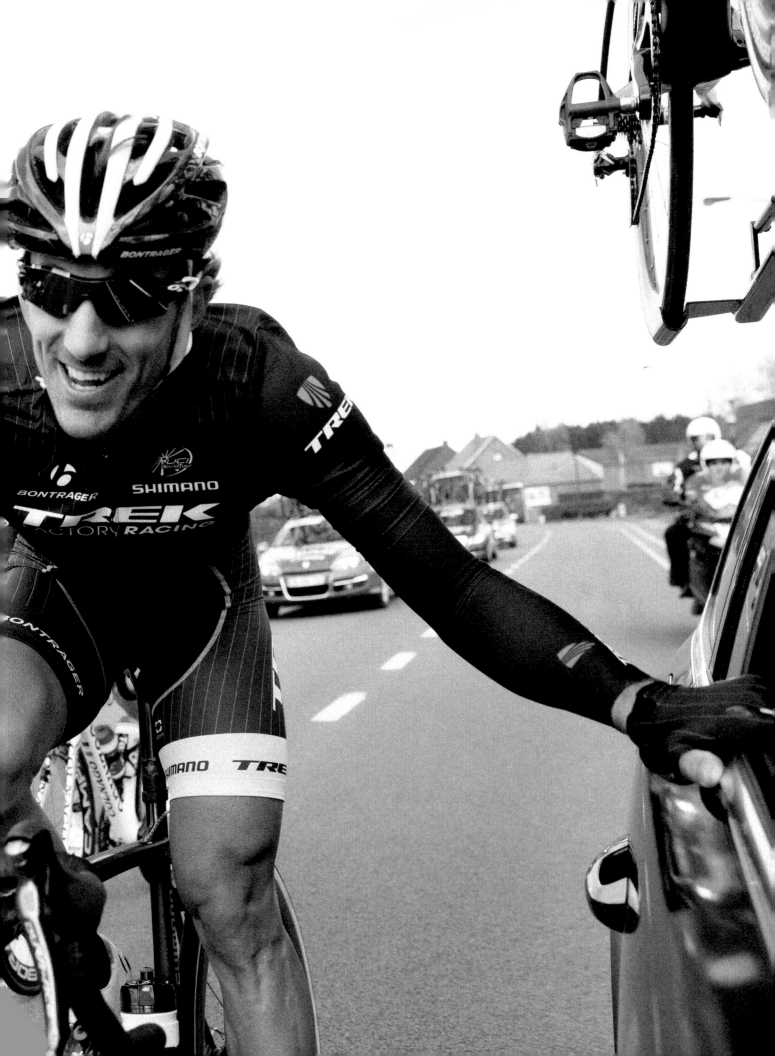

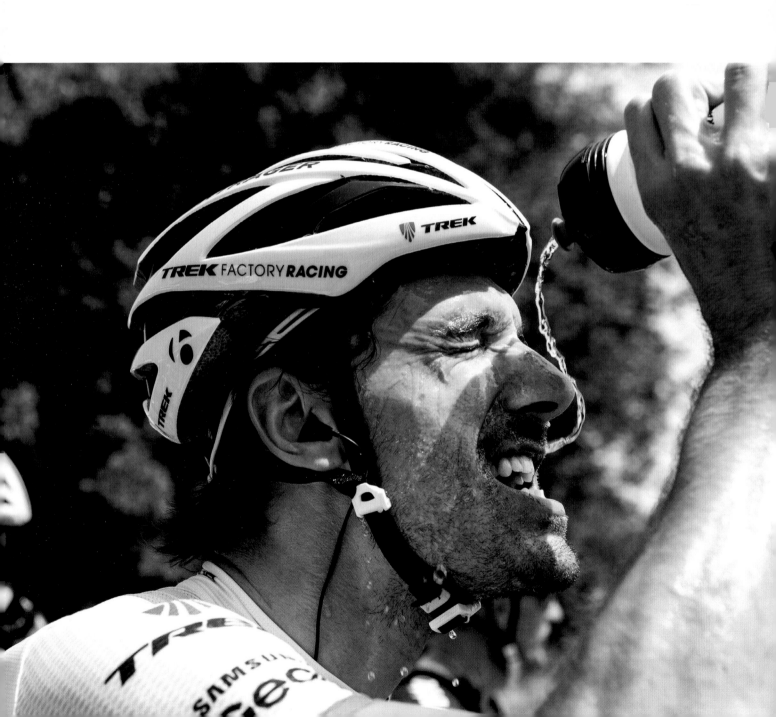

In his last year at Trek Segafredo, Cancellara renewed his focus on time trialling.

→

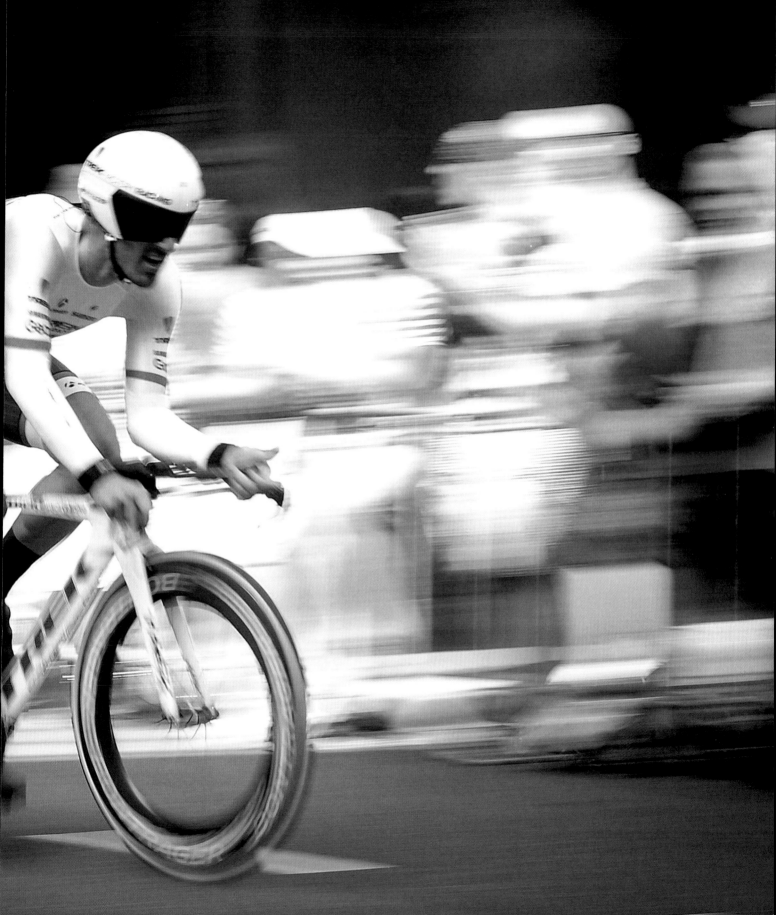

"In all these years, I've never been officially invited to the presentation of the Tour route. Despite the fact that, with my 29 yellow jerseys, I have meant something to the history of the Tour."

Focused during preparation for a time trial. Afterwards even the Swiss has to recover from his efforts.

→

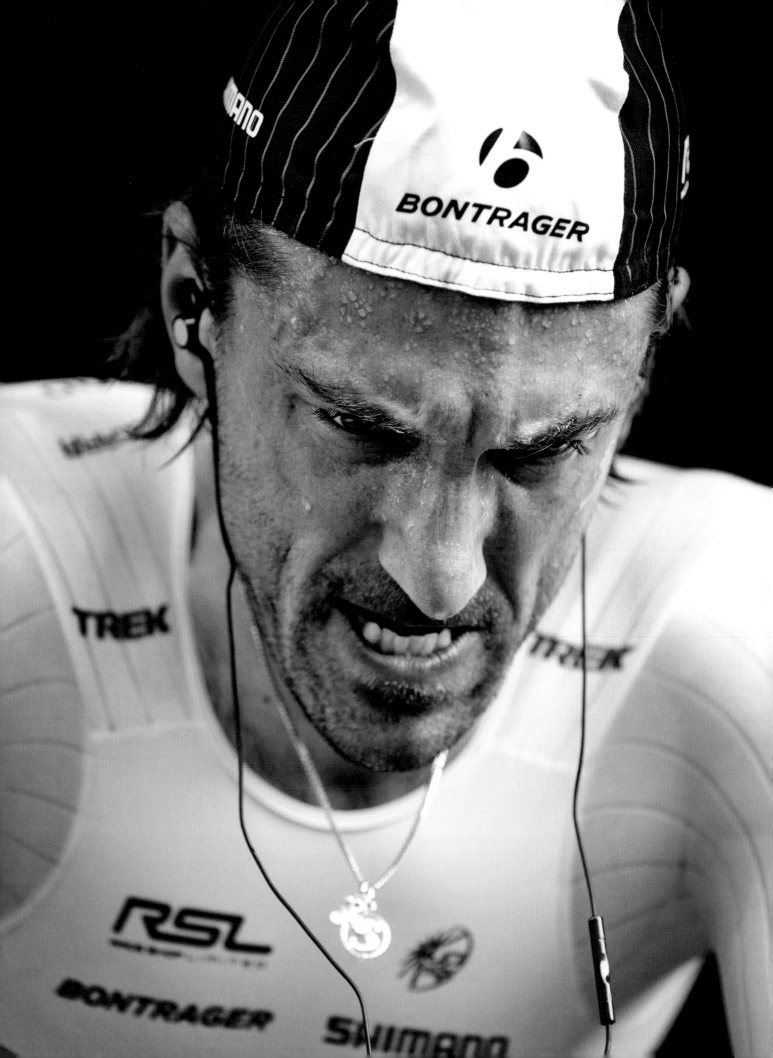

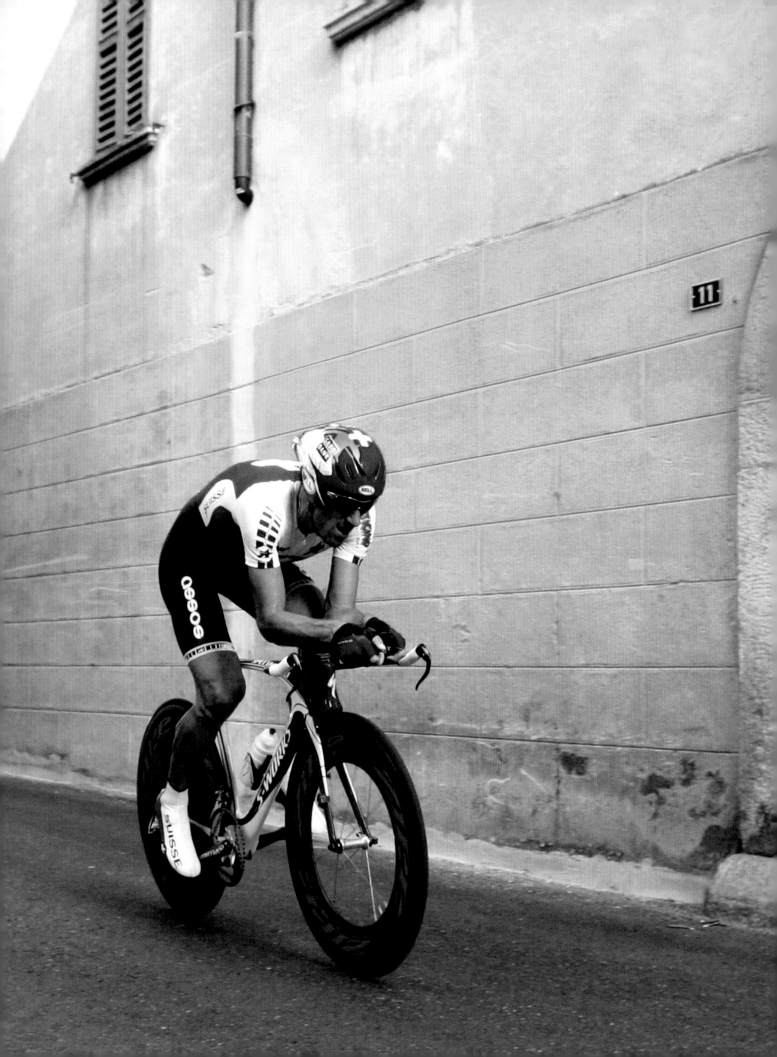

"The Italians regarded me as one of them. The Tripletta that I achieved in 2008 was for them as important as my Harelbeke, Flanders and Roubaix hat trick was for Flanders in 2010."

No lack of support from the Swiss fans for Fabian Cancellara.
←

The joy of victory.
→

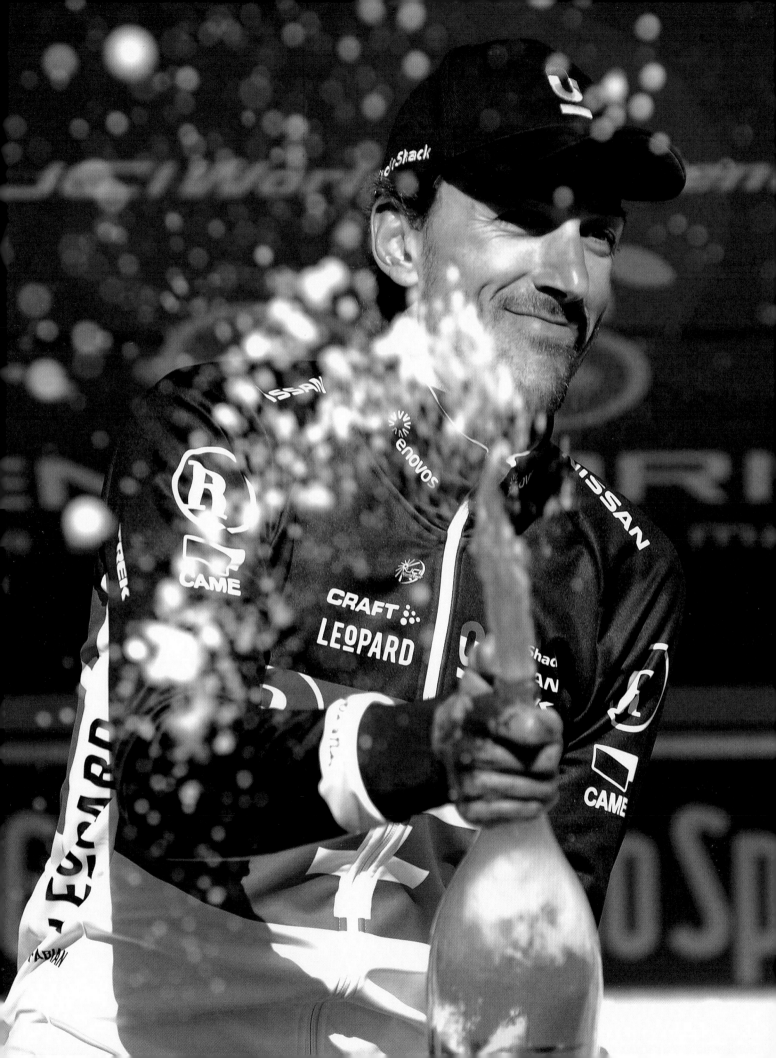

"Up until Rio, I was mainly known as the classics man, the man with the Tom Boonen rivalry. Now I'll always be remembered as the man who retired with an Olympic gold medal."

Saying goodbye to the track at Roubaix. Cancellara goes out of his way to thank his loyal fans.

←

Farewell to a great champion.

→

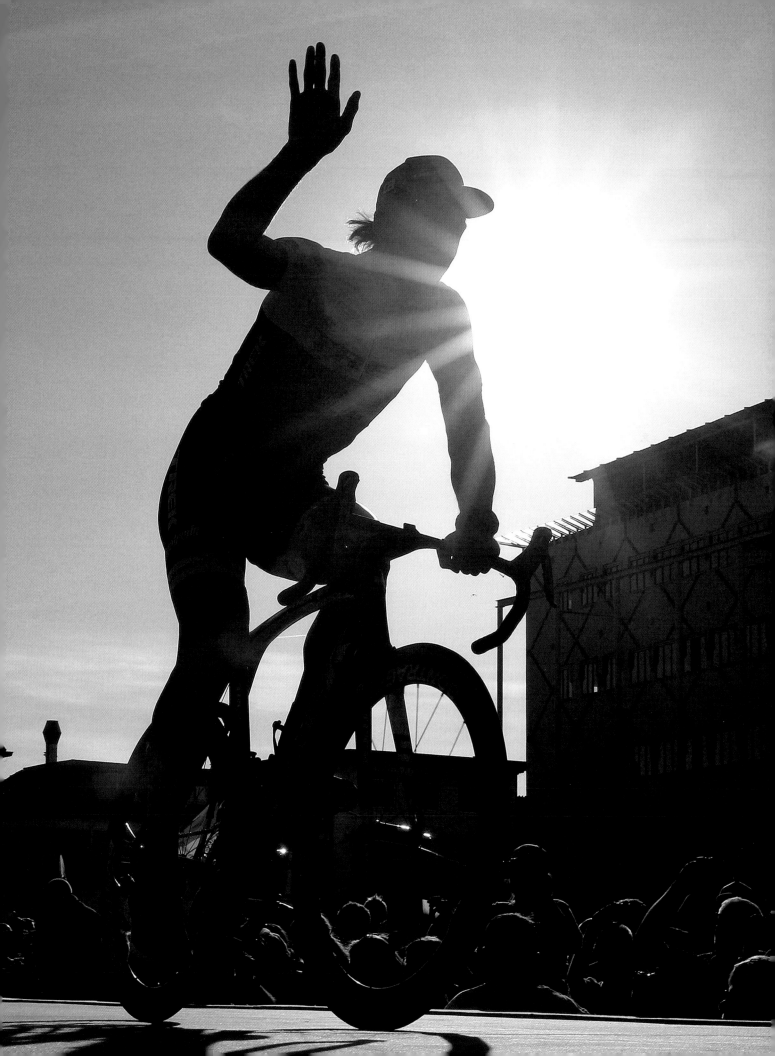

1998

Junior time trial, Road World Championships

1999

Junior time trial, Road World Championships

2001

> 2 victories

- Prologue Tour of Rhodes
- General Classification Tour of Rhodes

2002

> 9 victories

- Prologue Tour of Rhodes
- General Classification Tour of Rhodes
- Stage 3 Part B GP Erik Breukink (individual time trial)
- General Classification GP Erik Breukink
- ZLM Tour
- Stage 1 Part A Tour of Austria (individual time trial)
- Stage 3 Tour of Bohemia (individual time trial)
- GP Eddy Merckx (with László Bodrogi)
- Swiss National Time Trial Championships

2003

> 4 victories

- Stage 6 Tour of the Mediterranean (team time trial)
- Prologue Tour de Romandie
- Stage 4 Tour of Belgium
- Prologue Tour of Switzerland

2004

> 5 victories

- Stage 4 Tour of Qatar
- Stage 4 Tour of Luxembourg (individual time trial)
- Swiss National Time Trial Championships
- Prologue Tour de France
- Stage 1 Catalan Cycling Week

2005

> 4 victories

- Stage 4 Paris–Nice
- Stage 5 Catalan Cycling Week (individual time trial)
- Stage 3 Part B Tour of Luxembourg (individual time trial)
- Swiss National Time Trial Championships

2006

> 9 victories

- Stage 5 Tirreno–Adriatico (individual time trial)
- Paris–Roubaix
- Stage 1 Tour of Catalonia (individual time trial)
- Swiss National Time Trial Championships
- Stage 2 Tour of Denmark
- Stage 5 Tour of Denmark
- General Classification Tour of Denmark
- World Time Trial Championships Salzburg
- Stage 1 Vuelta a España (team time trial)

-2016

2007

> **7 victories**

- Prologue Tour of Switzerland
- Stage 9 Tour of Switzerland (individual time trial)
- Swiss National Time Trial Championships
- Prologue Tour de France
- Stage 3 Tour de France
- Stage 2 Tour of Germany (team time trial)
- World Time Trial Championships Stuttgart

2008

> **12 victories**

- Prologue Tour of California
- Strade Bianche
- Stage 5 Tirreno–Adriatico (individual time trial)
- General Classification Tirreno–Adriatico
- Milan–San Remo
- Prologue Tour of Luxembourg
- Stage 7 Tour of Switzerland
- Stage 9 Tour of Switzerland
- Swiss National Time Trial Championships
- Stage 20 Tour de France (individual time trial)
- Olympic Time Trial Beijing
- Stage 1 Tour of Poland (team time trial)

2009

> **9 victories**

- Prologue Tour of California
- Prologue Tour of Switzerland
- Stage 9 Tour of Switzerland (individual time trial)
- General Classification Tour of Switzerland
- Swiss National Road Race Championships

- Prologue Tour de France
- Prologue Vuelta a España
- Stage 7 Vuelta a España (individual time trial)
- World Time Trial Championships Mendrisio

2010

> **8 victories**

- General Classification Tour of Oman
- E3 Harelbeke
- Tour of Flanders
- Paris–Roubaix
- Prologue Tour of Switzerland
- Prologue Tour de France
- Stage 19 Tour de France (individual time trial)
- World Time Trial Championships Geelong

2011

> **7 victories**

- Stage 7 Tirreno–Adriatico (individual time trial)
- E3 Harelbeke
- Prologue Tour of Luxembourg
- Prologue Tour of Switzerland
- Stage 9 Tour of Switzerland (individual time trial)
- Swiss National Road Race Championships
- Stage 1 Vuelta a España (team time trial)

2012

> **4 victories**

- Strade Bianche
- Stage 7 Tirreno–Adriatico (individual time trial)
- Swiss National Time Trial Championships
- Prologue Tour de France

2013

> **6 victories**

- E3 Harelbeke
- Tour of Flanders
- Paris–Roubaix
- Swiss National Time Trial Championships
- Stage 7 Tour of Austria (individual time trial)
- Stage 11 Vuelta a España (individual time trial)

2014

> **2 victories**

- Tour of Flanders
- Swiss National Time Trial Championships

2015

> **2 victories**

- Stage 2 Tour of Oman
- Stage 7 Tirreno–Adriatico (individual time trial)

2016

> **7 victories**

- Trofeo Serra de Tramuntana
- Stage 3 Tour of Algarve (individual time trial)
- Strade Bianche
- Stage 7 Tirreno–Adriatico (individual time trial)
- Prologue Tour of Switzerland
- Swiss National Time Trial Championships
- Olympic Time Trial Rio

Bloomsbury Sport
An imprint of Bloomsbury Publishing Plc

50 Bedford Square	1385 Broadway
London	New York
WC1B 3DP	NY 10018
UK	USA

www.bloomsbury.com

BLOOMSBURY and the Diana logo are
trademarks of Bloomsbury Publishing Plc

First published in Belgium in 2016
by Cannibal Publishing
First published in the UK in 2017
by Bloomsbury Publishing

Text © Guy Van Den Langenbergh 2016
Introduction text © Marco Pastonesi
This book was developed in close collaboration
with Fabian Cancellara and Human Sports
Management AG, with special thanks to Fabian
Cancellara and Armin Meier.

Guy Van Den Langenbergh has asserted his right
under the Copyright, Designs and Patents Act,
1988, to be identified as the Author of this work.

All rights reserved. No part of this publication may
be reproduced or transmitted in any form or by
any means, electronic or mechanical, including
photocopying, recording, or any information
storage or retrieval system, without prior
permission in writing from the publishers.

No responsibility for loss caused to any individual
or organization acting on or refraining from action
as a result of the material in this publication can
be accepted by Bloomsbury or the author.

British Library Cataloguing-in-Publication Data
A catalogue record for this book is available from
the British Library.

Hardback: 9781472943897

2 4 6 8 10 9 7 5 3 1

Translated by Rebekah Wilson
Image editing by Séverine Lacante
Designed by Tim Bisschop
Printed in Belgium by die Keure
Bound in Belgium by Brepols

Photo credits: Belga Image (pp. 4-5, 19, 39, 40-41,
43, 57, 60-61, 74-75, 93, 105, 145, 146-147, 160-161,
166-167, 170-171), Belga Image/Reuters (pp. 90-91,
108-109), Cannibal Publishing (pp. 106-107), Tim
De Waele/www.tdwsport.com (cover image,
pp. 27, 29, 30-31, 33, 34, 58-59, 62-63, 65, 66-67,
69, 79, 80-81, 82, 85, 89, 97, 137, 138-139, 142-143,
148-149, 169, 173), Getty Images (pp. 21, 25, 33,
46-47, 52-53, 54-55, 94, 116-117, 164-165), Maurice
Haas (pp. 110, 112-113, 118, 121, 122, 123, 153, 154-
155,163), Kramon (pp. 86, 87, 100-101), Emily Maye
(pp. 114, 115, 119, 125, 126, 127, 128-129, 156-157, 158,
159), Pressesports (pp. 44, 73, 130-131, 134-135),
Sirotti (pp. 13, 14, 22-23, 76-77, 98-99, 132-133,
140-141), James Stuart (pp. 150, 151)

Bloomsbury Publishing Plc makes every effort to
ensure that the papers used in the manufacture
of our books are natural, recyclable products
made from wood grown in well-managed forests.
Our manufacturing processes conform to the
environmental regulations of the country of
origin.

To find out more about our authors and books visit
www.bloomsbury.com. Here you will find extracts,
author interviews, details of forthcoming events
and the option to sign up for our newsletters.